51416

743.4
SMI

KT-471-878

ED

D

ED

31 MAY 2024

WITHDRAWN

Coll. of Ripon & York St John

3 8025 00219918 3

77420

Drawing
and
Painting
the
FIGURE

Drawing
and
Painting
the
FIGURE

COLLEGE OF RIPON AND YORK ST. JOHN
RIPON CAMPUS

LIBRARY

PHAIDON

A QUILL BOOK

Published by
Phaidon Press Limited
Littlegate House
St Ebbe's Street
Oxford

First published 1983
© Copyright 1983 Quill Publishing Limited
ISBN 0 7148 2300 7

Published in the USA, its territories and dependencies and Canada by
Chartwell Books Inc, Secaucus, New Jersey.

Distributed in Australia by ABP/Methuen Pty Limited, Sydney, NSW.

No part of this publication may be reproduced, stored
in a retrieval system or transmitted in any form or by
any means electronic, mechanical, photocopying, recording
or otherwise, without the prior permission of the
publisher.

This book was designed and produced by
Quill Publishing Limited
32 Kingly Court
London W1

Art director James Marks
Production director Nigel Osborne
Editorial director Jeremy Harwood
Senior editor Liz Wilhide
Editor Joanna Rait
Assistant editor Sue Haskins
Designer Paul Cooper
Art assistants Annie Collenette Steve Wilson
Photographers Clive Boden Dave Strickland Don Wood
Picture researcher Penny Grant

Filmset in Great Britain by Front Page Graphics, London.
Origination by Hong Kong Graphic Arts Service Centre Limited, Hong Kong.
Printed by Leefung-Asco Printers Limited, Hong Kong.

Quill would like to extend special thanks to:
Ramsey Cain, Sonja Fairfield, Joan Marriott, Christopher
Sarroff, Debbie Weiss and Annie Williams.

CONTENTS

INTRODUCTION

The tradition of drawing and painting the figure, which has existed for thousands of years, is still firmly established today. The figure provides an absorbing study for both the experienced and inexperienced artist, and, as well as being a readily accessible subject, offers an infinite variety of shapes and forms. Within the discipline of painting or drawing the human figure, the principles of anatomical structure, perspective and form, together with the problems and potentialities of tone and colour, can be studied.

The social and moral attitudes of different civilizations can be measured and understood to some extent by their architecture, sculpture and painting. Attitudes to the human body and to representing it in art have varied through the centuries, and may be considered to epitomize the different societies' attitudes and ideologies. This is partly because the individual body and each body's death is a great source of puzzlement. A society's general view of man's position in the universe in relation to God or nature is often recognizable in how the figure is shown in art and how realistically. How man

regards himself in this position, whether he feels proud, humble, or simply confused, is similarly discernible.

Since the birth of the classical ideal some 25 centuries ago, artists have been influenced to a greater or lesser degree by the philosophy which was then expounded. A belief in the intrinsic beauty of the human body and its proportions, which was expressed in the art of Ancient Greece, later became one of the motivating factors for the artists of fifteenth-century Italy. This revival of interest in the human figure, which coincided with the existence of some of the greatest artists the world has ever known, led to that era being known as the Age of Humanism, or as it is more commonly recognized, the Renaissance.

Artists since then have worked in many widely differing styles, but their debt to the Renaissance remains clear. The understanding of perspective and anatomy, taken for granted today, is an heirloom from these earlier times. It is with good reason that these are still considered to be important areas of study for the artist: being able to represent the figure realistically, which has become

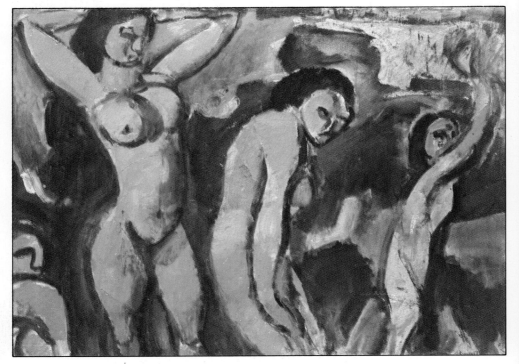

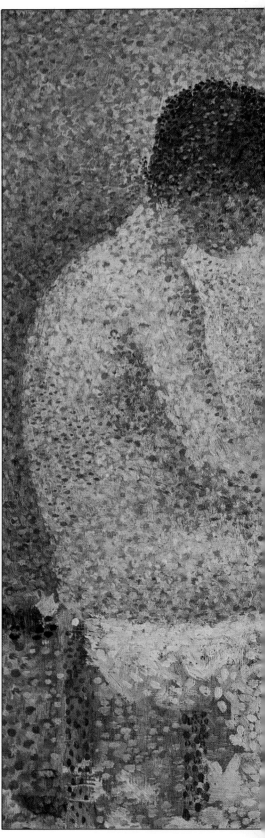

Above *The Bathers*, Georges Rouault. Rouault's apprenticeship to a stained-glass window maker was to have an effect on his art for the rest of his life. The rich, powerful colours and strong black outlines derived from medieval glass appear often in his work, together with simplified,

elemental forms drawn in a bold, curving line, creating a lively sense of movement.
Right *Sitter in Profile* (1887), Georges Seurat. Primarily concerned with scientific theories of colour vision and colour combinations, Seurat's figure style was influenced by Puvis de Chavannes (1824-98),

himself much impressed by Classical art. This oil sketch is typical of the way Seurat built up his monumental and simplified forms with an elegant and sensitive Pointillist technique.

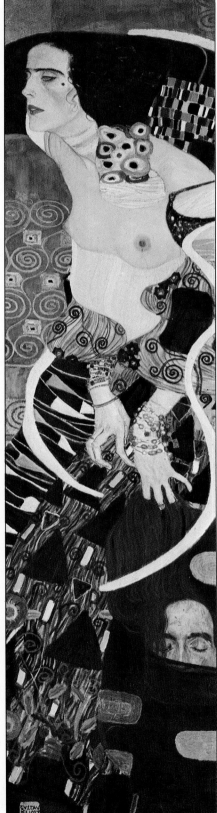

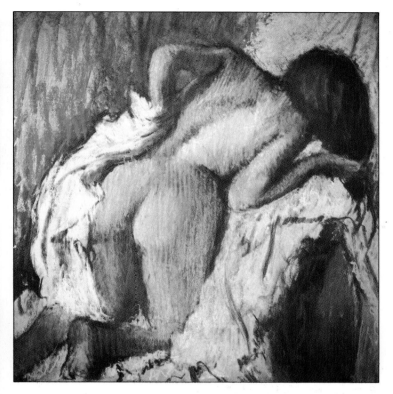

increasingly possible with the growth of scientific knowledge, has always been one of the most important initial aims for the figure painter. Man seems to have a strong desire to represent himself as he really is.

When "realism" is used as a term in painting it can be taken to mean one of two things. An artist whose work is described as "realistic" is generally one who is closely imitative of nature; to achieve a sense of realism in a painting is one of the most difficult and most prized aspects of representing life, especially the figure. However, the term may be considered, in a pure sense, as an attempt to reduce art to a science. In fact, any rendering of the human form by another human being cannot but be subjective; the act of creation in itself denies an objectivity because every artist, every human mind, is different. Each one sees the world and responds to it in different ways and in infinitely unaccountable combinations. "Man as he really is" is a term that is endlessly ambiguous in its attempted application.

Some artists of this century have delighted in the impossibility of man being able to comprehend the world totally and have rebelled against the tradition of attempted realism. By painting the figure symbolically and in abstract ways, often in bright, even stark, colours, they celebrated sensuality and intuitive responses, although their particular, and very individual rendering of figures was based on a sensitive understanding of form.

Left *Salome* or *Judith,* Gustav Klimt (1862-1918). The principal Austrian Art Nouveau painter, Klimt was also a decorator and founder of the Viennese Sezession. His mannered, linear figure style was much influenced by Japanese and Byzantine art as can be seen in the slinky, erotic figure set against a gold background, the colours vibrant as in a Byzantine icon.

Above *Woman Drying Herself,* Edgar Degas. More interested than the other Impressionist painters in draughtsmanship, Degas had a sound knowledge of traditional techniques and Italian Renaissance art. Influenced by the new techniques of photography and the Japanese print, he was concerned to convey the impression of movement and spontaneity, although his work was in fact always carefully composed. A great innovator of the pastel medium, he was one of the first to use broken colour as can be seen in this sketch where bold curves are complemented by strokes of pure colour. Both Degas and Bonnard painted pictures of women in the bath, drying themselves or combing their hair, affording the spectator intimate glimpses into their lives.

In its second sense, "realism" can be applied to paintings which are representative of life after conventions and inhibitions have been stripped away. If the subject matter of the painting comments on ordinary aspects of life without romanticizing, then it is often described as "realistic". This is known as "genre" painting. Both Bruegel (c. 1525-69), the sixteenth-century Flemish painter, and L.S. Lowry (1887-1976) in twentieth-century England, are good examples of artists who represented the human figure in this manner. By depicting scenes of peasant life, and people going about their everyday tasks, they were drawing attention to the importance of a broader view of humanity.

Although the actual appearance of the human body has presumably changed only a little over the centuries, any response to it is dependent on prevailing tastes and fashions, and these changing responses are evident in art. Ideals of proportion and beauty have varied greatly throughout the ages and this is nowhere more apparent than in the treatment of the human figure. By looking at paintings of the Renaissance, for instance, it can be seen that their ideal of feminine beauty demanded a fair skin.

It is interesting to compare two very different paintings of the same subject, the Three Graces, one by Baldung (1484/5 - 1545) and one by Rubens (1577 - 1640). The subject has always been popular, perhaps because it provides an excuse for painting the female nude under the respectable cloak of mythology. Baldung's medieval sense of beauty dictated his portrayal of cool, pale and graceful nudes. The element of sensuality is present but firmly under control. Rubens, on the other hand, makes no secret of the sexuality of his figures. By his emotive use of colour and the tactile quality of his paint, he portrays the female nude as an object of desire, both healthily lusty and deliberately provocative. To a certain extent, these differences are due to the artists' personalities. However, with the benefit of hindsight it is possible to recognize where the attitudes reflected are those of the individual and where they were influenced by the age. Interestingly, our reactions to paintings today are similarly coloured by current trends of thought.

It is useful and enlightening for the modern artist to learn something of the various ways the figure has been treated by artists through the ages, and the reasons for the variety. The training of art students still emphasizes the importance of a full understanding of the techniques and methods for representing the human body. Although the influence of Ancient Greece and Rome is more easily discernible in the Western art of later periods, it is worth pausing first to consider the paintings and reliefs of the Ancient Egyptians.

All the great Egyptian sculpture, architecture and painting was made for a single purpose: to glorify the dead pharaoh or nobleman who was considered to have moved on to another life among the gods. Surviving paintings are decorations on the walls of elaborate tombs, constructed to house the body of the departed pharoah and keep it safe during his journey to the afterlife. The paintings, usually accompanied by inscriptions, illustrated scenes from the pharaoh's life on earth, usually concentrating on the more illustrious episodes to ensure him a good reception in the afterlife.

Artists of the time were not expected to have an individual style and were considered as anonymous craftsmen whose job it was to follow a complicated system of rules which were applied to all pictorial representations. Unlike later artists, the Egyptians were not concerned with creating an impression of reality; the purpose of their paintings was to convey accurate information to the gods, almost like a written description. The human figure was depicted with each part of the body shown from its most easily recognizable angle, producing an image which appears strangely flat and stiff to modern eyes. Figures were usually portrayed facing to the right with the head in profile. Onto that profile the eye was painted as though viewed from the front, thus showing its characteristic shape. The shoulders are also seen straight on, although the chest is slightly turned so that one nipple is in profile. Arms and hands are seen from the side, thus obviating any problems of foreshortening; the hips are at a three-quarters angle; the legs and feet are again in profile, one in front of the other.

There were many rules regarding the depiction of people not walking from left to right and of seated figures, or figures facing in the opposite direction. It is interesting to note that, although these rules were applied rigidly to the higher social orders, the treatment of ordinary people allowed the artist greater flexibility. An insight into everyday life in Egyptian times can be gained by examining the many scenes showing labourers and peasants going about their various tasks, looking after animals, sowing, reaping and cooking. The proportions of the figure were also governed by rules and were drawn within the guidelines of a grid which was only slightly modified over the years. Sometimes grids were drawn over the top of finished paintings to allow copies to be made more easily.

Paintings were made onto smoothly plastered walls with the designs carefully drawn out first in diluted black ink. Many of

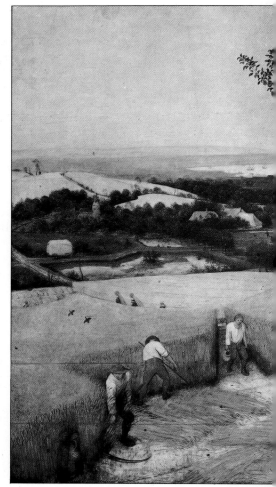

these paintings are actually coloured reliefs, but the approach was similar, with the main outlines indicated before the carving began. The painter had at his disposal a narrow colour range made from a mixture of earth and mineral pigments. The most commonly used colours were yellow ochre and reddish-brown; blue and green were obtained from cobalt and copper, white from chalk and black from lamp black. These paints were applied using thin reeds which were chewed at the end in order to spread the fibres.

Just as with the drawn outlines, colour was used as a code to convey information, not to describe solid form. Each area of the painting was laid in with a flat area of colour. The colours were not mixed and there was no use of tone. Form was emphasized by black outlining. The male body is always a dark reddish-brown, while the female is a pale yellow, the shade now known as Naples yellow, or pink. The colouring of the figure was considered to be as important as the drawing and it is unusual to find a finished picture of a human being which was deliberately left unpainted.

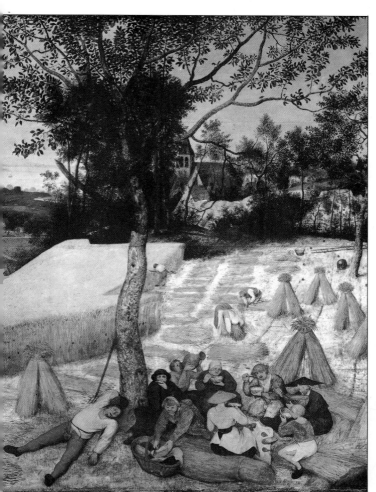

Left *The Corn Harvest* (c. 1565), Pieter Bruegel. Bruegel devoted the last ten years of his life to painting genre scenes and religious subjects set in vast landscapes. Nicknamed "Peasant Bruegel" after the subjects he painted, he was one of the most important Netherlandish satirists, showing a genuine interest in rural life, combined with a satirical attitude towards vice. The naturalistically rendered landscape is peopled with little figures all busy at their labours. Colour is an adjunct to form, the bright, strong hues of the peasants' clothes standing out against the gold corn and the shapes of the stooks echoing the women's conical hats.
Below *The Pond*, L.S. Lowry. Lowry sets his brightly dressed stick figures in an industrial landscape, walking in horizontal processions which repeat the strong horizontals created by the streets, the edges of the pond and the viaduct. The figures, pushing prams, pulling dogs and children, echo the verticals of factory buildings, chimneys and smoke; they are submerged by their industrial surroundings.

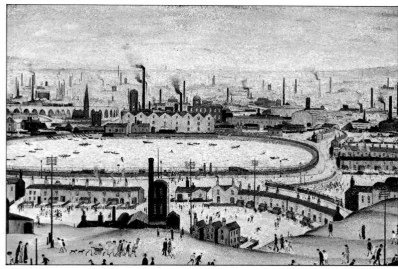

The scenes described in Egyptian tomb paintings are usually painted against a white or a yellow background, with no indication of surroundings. They are often sequential and can be read like a comic strip. Figures march along a base line with no attempt to represent depth within the picture. Although the proportioning of individual figures is realistic, the scaling of one figure in relation to another is not. Instead, the most important people are shown as the largest, which allows easy recognition of the central characters in each painting. The owner of the tomb was usually many sizes larger than the rest of the family. Social rank was demonstrated by the way in which figures related to one another. For instance, if a man and woman were shown seated together then the man would be in front of the woman so that his body was unobstructed. She would be seated to his left, as this was the "inferior" side, in keeping with woman's place in Egyptian society.

The timeless sense of order and calm is often considered an attractive aspect of Egyptian painting for the modern viewer.

Everything has its correct place and everyone their position. Symbolism was of paramount importance in these paintings and little was included that did not have some religious significance.

In contrast to the Egyptians, whose sights were set on the hereafter, the Ancient Greeks were concerned with the here-and-now. The Egyptians made no attempt to represent man as he really was; this would not have served their purpose. Man was represented by his most obvious features to make recognition by the gods and acceptance into the afterlife inevitable. The Greeks, however, did not share the Egyptians' conviction that there was better to come in the afterlife. Their gods were not always hard to please and, in fact, suffered from recognizable human weaknesses. The Greeks made their gods and goddesses in their own image.

The Greek interest in the human physique and their conviction in its inherent beauty led to their desire to represent it in art in the most vibrant, lifelike manner imaginable. It is possible to gain an idea of how Greek figure painting developed by looking at their pots

and vases, a substantial number of which have survived to the present. The Greeks had perfected techniques of production and a characteristic style of decoration which transformed their pots from mere utilitarian objects to works of art in their own right. Until the fifth century B.C. the figures on these vases remained stylized. Work dated before this time is usually known as "black figure pottery" because the figures, which tend to be of a geometric design, are silhouettes filled in with either dark brown or black. This contrasts well against the background, which is usually the natural red of the pot but sometimes lighter in tone or gilded.

Around 500 B.C. this decorative scheme was reversed and the figures were picked out of the red against a black background. This was an important change as it meant that the figures could be elaborated, using black lines to describe the form, giving a feeling of solidity. Later there were indications that artists were grappling with the problems of foreshortening and perspective, although in a simple way. Depth was indicated by placing

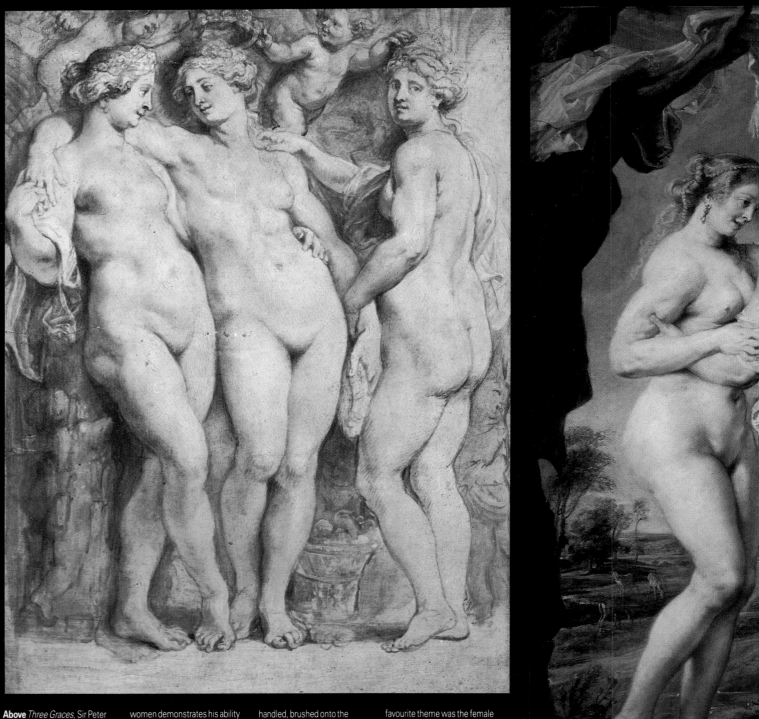

Above *Three Graces*, Sir Peter Paul Rubens. One of the greatest painters of his time, Rubens spent four years in Italy where he was able to study Classical sculpture, and Italian art, and copy Michelangelo's sculpture and frescoes. Draughtsmanship was the basis of his genius, and this sepia sketch of typically Rubensian women demonstrates his ability to convey his ideal of beauty in the solidity and fleshiness of the marvellously voluptuous female forms.

Right *Three Graces*, Sir Peter Paul Rubens. Modern taste tends tc prefer Rubens' sketches to his finished oil paintings, but the absolute mastery with which the paint is handled, brushed onto the canvas in rapid strokes of opulent, rich colour, brings the forms into palpitating life.

Far right *Harmony of the Graces*, Hans Baldung Grien. A fine draughtsman and colourist, Grien may have trained in Dürer's workshop and was also influenced by Mathias Grünewald (1460-1528). His favourite theme was the female nude, often depicted in macabre allegories in a mannered, linear style and exuding a coolness and asceticism typical of Northern art.

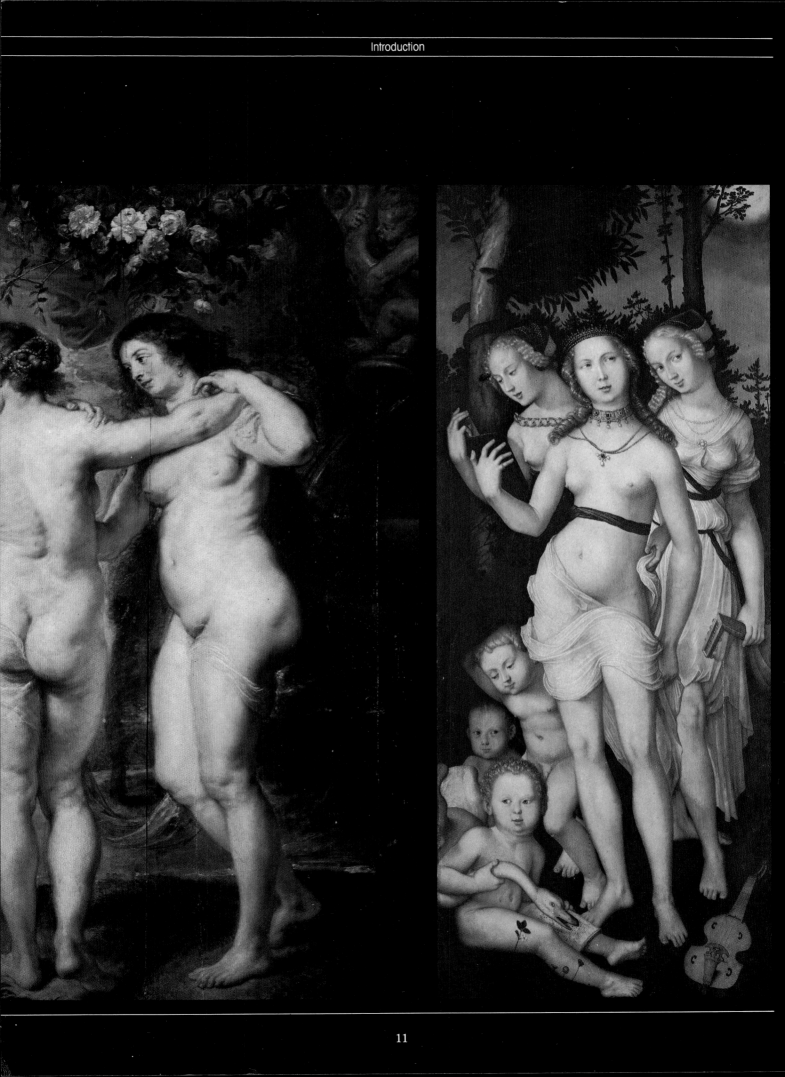

Right *The Charioteer of Delphi.*
This beautiful bronze statue
formed part of a group
dedicated at Delphi by Polyzalus
of Gela to commemorate his
victory at the Games in 474 B.C.
Archaic sculpture had depicted
the figure in rigidly frontal poses,
the male naked and the female
draped, called *kouros* and *kore*
respectively. Although in the
sixth century B.C. there is
greater understanding of the
human, particularly male,
anatomy, interest lies more in
the folds and elaborate coiffure
rather than in the underlying
structure of the body. By the
fifth century, the figure
becomes more relaxed by
shifting the axes of the hips and
shoulders and the position of
the head. The Classical
sculpture from this period, of
which the Charioteer is a prime
example, developed a greater
variety of poses and freedom in
the treatment of hair and
drapery. The columnar fluting of
the Charioteer's *peplos* hangs
naturally, acknowledging the
body beneath. The muscles of
the arms are conceived in a
lifelike manner as are the feet
flexed against the chariot for
balance.

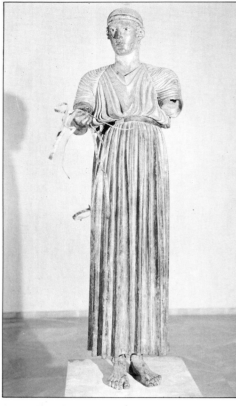

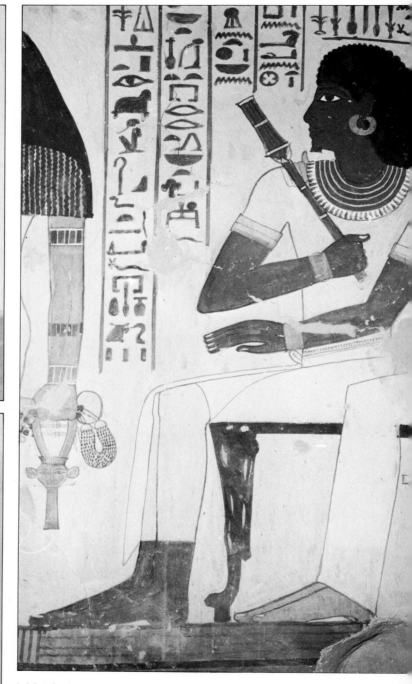

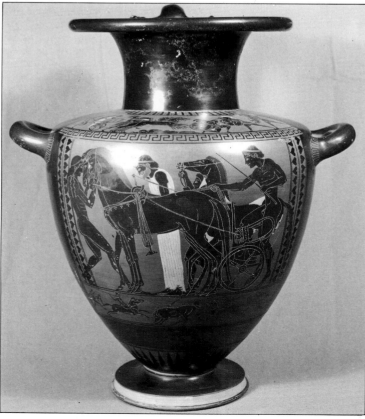

Left Early Greek vases were
decorated with geometrical
designs set in friezes round the
vase. Figural compositions
appeared in the seventh century
B.C. with the strictly frontal view
or profile being the rule. This
silhouette style became
inadequate for depicting
movement and a new technique
was invented where figures
were drawn in silhouette with
the details incised to show the
clay beneath in thin lines. This
encouraged a greater realism,
further enhanced by the
addition of red and white paint to
pick out features such as hair,
eyes and ribs. In this sixth
century vase, the little figures,
hardly more than 1 inch
(2.5 cm) high, are rendered in a
lively manner, with the forms
filled out and muscles bulging
giving an impression of energy.
Above *Sennufer and his Wife.*
The Egyptians believed that by
recreating living creatures and
objects they ensured their
continued existence. A picture
of a ruler enjoying life with his
possessions around him meant
that he would go on in the same
way in the next life. It was a
descriptive art, expressing a
rational, objective truth which
was unrelated to time and
space. Three-dimensional
perspective was unknown.
Objects are shown from their
most characteristic view with all
the essential features visible. As

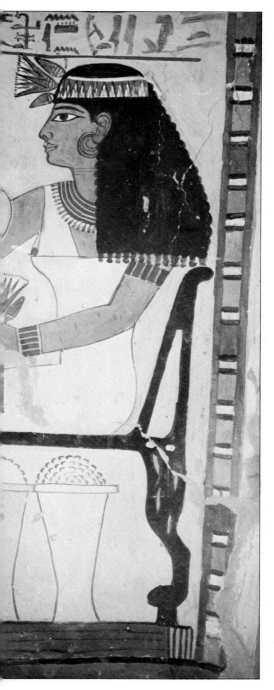

these portraits from the tomb of Sennufer at Thebes demonstrate, the ideal human figure was shown with its head in profile but with the eye almost frontal, the shoulders face on, chest in profile and lower half in three-quarters profile. Men are generally depicted in their virile prime, their skins painted in red ochre; women are ever-youthful with taut and graceful bodies, their skins a paler colour than the men's. Heads were carefully modelled with emphasis on the eyes. Some attempt was made to individualize the sitters but this was relatively unimportant as identity was established by the inscription of the name.

a larger figure in front of a smaller one, and sometimes a few drawn lines hint at a receding plane. Suddenly the drawings on these vases appear much more realistic and "modern".

Greek artists were not content to remain anonymous, and often signed their paintings and sculptures. Many of their names have survived by repute although their work has long since been lost. Sculpture was a popular Classical art-form and fortunately a certain amount has survived, mostly the Roman copies of the Greek originals. Where the copies and originals both remain it can often be seen that much of the character was lost by the imitator, but even so, such copies make it possible to trace the development of Greek art where there would otherwise be gaps in the knowledge of this subject today.

As with painting, sculpture before the fifth century B.C. remained archaic and stylized, and lacked movement. The sculptor had not yet mastered his material and pieces from earlier than this period retain much of the original character of the block of stone from which they were fashioned. Poses were staid and upright, and not fully considered as three-dimensional forms. However, *The Charioteer of Delphi*, a bronze sculpture made in 475 B.C., represents the beginnings of a move towards a greater naturalism. The sculpture displays a tendency towards stylization, and the pose is stiff, but there are realistic sinews standing out on his arms and his feet are braced against the chariot to hold his balance.

A sculptor who enjoyed much acclaim among his contemporaries was Polyclitus, who lived in the fifth century B.C. This recognition was partly due to his system of measuring human proportion according to an arithmetical formula. His careful calculations led him to suggest that the head should fit seven and a half times into the overall height of the body; the length of the foot should measure three times the palm of the hand; the length between the foot and the knee should measure six times the palm of the hand, as should the distance from the knee to the centre of the abdomen. Although Polyclitus' demonstration model *Doryphoros*, or *The Javelin Carrier*, has not survived, several Roman copies show a much more fluid figure than had previously been achieved. All the weight is carried on one leg, while the other is more relaxed and bent slightly behind as though the figure is walking. The hips are tilted and, to compensate for this movement, and to regain a balance and harmony in the composition, the shoulders swing slightly out of alignment with the torso. The effect is of a young man who, though poised for movement, is balanced and at ease. It is an interesting pose

as it is neither static, as a figure standing squarely on both legs would be, nor does it have the unnatural theatricality of a figure involved in violent movement.

That the Romans were impressed by the art of Greece is obvious not only from the numerous copies which they made but also from the number of complimentary references made to it by the Latin writers. They did more than simply admire from afar; in the same way that young artists made their way to Paris in the late nineteenth and early twentieth centuries to complete their art education, so the Romans went to Greece. Many were trained in Greece, or had Greek tutors. Also, much of the work produced as Roman art was in fact made by imported Greek artists. Even as Rome was becoming mistress of a great, expanding empire she looked to Greece for guidance in matters of aesthetics and art.

However, the Romans were of a different psychological make-up, and this soon began to show in their painting and sculpture. Certain aspects of Greek and Roman art share a common purpose: both races applauded acts of daring and fortitude and their art abounds with triumphant heroes. But, whereas the Greeks moulded their young heroes into the perfect shape, the Romans were concerned to portray realistic likenesses. The Greek passion for ideals obliterated personality; a man who is truly perfect loses those characteristics which make him an individual. The young gods and heroes of the best of Greek art do not look capable of anger or sorrow, elation or exultation; occasionally they were allowed detached and condescending half-smiles. Not so with the Romans. Their realism was often unflattering and sometimes brutal despite the fact that the subjects were usually the ones to pay the artists' bills.

Many Roman wall paintings were executed in fresco which continued as a popular and durable method until, and after, the Renaissance. This involved the careful preparation of small areas of wall, onto which pigment was directly applied to wet plaster, so, rather than lying on the surface and later flaking off, the paint became bonded into the wall as it dried. Tempera paint was used, this being a mixture of finely ground pigment and egg yolk or white; sometimes wax was mixed with the colours thus making it possible to paint onto marble or wooden panels. The Romans used a wider range of colours than the Greeks, including clear blues and vivid greens and reds, as a result of which some of their paintings are highly naturalistic, even impressionistic in style.

Another insight into Roman painting can be arrived at by reading the work of Vitruvius, a Roman architect. Towards the

end of the first century B.C. he wrote *De Architectura*, a manual outlining the rules which should be applied to architecture; this influenced artists in all fields for many centuries. He was an exponent of the Greek philosophy that "man is the measure of all things", and suggested, in his list of rules for the guidance of architects, that buildings should conform to the same proportions as human beings. The strong link between mathematics and art probably led Vitruvius to reflect that a man with his arms and legs extended could be contained within the square and the circle, both shapes being considered to represent aesthetic perfection. Of the many examples of men so depicted, perhaps the best known is that by Leonardo da Vinci (1452 - 1519), drawn over 1,500 years after the death of its innovator.

There was a continuing interest in works of art which retold stories from mythology, but these existed alongside pieces of historical documentation. One of the murals in Pompeii illustrates a riot which took place in the amphitheatre between the locals and a visiting town. It is interesting because of the subject matter, which seems to have a modern relevance, and also because of the treatment of the many tiny figures, scurrying about and fighting. These are sketched in with vivacity and a discerning disregard for detail. Because the artists of this period had only a limited grasp of the rules of perspective, the amphitheatre is tipped at an angle to show the inside as well as the outside, and the figures in the foreground are more or less the same size as those further away. In spite of this, the overall mood has the immediacy of the work of a good, modern caricaturist.

Arguably some of the best portraiture ever produced is from this period. These were mostly pieces of sculpture, but there were also portrait paintings, a sufficient number of which survive to indicate their similarly high standard. Another example of wall painting in Pompeii from the first century A.D. is a double portrait of the lawyer Terentius Meo and his wife. The artist made realistic use of tone, highlighting, and naturalistic colours to enhance their forms and create a sensitive and expressive piece of work.

This era saw the emergence of the female nude as an interesting subject, as long as she was held within the framework of mythology. The Greeks had shown little interest in the female figure until late; the male Greek attitude to their womankind demanded modesty, despite the fact that it was acceptable for the young men to cavort in near nudity, and paintings of female nudes from the Greek period are often coy. Roman paintings of the subject display a certain eroticism, however. The Venus who appears on the wall of the House of Venus Marina in Pompeii, although painted around A.D. 10, still obeys certain Greek conventions: she is stocky, with a narrow torso, and has no pubic hair. Nevertheless her pose is inviting and the overall composition of Venus floating on a large sea-shell flanked by cupids is light-hearted. The Romans continued to paint the

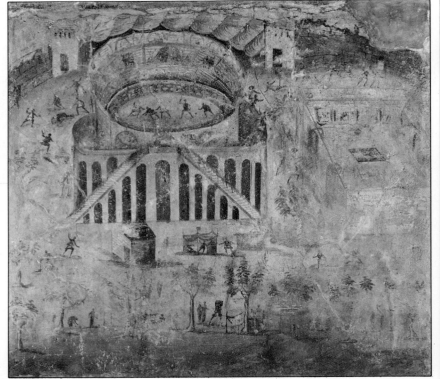

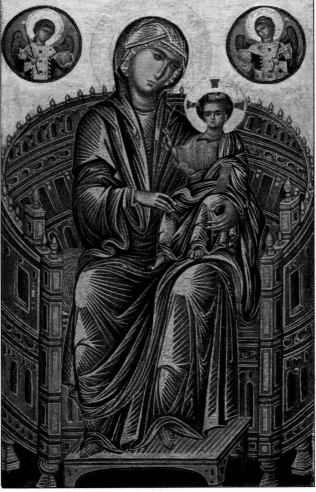

Above *The Riot in the Amphitheatre*. The murals at Pompeii were executed from the end of the second century B.C. until A.D. 79 when Vesuvius erupted. Painted as interior decorations, they consist of perspective friezes, landscapes and figural scenes. A single vanishing point perspective and uniform light system had not yet been mastered by the Romans so that a somewhat "plunging" effect was the result, with the amphitheatre tipped up and the figures all on the same scale.
Right *Enthroned Madonna and Child*. An imperial art glorifying Byzantium's greatness, Byzantine art was also a theological art, voicing the dogma of the day, and as such was stylized and opposed to Greek naturalism. Enclosed in a throne in which an attempt to create space and depth has been made, the Madonna and Child gaze out, the stylized folds of the robe creating rhythmic lines to form her shape; the foreshortened legs are particularly well achieved.

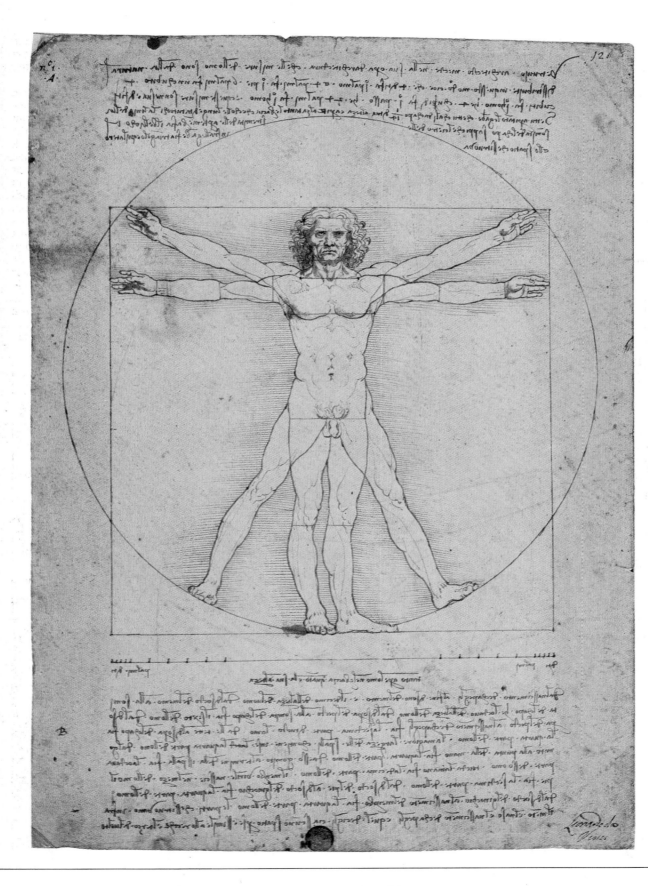

Left *Sketch of the Proportions of the Human Body from* De Architectura *by Vitruvius,* Leonardo da Vinci. The treatise of the Roman architect Vitruvius is the only handbook of its kind to survive from antiquity. In it he expounded on architecture and building, from the construction of theatres, temples and villas to town planning and hydraulics. The origin of these ideas came from Greek theories, but were not fully explained or understood by Vitruvius and left much scope for speculation and interpretation. The Greek idea that "man is the measure of all things" provided a useful doctrine of proportion on which later architects, particularly in the Renaissance, were able to base their own work. Leonardo's drawing shows his age's concern to determine systems of proportion, and the attempt by the architect Alberti (1404-72) to assert a link between primary geometric forms and those of the human body derived ultimately from Plato's statement in the *Timaeus* that the universe was built up from geometric solids. By containing the human body within a circle, Vitruvius was also affirming its divine proportions, the circle being the symbol of divinity or perfection.

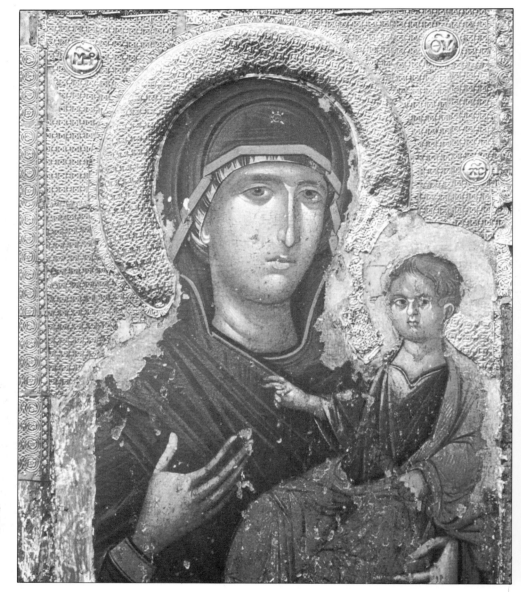

Right *Madonna and Child.* This Byzantine Madonna is of the *Hodegetria* type or "She who points the Way", introducing the spectator to her Son. Both faces are strongly modelled, with light and shade stylized into sharp patterns. An attempt to create plasticity has been made with the schematic comb patterning on the Madonna's shoulder.

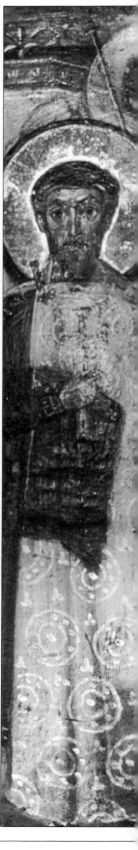

Right *Madonna and Child Enthroned with Saints Theodore and George and two Angels.* The production of icons or painted panels was important from very early on. Contemporaneous with the rise of Constantinople, other Near Eastern cities became important, notably Alexandria and Antioch in Syria. Alexandrian art had a Hellenistic elegance until the sixth century when the coarser Coptic style was adopted throughout northern Egypt. This sixth-century icon, found at St Catherine's monastery, Sinai, shows the still frontal, hieratic poses which came to Egypt from Syria.

female nude, sometimes in an openly provocative manner, for two or three centuries, after which time it disappeared as a subject until the Renaissance.

In A.D. 311, the Roman Emperor Constantine I (d. A.D. 337) proclaimed Christianity the official religion of his state; this had a profound effect on the art of the Western world. Christian dogma commanded that there should be no graven images and sculpture, an art-form that had risen to heights of excellence during the preceding centuries, was disallowed. Fortunately, painting was considered to be important in educating the newly converted masses, despite a minority who believed that images of any sort were irreligious. Their consciences were salved towards the end of the sixth

century when Pope Gregory the Great pronounced that, for those who could not read, illustrations of scenes from the Bible were an acceptable, even desirable, way of conveying information.

Paintings of illustrative figures were therefore encouraged, but the artist was never allowed to lose sight of the divine purpose of his work. Only what was thought to be absolutely essential to the religious message could be included in a picture. Shapes became stylized again, and lost their dependence on direct observation. There is evidence in paintings from this period that a limited knowledge of perspective, anatomy and foreshortening existed below the surface, but it was, simply, unimportant. With the demise of realism came a return of

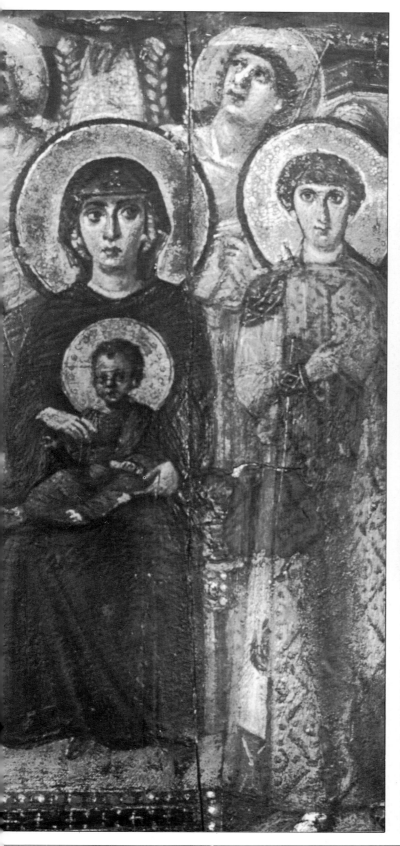

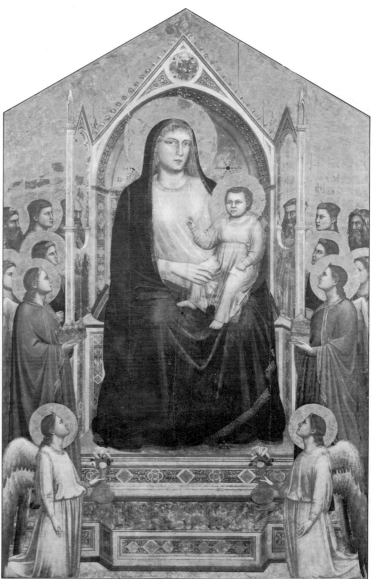

symbolism, particularly in the use of colour. Figures were set against areas of flat colour, often gold or blue, or sometimes a richly elaborated pattern of jewel-like shapes.

In Byzantium, the capital of what had been the Eastern or Greek-speaking part of the Roman Empire, pictures which represented Christ, his mother Mary or the saints, came to be considered holy in themselves. Artists were strictly required to paint within traditionally acceptable guidelines; only certain ways of depicting the figure, facial expressions and gestures were permitted. A typical Byzantine altar-painting, *Enthroned Madonna and Child*, demonstrates both the restrictions imposed by the Church and a touch of the realism from earlier times. The figure is seated on a throne placed against a

Above *Madonna Enthroned,* Giotto. Rejecting the stylized art of Byzantine and contemporary Sienese painters, Giotto attempted to render a more naturalistic world and is thus regarded as a founder of modern painting. By simplifying the drapery, he makes the figure stand out as a solid mass, and by using green pigment as an undercoat, achieves relief on the two-dimensional plane. Although posed similarly to the Byzantine Madonna, the solid, massive frame of Giotto's sculptural Madonna has a humanity and naturalism which was the major part of Giotto's contribution to art.

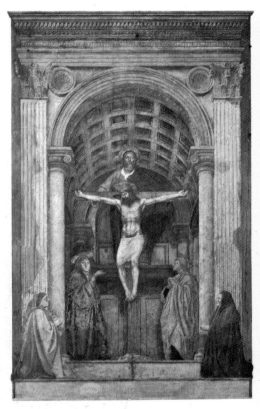

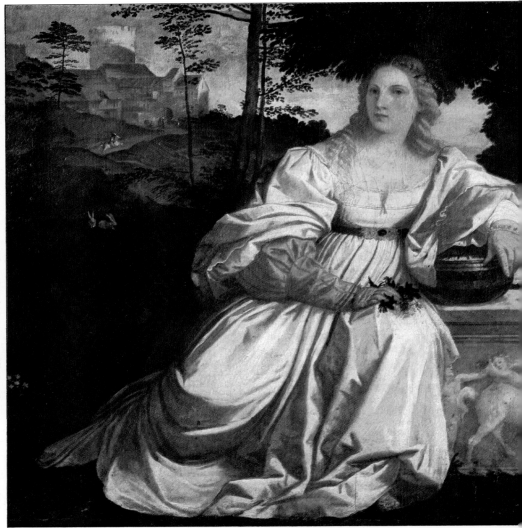

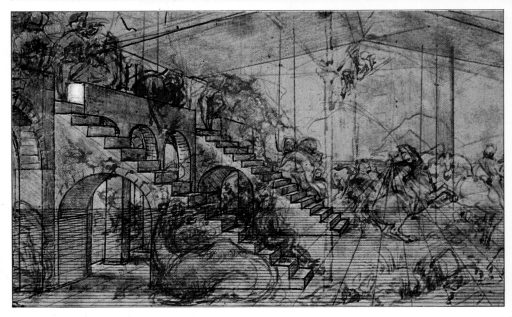

Above *The Trinity* (c.1426), Masaccio. Masaccio's style is akin to Giotto's in its realism, narrative power and the way in which he creates space, light and solidity of form. His naturalism owes much to the architect Brunelleschi, the pioneer of the central perspective system and is shown clearly in this fresco in Santa Maria Novella, in Florence. Concerned more with the underlying structure of objects than with surface decoration, Masaccio uses light to define the construction of a body and its draperies. Set within a perspectively created space, which gives the impression of actually being a chapel extension, the figures stand with the light falling on their volumetric drapery assuring the solidity of their forms. Christ's body demonstrates Masaccio's knowledge of anatomy, derived from a study of classical sculpture. A humanist and intellectual art, it results in monumental and austere forms perfectly in accord with the scientific aims of the Renaissance.
Above right *Sacred and Profane Love* (c.1516), Titian. Painted to celebrate the marriage of Niccolò Aurelio, a Venetian

humanist and collector, the subject of the painting was chosen from neo-Platonic writings. The nude figure, unashamedly displaying her beautiful, voluptuous body, represents the principle of universal and eternal love while the richly dressed figure, possibly a portrait of the bride, stands for natural love. Titian uses large planes of brilliant blue, red, rose and green to set off the sculptural forms whose warm flesh tones and generous proportions contrast with the hard outlines of the sarcophagus, making them two of the most beautiful female figures in Renaissance art.
Right *Perspective study* (c.1480), Leonardo da Vinci. In this pen and ink preparatory study simply for the background of his *Adoration of the Magi*, Leonardo has used the central point perspective propounded by Brunelleschi. Perspective plots a stage in which to place figures in correct spatial relationships but also has a dynamic quality – note the vanishing point is to the right of centre, matching the vigour of the figural movements. The rearing horsemen announce Leonardo's lifelong interest in this extremely difficult anatomical subject.

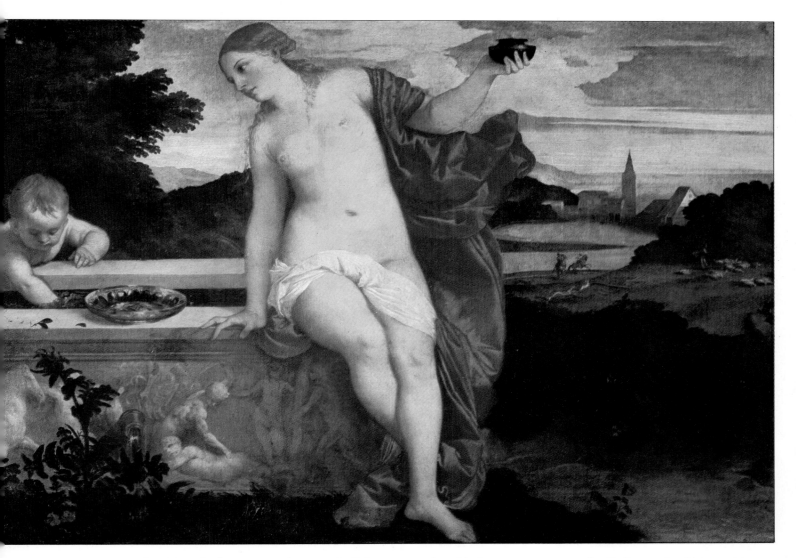

flat, gold background. Although the composition has an abstract quality and is treated as a pattern of flat shapes, the line representing the back of the throne which encircles the Madonna nevertheless implies an enclosed space and therefore depth. Again, the folds of the Madonna's robes are highly stylized in the way they fall from her shoulders, around her arms and over her knees, but they give a good impression of the shape underneath, including a foreshortening of the upper legs. The expression on the faces of both mother and child is serene, though solemn, a reminder of the religious fervour that permeates Byzantine art. The human figure was always portrayed in certain rigid poses which the artists learnt as apprentices. Anything not included in this repertoire would have been difficult to represent as no one ever drew directly from the figure – there seems to have been neither the demand nor the need.

Nearly all the surviving paintings from this time are of religious scenes, but this does not necessarily imply that no other paintings were produced. Private homes, castles and palaces probably contained non-religious paintings, but these were vulnerable to the whims of private owners whereas paintings in churches were revered and protected. It is difficult to judge whether artists obeyed the same set of rules when producing secular pieces, but it seems probable. The artist had again become an artisan, trained in a skilled craft but not expected to be innovative. Painting was often considered an adjunct to architecture at this time. Even when a painting was not made directly on the wall of a church or cathedral, its size was designed specifically for the proposed location, so imposing further constraints on an already rigidly ordered style of painting.

The work of Giotto di Bondone (c. 1267 - 1337) is generally recognized to have been a major turning point. His paintings may still appear static to modern eyes, but when compared with the work of his contemporaries it can easily be seen that Giotto was breaking the pattern. His treatment of form has a monumental quality not apparent in other paintings of the time, in spite of the backgrounds which at first remained flat, in the current style. The Ognissanti *Madonna*, painted by Giotto in about 1308, still retains much of the Gothic mood; it has a typically symmetrical composition with the Madonna seated centrally on a throne, surrounded by saints and angels. However the figures, especially those of Mary and Jesus, appear sculptured because the artist made effective use of tone. Mother and child are posed in almost exactly the same way as the Byzantine *Enthroned Madonna*, but the folds of drapery which had, until then, been set into a standardized pattern are transformed by Giotto into rich, flowing lines, The faces, though still serene, look capable of changing their expressions, and the babe's proportions are less like those of a miniature adult.

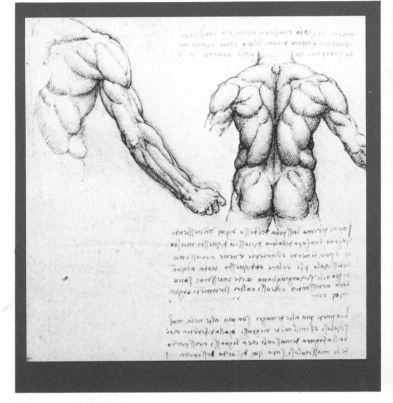

Above *Study of a Male Torso,* Leonardo da Vinci. Leonardo's notebooks were filled with studies of birds, cloud formations, water effects, skeletons, flowers and children in the womb. These minutely detailed sketches show his preoccupation with a scientific rendition of musculature, utilized in his interest in displaying the figure in movement.

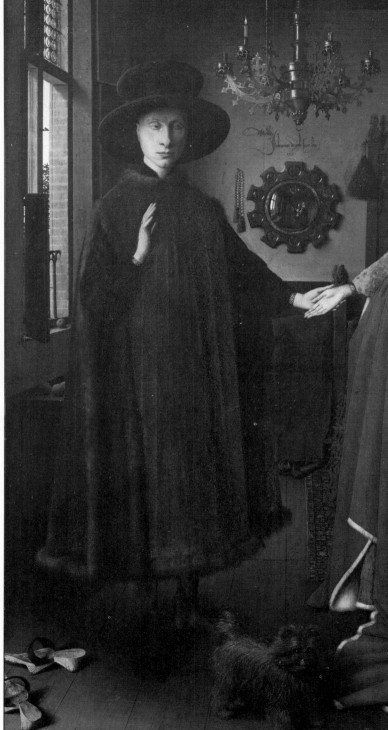

Giotto's work was obviously considered valuable and unusual during his lifetime. It is known that he was greatly admired by Dante. Some of Giotto's finest work is contained within the Arena Chapel at Padua in northern Italy. This is an architecturally undistinguished chapel which was, unusually, built specifically to house these 36 fresco paintings, illustrating the lives of Christ and the Virgin. Giotto was painting not simply events, but moods, feelings and emotions; it is this which marks him out as an innovator.

It took some time for these new ideas to have any effect. The next half-century saw a general loosening of style, with artists increasingly interested in the use of light and shade and beginning, like Giotto, to represent their figures as human beings with human emotions. Coming at the tail end of an era which had devoted much of its creative spirit to religious fervour, these awakening techniques and the idea that artistic subjects could be other than divine, were revelations to artists and philosophers alike. The emphasis in figure painting was changing from religion towards realism, from the artist as instrument to the artist as creator. Available materials and pigments were simultaneously improving, and canvas was introduced as a support, releasing artists from medieval conventions into a greater freedom.

Above *Arnolfini and his Wife,* (1434), Jan van Eyck. Van Eyck is the major artist of the Early Netherlandish school. Among his achievements was the perfection of an oil medium and varnish fluid enough for him to obtain extremely subtle light effects and minute detail. This enabled him to create an extraordinary realism through the depiction of contrasting textures, space and light. Although the pose of Arnolfini and his wife is still medieval, the shadow on the sombre faces, the attention to detail in the rich furs and materials, and the light

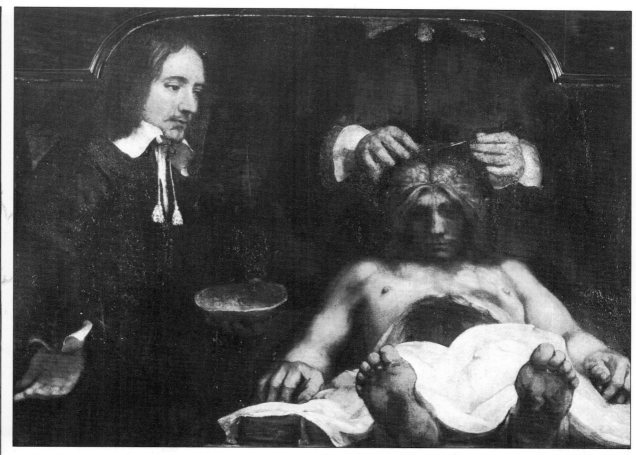

coming in from the window belong to the scientific age. Reflected in the mirror behind in remarkable perspective are the back views of his patrons and facing out, the artist himself.

In the early fifteenth century, a discovery was made by a young architect which was to prove an inspiration to contemporaries and to succeeding generations. Filippo Brunelleschi (1377-1446) revealed what is now known as "the single vanishing point". The Romans had been aware of perspective and had made use of it in a limited way, but they had never understood the principles. Having established that there must be a fixed eye level, Brunelleschi found that lines running away from the viewer into the picture, although they are parallel, appear to converge to a single vanishing point on the eye level. Geometrical harmony and mathematics, so beloved by Classical artists, were to come into their own once more, to create the illusion of depth.

Masaccio (1401-28) was one of the first to realize the extent to which perspective could be used to imply space and depth. He used architectural detailing in his painting of *The Trinity* to place the figures within an alcove in the wall. A later artist, Uccello (1397 - 1475), was so excited by perspective that he worked ceaselessly in his experiments to establish the principles and mathematical rules by which it worked. His famous *Battle of San Romano* consists of three panels in which he has constructed a grid made up of fallen lances and figures to create an illusion of depth within the picture plane. In spite of his vigorous application of the rules which he had worked out, Uccello made mistakes. A fallen figure in the foreground, although painstakingly foreshortened, is out of scale with its surroundings and the overall effect of the painting is unreal and disjointed. Piero della Francesca (1410/20 - 1492), who was slightly younger than Uccello, had a better grasp of the atmospheric quality of perspective and was able to suggest depth not just by diminishing size but by decreasing tonal contrast. Whereas Uccello's figures are like well-made models in a stage setting, Piero's are real people in real locations. Often they were modelled on local dignitaries who were flattered to have their portraits included in religious paintings.

The Renaissance was a period of upheaval because it marked a change from the common belief in a divine order to a greater understanding of the scientific rules which govern the universe. Principles about proportion and the anatomy, solid form, space and depth, initially made by the Greeks, were

Above *The Anatomy Lesson* (1656), Rembrandt van Rijn. Rembrandt first made his name with a painting of *The Anatomy Lesson of Doctor Tulp* in 1632. This painting was also commissioned for the anatomical theatre of Amsterdam and depicts its lecturer, Doctor Deyman, dissecting the brain. It is a calculated design, the central figure which is nude and frontal, and steeply foreshortened, harking back to the perspective of Renaissance art theory. Rembrandt may have been influenced by Mantegna's *Dead Christ*. The strong *chiaroscuro* emphasizes the pathos of the scene, and illuminates the gory brain area and excavated stomach; the assistant on the left holds the removed skull. The painting illustrates the seventeenth-century fascination with science and medicine and Rembrandt's own particular interest in anatomy. Operations like this were often carried out on condemned men.

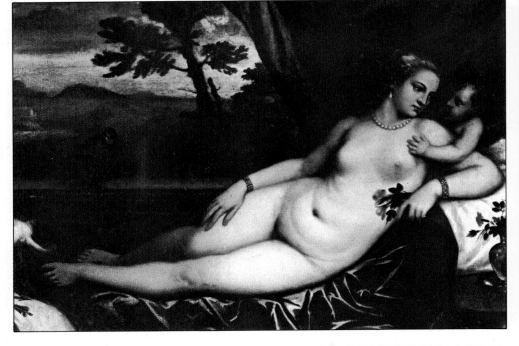

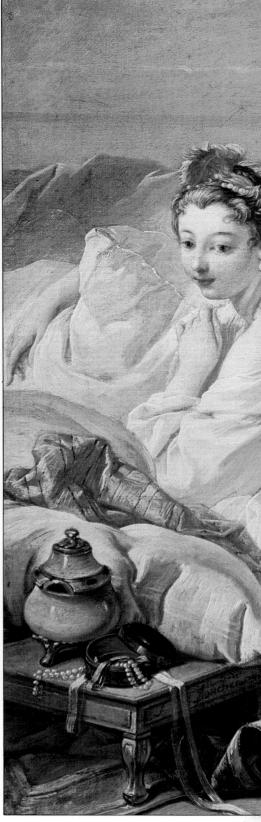

rediscovered. These new lines of thought are nowhere more evident than in the visual arts. However, they were not without opposition. Savonarola (1452 - 1498), a fanatical preacher of doom in the fifteenth century who feared the moral results of scientific progress, persuaded Sandro Botticelli (1445-1510) to burn bundles of his drawings, many of which demonstrated the new learning.

During the Renaissance, artists became less dependent upon the Church for patronage because of the rise of rich families who were able to encourage the arts and, incidentally, record their ascent to power. There was a reemergence of portrait painting which was to surpass even the achievements of the Roman period. Giovanni di Arrigo Arnolfini was an Italian merchant based in Bruges who wished to document his marriage to Jeanne de Chenany, set in a comfortable, affluent background which epitomized contemporary bourgeois luxury. The double portrait of *Arnolfini and his Wife* by Jan van Eyck (doc. 1422-d.1441) who painted it for their marriage in 1434, is an excellent example of the way in which secular painting still retained much of the influence of medieval

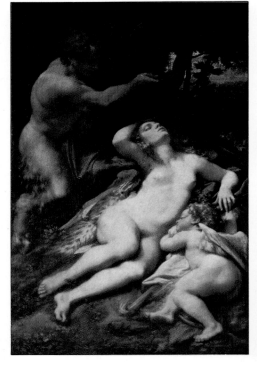

Top *Venus and Cupid* (*c*.1560), Titian. The Holy Roman Emperor, Charles V, was one of Titian's most eager patrons, commissioning paintings on religious and imperial themes, and a series of erotic subjects, known as *poesie*, mythological in title and blatantly erotic in content. This late painting

shows a full-blown, heavy figure, the loosely handled paint and sensitive merging of autumnal colours creating a sense of warmth and shimmering light into which form is dissolved.
Above *Jupiter and Antiope* (*c*.1532), Correggio. Correggio painted several pictures for

private patrons with classical subject matter having strongly erotic overtones. One of four compositions depicting Jupiter's amours, this scene shows Antiope's marvellously soft, languorous body, its soft warm tones set against the dark greens and browns as Jupiter takes her by surprise.

Right *L'Odalisca*, François Boucher. Correggio's sensual compositions look forward to Boucher's Rococo style. Boucher painted numerous mythological pictures in which the subject was transformed into wittily indelicate *scènes galantes*, full of light-hearted voluptuousness.

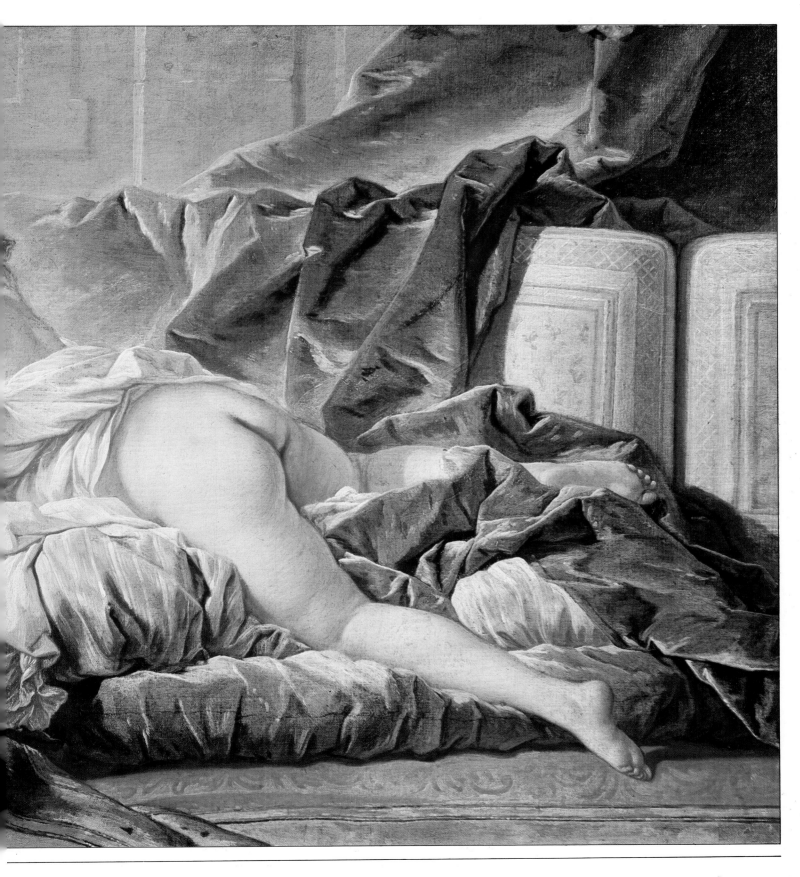

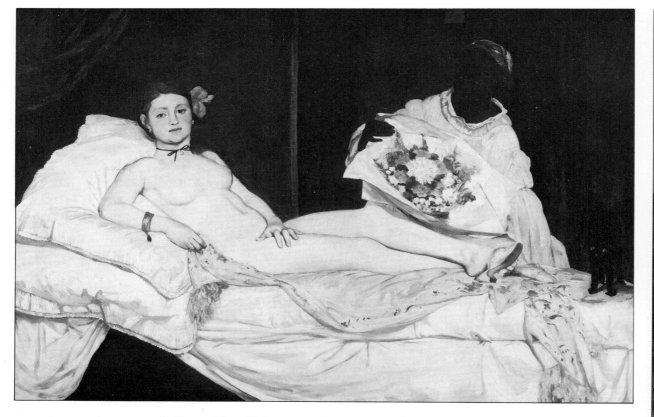

Above *Olympia* (1863), Edouard Manet. Rebelling against the academic history painting prevalent in France in his youth, Manet created a new style based on Velasquez, Goya and Ribera (1591-1652) in which he used the opposition of light and shadow with very little half-tone, a restricted palette with an emphasis on black, and painted directly from the model. His paintings caused much indignation, particularly the *Déjeuner sur l'Herbe* which closed the 1863 Salon and *Olympia,* exhibited in 1865. A Realist painter, he portrayed the world around him, sometimes with surprising touches. By placing the bed and body against a dark background, and throwing direct light with very little shadow on the forms, Olympia's cool sexuality directly addresses the spectator, her carefully placed hand drawing attention to what it pretends to hide.

symbolism, while utilizing recent discoveries and innovations. The artist was aware of the rules of perspective recently discovered and utilized in Italy, and his painting is a good demonstration of how quickly new thinking was spread through the civilized world.

Released from the strict confines of religious painting, artists were free to use a wider range of subjects and there was a resurgence of interest in mythological themes. Also, the study of anatomy, abandoned for centuries, was resumed with vigour, leading to a mastery of nude painting in this period. Once the rules of perspective had paved the way to a greater realism, it was natural that artists should become interested not just in the outward appearance of the human body but also in its underlying structure. The sketchbooks of Leonardo da Vinci show that he had made a study of anatomy, including a careful dissection of corpses which was considered almost blasphemous at the time. His exploratory drawings include the investigation of the growth of a child in the womb, and numerous annotated studies of parts of the body.

The Renaissance curiosity was not confined to the visual arts but was also concerned with philosophy and science. The body was studied for its own sake, not just for the sake of realism in art. Artists were required to record facts and results; their role

changed in this sphere, by necessity. Leonardo recorded his own discoveries; Rembrandt (1606-69), in 1632, recorded the mood of scientific curiosity in his first major group portrait, *The Anatomy Lesson of Dr Tulp.* He returned to this theme in 1656, when he painted *The Anatomical Lesson of Dr Joan Deyman*, which depicts the dissection of the human brain.

With the growing interest in and understanding of the naked body, combined with fewer moral constraints, asceticism gave way to sensuality, at first tentatively, and later with wholehearted delight. Patrons encouraged artists to produce works with only a thinly veiled erotic content. The paintings of Titian (c. 1487-1576), Correggio (c. 1489-1534), Rubens and Boucher (1703-70) are examples of a frank enjoyment of voluptuous female flesh. Oil paint came to be increasingly widely used, and the laying of transparent glazes, one on top of the other, allowed artists to paint with a transparency and luminosity that lent itself well to a sympathetic rendering of flesh, and, at the same time, to blend tones which created a great vitality.

A fascination with the texture and elasticity of skin and its light-reflecting qualities was constant through the next few centuries. The eighteenth and nineteenth centuries saw some of the most sensitive and sensual painting of the female nude, but

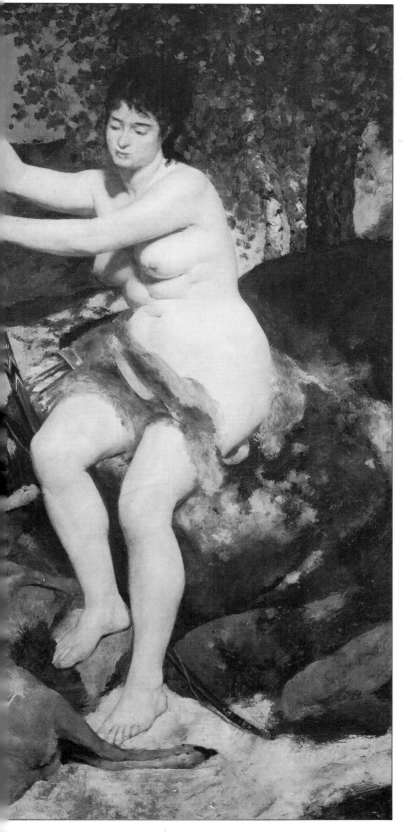

Left *Diana*, Auguste Renoir. A French Impressionist painter, Renoir's paintings have elements of the decorative techniques of the eighteenth century and Boucher's pretty colour. He introduced the "rainbow palette" into the Impressionist technique which was restricted to pure tone and eliminated black. The human figure, especially female, formed a more important part of his art than in that of his fellow painters, and there are many studies of charming women, young girls, flowers and pretty scenes. His late works are mainly nudes, fleshy and voluptuous, the warm, pink skin tones enabling him to use his favourite colour scheme of pinks and reds. "It is necessary," he said "to be able to actually *feel* the buttocks and breasts."

there was a danger of the subject becoming stifled by the classical tradition many artists sought to emulate. There was a strange double standard which accepted paintings of nude figures in a classical mould as respectable but cried out in horror at work which simply presented the body as a thing of beauty, worth revealing simply for its own sake. It is ironic that this same attitude was the basis of most of the work produced in Ancient Rome, when female nudes were presented in mythological settings. The attitude is pinpointed by Auguste Renoir (1841-1919), when he described a nude painting "which was considered pretty improper, so I put a bow in her hand and a deer at her feet. I added the skin of an animal to make her nakedness less blatant – and the picture became a Diana."

It was no doubt this sort of hypocrisy which prompted Edouard Manet (1832-83) to paint his notorious *Déjeuner sur l'Herbe*, which, despite being based on *The Judgement of Paris* by Raphael (1483-1520), caused a huge public outcry when it was exhibited because of the juxtaposition of the naked woman with the fully clothed men. The fact that the nude is relaxed in the woodland scene and the men seem like intruders in spite of their obvious pleasure, enhances the absurdity of convention. Two years later, in 1865, Manet painted *Olympia* which was received with shock and outrage. In this painting the viewer finds his gaze returned with disconcerting candour by a nude who is reclining on a bed draped with splendidly decadent silks and tassels.

Towards the end of the nineteenth century, artists began to create works in which the nude figure is painted performing everyday tasks. Edgar Degas (1834-1917) and Pierre Bonnard (1867-1947) both produced a number of pictures of women in the bathtub, combing their hair and so on, which are like intimate glimpses into the subject's private life. At the same time as the content was becoming less important in the new freedom, the way it was treated was gaining importance. The Impressionists, for instance, were preoccupied with light and colour being reflected or partially absorbed by objects and wanted to convey the effects of light in the paint. The Fauves were concerned to portray emotion using particularly strong colours.

The choice of subject matter in painting is now relatively free of convention, if not of inhibition. It is interesting, however, that representing the male nude is still frowned on, although it is legally and morally permissible. Artists can today concentrate on the methods and techniques of representing the human figure, with a firm backup of scientific knowledge, and need not be concerned about society's reaction.

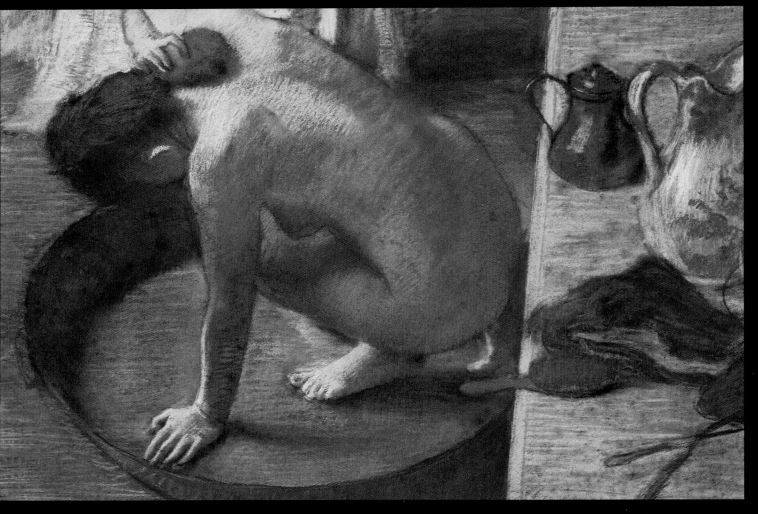

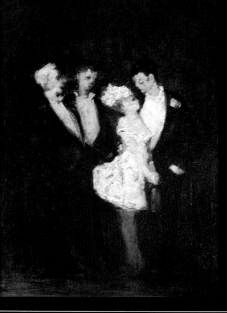

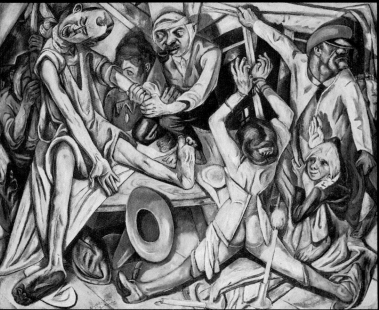

Above *The Tub,* Edgar Degas.
Degas has used pure pastel,
strong colours and a simple
composition for this drawing.
The strokes sometimes move
across the body and sometimes
with it, a technique which
imbues the work with life.
Far left *La Gommeuse et les
Cercleux,* Jean Louis Forain
(1852-1939). Form and mood is
brilliantly suggested by light
falling on the men's faces and
shirt-fronts and highlighting the
scantily dressed girl.
Left *The Night* (1918-19), Max
Beckmann (1884-1950). A
leading German Expressionist,
Beckmann painted several
allegories reflecting the human
condition. The brutal, cruel
figures are depicted in a semi-
Cubist style, evoking a
nightmarish world in a fusion of
dream and reality.
Right *The Kiss,* Gustav Klimt.
Klimt has created one body out
of two, swathing the two lovers
in a stylized cloak, and achieving
a highly decorative effect.

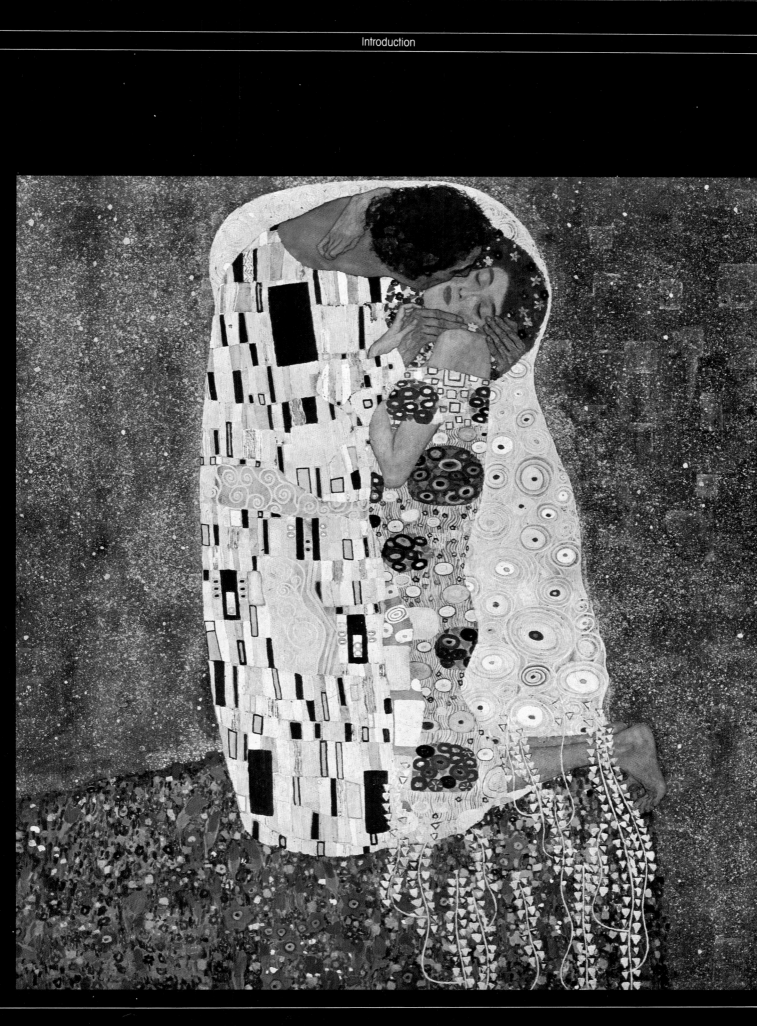

THE ANATOMY

Early Anatomical Research

Teaching in art schools has always included a strong emphasis on figure drawing and drawing from life. The body is a complex piece of machinery; making convincing visual representation of it requires an understanding which can only be gained by detailed preliminary study. Today, this is greatly facilitated by the wealth of anatomical and physiological information readily available to the art student in libraries, but this has not always been the case. There was, for a long time, a reluctance to use the dead body for anatomical dissection and much "knowledge" was simply guesswork. The instinctive horror which caused people to recoil from dismembering a corpse was usually bound up in religious beliefs and a considerable fear of the unknown. Early Christians, for example, suspected that after the soul had left the body, it continued to hover for a while in close proximity. The combination of respect and fear led to a widely held opinion that the violation of mortal remains was morally wrong. These factors inhibited a scientific study of the human anatomy until well into the Enlightenment of the eighteenth century.

Artists from Ancient Greece and Rome arrived at their understanding of the human anatomy largely through surface study, which makes the level of their attainment remarkable. The word "anatomy" was invented by the Greeks, who made great advances in understanding the structure and functions of various parts of the body, but their findings were not always accurate. In spite of the teachings of Socrates (469-399 B.C.) and his pupil Plato (c. 427-347 B.C.) on the unimportance of the body after death, actual dissection of the human corpse was severely limited out of respect for mortal remains. Early anatomists conducted much of their research on animals, with the result that they made some fundamental errors of judgement.

The first anatomical studies of any authority were carried out around 300 B.C. by Erasistratus and Herophilus of the Ptolemaic medical school in Alexandria, who were later accused, probably without justification, of human vivisection. Although it is certain that they conducted a number of dissections, possibly even some in public, and that their studies were to be an important source of information for following generations, this type of inquiry was to cease with their death and was not seriously revived for more than 1,000 years.

Because of the moral climate in which these early dissections took place, there is little satisfactory documentary evidence about them. The writings of Galen (c. A.D.

Below Mondino de Luzzi is considered by many to have been the first professor of anatomy, working in the University of Bologna during the early part of the fourteenth century. This picture depicts Luzzi directing a dissection, and was used as the frontispiece of the 1493 edition of his book *Anathomia*. Luzzi's book and his teachings were heavily influenced by the often inaccurate work of Galen, and, while professors conducted their research and teachings from high pedestals, only allowing assistants to touch the body, no real progress was made in anatomical research.

130 – c. 200) in the second century A.D. are largely based upon the dissection of monkeys and apes, although his book *Bones for Beginners* was the result of seeing a human skeleton in the medical school in Alexandria. References to the subject over the next few centuries indicate that human dissection was discouraged, if not actually forbidden on religious grounds.

It is not until the thirteenth century that there is evidence of official lessons in anatomy taking place. In Salerno, Italy, it was decreed that the study of anatomy should be an obligatory part of a surgeon's training and there are records of post-mortems and autopsies being carried out in the medical faculty of the University of Bologna. By the beginning of the fourteenth century the practice of human dissection was common

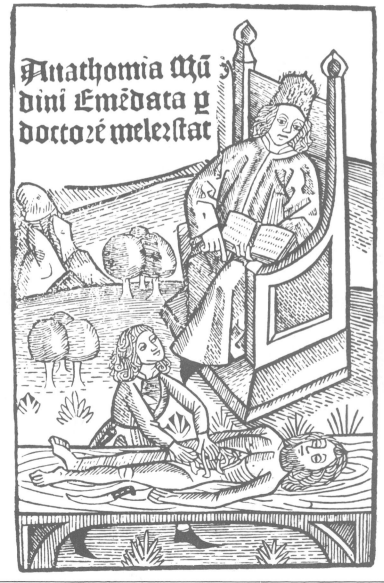

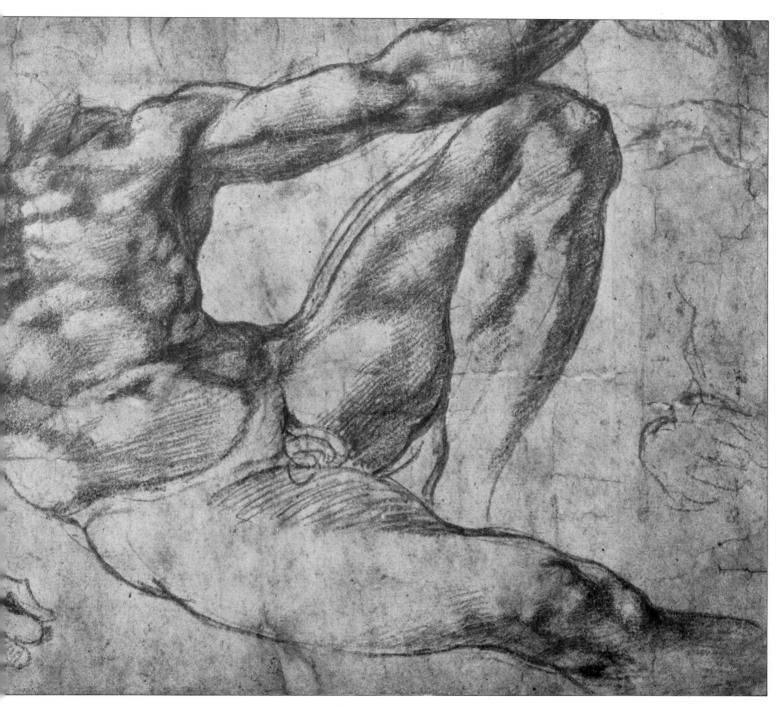

Above A study for *The Creation of Adam*, Michelangelo. This figure was to be used in a section of the Sistine Chapel fresco in Rome, which was painted between 1508 and 1512. Michelangelo considered himself to be primarily a sculptor, and this is apparent from his treatment of the figure. The accurate representation of the positions and interrelations of the bones and muscles of the male torso is drawn with force and vigour and shaded with great subtlety to give a powerful, almost monumental statement of volume. There is also great emotive force in the pose; although the figure is reclining, leaning back on his elbow, the reaching movement of the left arm provides a tension which implies that the body is communicating with another, even if the viewer is unaware of the whole picture. Adam's feelings of innocent love and acceptance are obvious in the position of the body; the facial expression hardly needs to be seen.

across Europe, including England. Although the subjects of these dissections were usually the bodies of executed criminals, the supply cannot have been too plentiful as there were many instances of grave-robbing by over-enthusiastic medical students.

As rules relaxed concerning dissections, it became customary for medical schools to give public demonstrations which were well attended. They were directed by a professor who did not touch the body but indicated where cuts should be made by pointing with a stick. The person who in fact wielded the knife would be a barber or servant with little social status who simply carried out orders.

It was natural that artists should become closely involved in the progress which was being made in the medical field. Apart from their own curiosity, which combined with their aim of truly representing the human figure, they were needed to document developments and provide illustrations for books of instruction on the subject. All such records, which would now be made with the camera, relied upon the skill and accurate observation of painters and draughtsmen. Leonardo da Vinci, who carried out dissections for his own information, and made hundreds of carefully observed drawings of each stage, wrote in one of his notebooks: "I have dissected more than ten human bodies, destroying all the various members and removing the minutest particles of flesh which surrounded the veins, without causing any effusion of blood other than the imperceptible bleeding of the capillary veins. And as one single body did not suffice for so long a time, it was necessary to proceed by stages with so many bodies as would render my knowledge complete". He described the artistic reasons for such an investigation in these direct terms: "Perhaps you may lack the skill in drawing, essential for such representation, and if you had the skill in drawing, it may not be combined with a knowledge of perspective; and if it is so combined you may not understand the method of geometrical demonstration and the methods of estimating the force and strength of muscles; or perhaps you may be wanting in patience so that you will not be diligent".

Leonardo was in no doubt about his contribution to medical science, and his studies of anatomy and of physiology have been proved to be of lasting importance to medical and art students alike. He was not

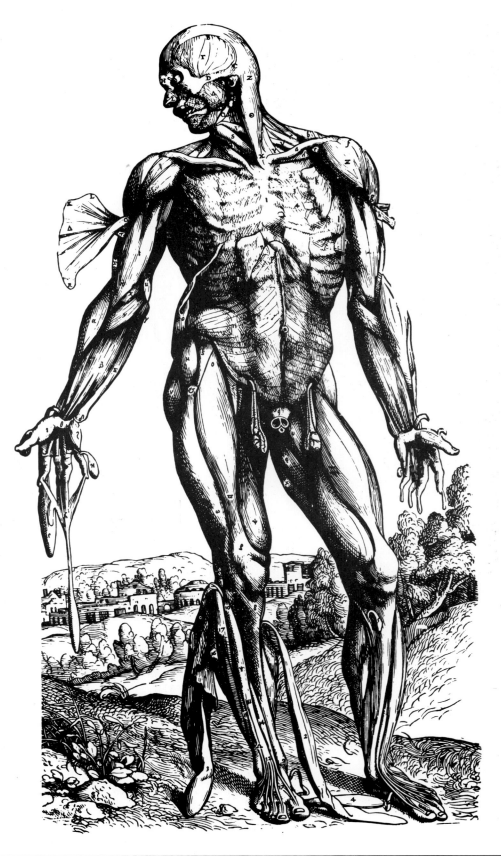

Right One of a great number of illustrations in *De Humanis Corporis Fabrica* by Vesalius (1514-1564), this displays the underlayers of muscles. Vesalius completed the intricately researched and detailed tomes in 1543, rousing the fury of contemporary academics.

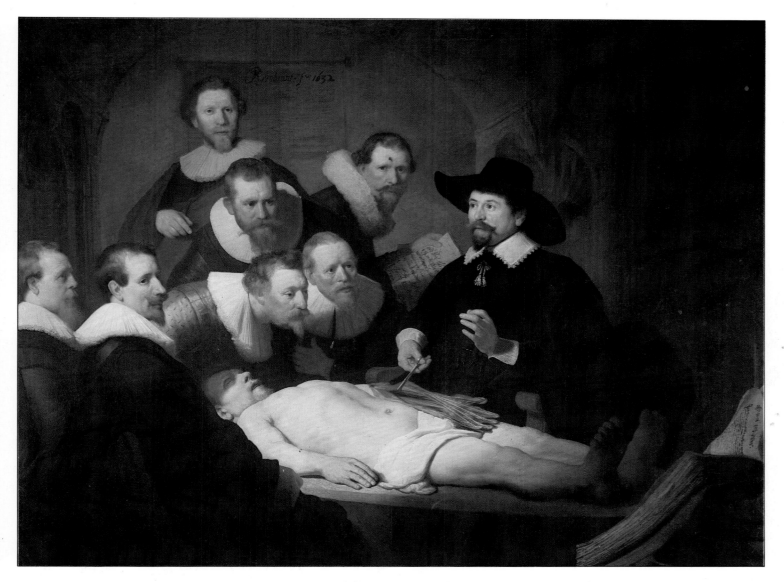

the only artist to conduct dissections;
Albrecht Dürer (1471-1528), Donatello (*c.*
1386-1466), Michelangelo (1475-1564) and
Raphael (1483-1520) are all known to have
improved their knowledge of anatomy this
way. There are also in existence a number of
paintings of anatomy lessons which show the
importance of the artist as a vehicle for social
and scientific documentation, and the
inherent interest of the subject.

The modern attitude to anatomizing is
obviously more efficient than it was then, but
even so, it is still unusual for art students to
have access to real cadavers. However,
thanks to the drawings of Leonardo and the
many who followed in his footsteps, and
more recently to excellent photographic
reference, there need be no mystery for
anyone who wishes to discover more about
the workings of the human body.

The Principles of Anatomy

It is important for artists to be aware of the
actual structure, or anatomy, of the body and
to know how these various parts function
together. The job of seeing and understand-
ing what is happening to the outside of the
body is greatly simplified if the artist realizes
the causes of the various movements beneath
the skin. Obviously, an artist's knowledge
need not be as detailed as that of a doctor,
who must understand the workings of the
organs and the systems of the body in
biochemical and biological terms. These
need only concern the artist as far as they
affect external appearances. However, to
have a working knowledge of how the body
fits together and to be able to recognize each
part of the whole in any position and from
any angle, greatly facilitates confident visual

Above *Anatomy Lesson of
Doctor Nicolaes Tulp* (1632),
Rembrandt. The Surgeons' Guild
in Amsterdam commissioned
Rembrandt to paint his first large
group portrait, and the result
guaranteed his position as
Amsterdam's leading portrait
painter for the next decade. In
Holland there was an
established tradition of official
group portraiture and
"anatomies" had already been
painted by de Keyser (1596/7-
1667) and others; however,
these works were stiff and
contained none of the emotional
or pictorial strength visible in
Rembrandt's pictures. By the
middle of the seventeenth
century, dissection had become
an acceptable form of inquiry
into the human condition, and
anatomists important members
of society.

representations. Being familiar with the names of the main bones and muscles is an easy way of learning to differentiate between them. Once familiar with the basic structure of the body, the artist will more easily be able to recognize individual peculiarities.

The simplest approach to the study of anatomy is to take sections of the body separately and examine them in detail. In each case there are four main categories to be considered. First is the skeleton, which is a living fibrous tissue hardened by a build-up of deposits within its mesh-like structure. It consists of 214 distinct bones – the framework of the body. The second category, the joints and ligaments, hold the bones of the body together and at the same time allow articulation. Thirdly, the muscles make up the flesh of the body and control all movement. They consist of contractile tissue. The last category is the skin, which covers the entire external surface of the body. Skin is a sensory organ which protects the body and regulates its heat. In connection with the skin are two special structures – the hair and nails – which are both formed from a modified version of the same cells which make up the epidermis. Although the skin is properly an anatomical topic, it is more usefully considered in the next chapter, along with the variety of textures and tones of clothing and drapery.

Below No two figures are alike, and it is impossible to presume that all male and all female figures conform to a precise or standard shape. However, it may be worth generalizing a little, if only to notice how the individual differs from the norm. Generally, the structure of the female figure can be seen to be based on the shape of a triangle and that of the male on an inverted triangle. Women tend to have broader hips than shoulders and men to have broader shoulders than hips.

The bones Bones are a body's basic structure and support. They efficiently protect the internal organs and simultaneously provide each body with an intricate system of levers allowing movement and action of an extraordinary variety and complexity. Muscles are attached to the bones directly or by tendons.

The muscles Muscles cause the bones to move by contracting and relaxing in groups. Muscle movement is controlled by the nervous system, as directed by the workings of the brain.

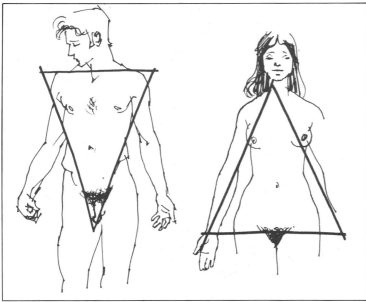

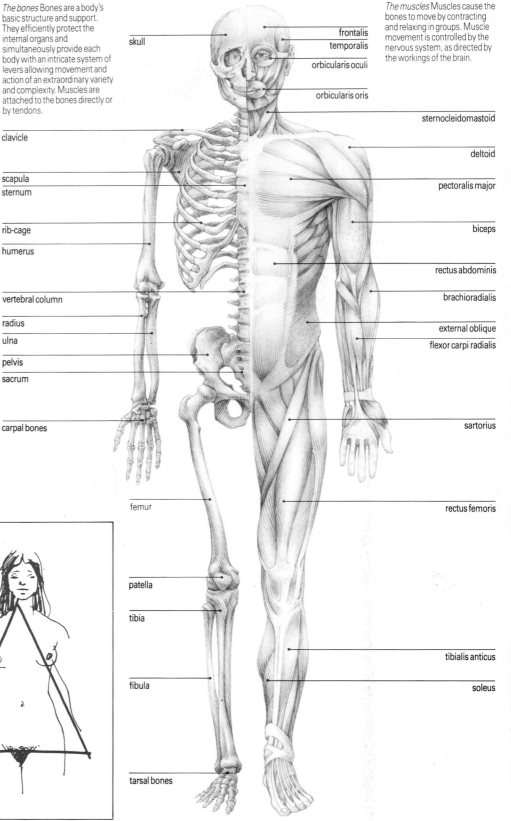

skull

clavicle

scapula
sternum

rib-cage

humerus

vertebral column

radius

ulna

pelvis

sacrum

carpal bones

femur

patella

tibia

fibula

tarsal bones

frontalis
temporalis
orbicularis oculi

orbicularis oris

sternocleidomastoid

deltoid

pectoralis major

biceps

rectus abdominis

brachioradialis

external oblique
flexor carpi radialis

sartorius

rectus femoris

tibialis anticus

soleus

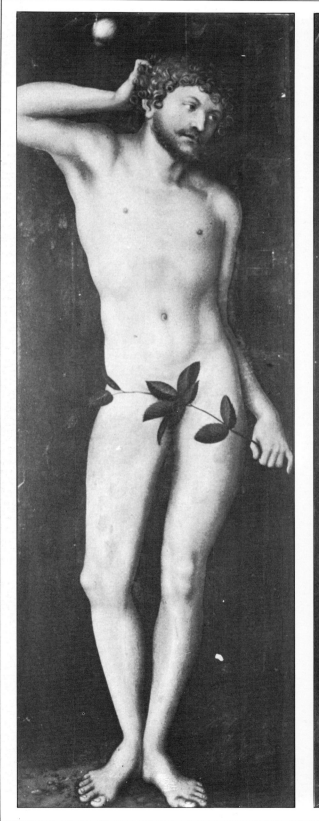

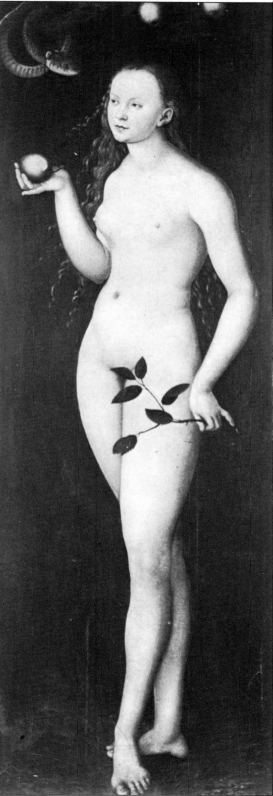

Male and female form
Despite the medieval delicacy and feigned modesty in these portraits of lost innocence, *Adam* and *Eve* by Lucas Cranach (1472-1553) illustrate some of the main distinguishing features between the male and female forms. The generalized triangle shape of the female and the inverted triangle of the male are evident, although their poses twist the simplicity of this principle. The main difference between the male and female skeletons is in the size and shape of the pelvis: women's are wider and shallower. There tends to be more fat in this area in the female, but here this is only slightly noticeable because of Eve's slenderness and youth, qualities which are emphasized in her small, high breasts. Their heads are of a slightly different size in relation to their bodies, and Adam's face is more angular. The artist was required to follow certain conventions regarding the representation of the female form; it was essential to give her a fair skin, for example. Adam's is obviously coarser and slightly darker. Medieval ideals of female beauty included a high forehead, reddened lips, blond or light-coloured hair and protuberant belly, all of which Cranach used in *Eve* to emphasize her potential fertility. Although the two portraits were painted within a religious theme, which the artist may only have used as an excuse to portray nudity, the two figures must have exemplified the type of beauty popular at that time. Their tactile qualities, however, including the way their skin is painted and their facial expressions, give them a lasting liveliness and attraction.

Right A ballpoint pen sketch of a skull illustrates the basic forms and cavities. The eye-sockets, or orbits, are deep in strong shadows, with the margins still intact. The nasal aperture is topped by two cracked or crumbling nasal bones, which constitute the bridge of the nose, and enclosed by the broken margins of the maxillas, or upper jawbones, on either side. The nasal spine, beneath the aperture, has also broken. The mandible, or lower jawbone, is uncracked, and remains neatly jointed to the upper part of the skull underneath the temporal bones and cheekbones.

The Head

The underlying bony structure of the head is known as the skull and consists of two main parts: the cranium (the upper and posterior part of the skull) which is made up of plate-like bones knitted together to form a rounded cavity for the protection of the brain; and the face (occupying the lower and anterior part of the skull) which is formed of a number of light bones with cavities for the eyes, nose, mouth and the jawbone. All the bones of the skull are jointed together in such a way that they are incapable of independent movement, with the exception of the jawbone, which can be moved up and down and also sideways.

The cranium, the larger part of the skull, is almost egg-shaped. The bones of the face which influence the surface appearance are the nasal bones, the cheekbones (malars), two upper jawbones (maxillae) and the lower jawbone (mandible). Viewed from the front, over a third of the area of the skull is taken up by the frontal bone of the cranium. Beneath the frontal, and separated by the nasal bones, are the eye-sockets, or orbits. These are deep cavities, the margins of which are rectangular with rounded edges. The lower orbital margins are made up by the cheekbones and upper jawbones. Beneath the nasal bones, the pear-shaped aperture of the nose is enclosed by the upper jawbones. The lower jawbone is jointed to the cheekbone at the point where it meets the temporal bone at the side of the cranium. Both upper and lower jawbones carry, ideally, a row of 16 teeth.

The most important bones to an artist are those which are immediately subcutaneous, or directly beneath the surface of the skin, with an effect on the external form. The face and head are largely made up of these subcutaneous bones and many of the differences between the male and female skeleton are easily recognizable in this area. For instance, in the male there is a marked bony protuberance above the nasal bones and upper orbital margin which is scarcely present, if at all, in the female. The mandible of the male is usually much more square and angular than that of the female, while the skull of the female tends to be smaller, smoother and rounder. It must, however, be remembered that it is impossible to apply

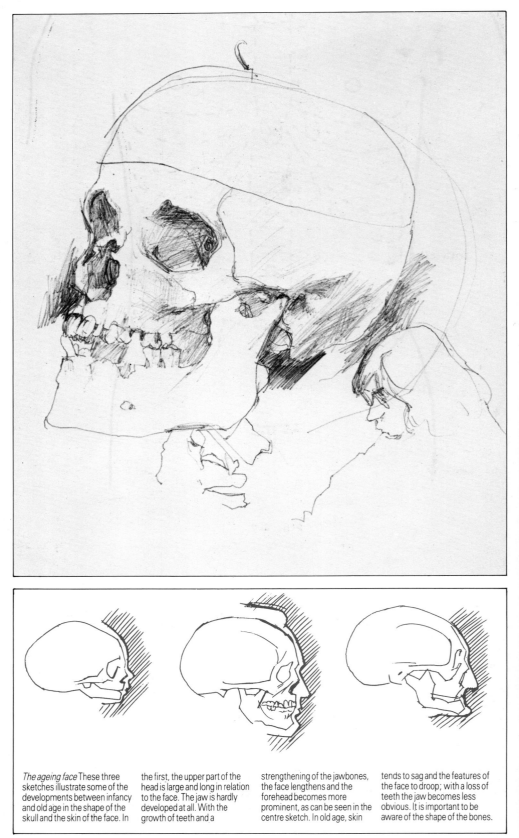

The ageing face These three sketches illustrate some of the developments between infancy and old age in the shape of the skull and the skin of the face. In the first, the upper part of the head is large and long in relation to the face. The jaw is hardly developed at all. With the growth of teeth and a strengthening of the jawbones, the face lengthens and the forehead becomes more prominent, as can be seen in the centre sketch. In old age, skin tends to sag and the features of the face to droop; with a loss of teeth the jaw becomes less obvious. It is important to be aware of the shape of the bones.

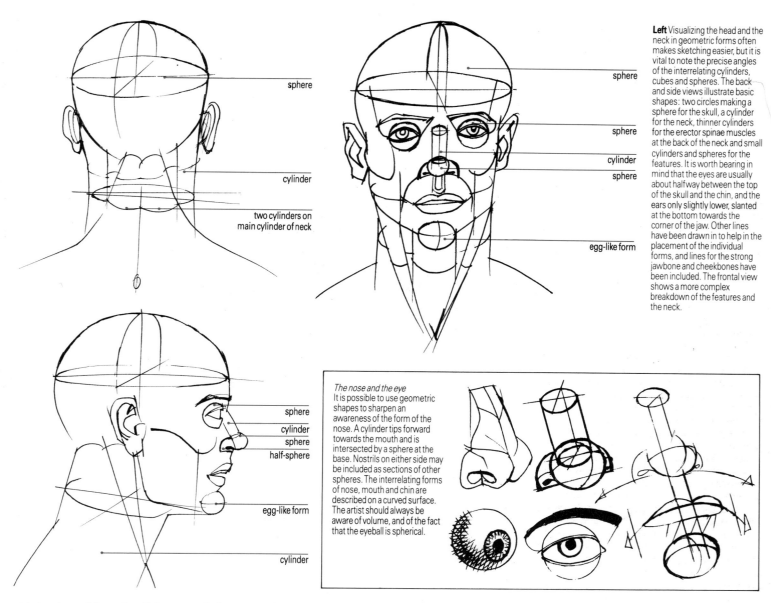

sphere

cylinder

two cylinders on
main cylinder of neck

sphere

sphere

cylinder

sphere

egg-like form

Left Visualizing the head and the neck in geometric forms often makes sketching easier, but it is vital to note the precise angles of the interrelating cylinders, cubes and spheres. The back and side views illustrate basic shapes: two circles making a sphere for the skull, a cylinder for the neck, thinner cylinders for the erector spinae muscles at the back of the neck and small cylinders and spheres for the features. It is worth bearing in mind that the eyes are usually about halfway between the top of the skull and the chin, and the ears only slightly lower, slanted at the bottom towards the corner of the jaw. Other lines have been drawn in to help in the placement of the individual forms, and lines for the strong jawbone and cheekbones have been included. The frontal view shows a more complex breakdown of the features and the neck.

sphere
cylinder
sphere
half-sphere

egg-like form

cylinder

The nose and the eye
It is possible to use geometric shapes to sharpen an awareness of the form of the nose. A cylinder tips forward towards the mouth and is intersected by a sphere at the base. Nostrils on either side may be included as sections of other spheres. The interrelating forms of nose, mouth and chin are described on a curved surface. The artist should always be aware of volume, and of the fact that the eyeball is spherical.

strict rules; although all human skeletons conform to a basic pattern, each has its individual features. There are variations due to differences of age and race as well as sex. It is by knowing what to expect as the norm that these differences can be recognized.

The muscles of the head are fairly numerous and each has a specialist job to perform. They are unlike the rest of the muscles of the body because they are inserted into the skin, thus allowing independent movement of the surface. Without being too technical, it is worth setting out the names of the main muscles and explaining the action of each one, since the face is such an expressive feature of the human figure.

There are two main muscles concerned with moving the jaw for chewing and speaking. The first of these is the masseter

(from the Latin, "to chew") which is a short, thick muscle of quadrilateral shape. It can be felt by placing the hand against the line of the jaw and clenching the teeth. The other is the large, fan-shaped temporalis muscle located at the side of the head, between the eyebrows and the hairline. When chewing, this muscle can plainly be seen, alternately contracting and relaxing.

The muscles which are used for facial expression cannot themselves be seen on the surface; only their effects are visible. Older people usually have wrinkles revealing which of these expressive muscles they habitually use. One of the largest of the facial muscles is the orbicularis oris which entirely surrounds the mouth and makes the foundation for the lips. When drawing the mouth it helps to remember that this muscle

exists just beneath the skin and extends further than the visible lips. The function of the orbicularis of the mouth is to purse the lips, which makes them appear smaller; it is used for sucking, puffing, whistling, speaking and kissing. Its action is apparent when the face is expressing pain, anger or indecision.

The buccinator (from the Latin *buccina*, meaning "trumpet") is used for expelling air from the cheeks. It is located at the side of the mouth and is overlaid by a pad of fat, often referred to as the "sucking pad". This is because it is particularly marked in the very young, when it helps to keep a clear passage of air for breathing while the infant is feeding. It has been observed that even in infants who are emaciated this fatty pad still remains.

The naso-labial furrow separates the cheek from the upper lip, forming a groove which

Right *Self-portrait,* Sir Peter Paul
Rubens. Having studied the
basic shape of the face, the
artist can begin to think about
the character and emotions
of the person portrayed. In this
portrait, Rubens displays his
own sense of humour, evident in
the bright, perceptive eyes and
the lifted mouth. The jaunty
angle of the head adds to this
impression. He used the flowing
outlines of his hair, beard and
moustache to add interest to the
simpler lines of the face, and
emphasized his own youth by
leaving the forehead and cheeks
almost completely empty of
lines and wrinkles. Like many
portraitists, Rubens drew his
own face frequently, as an
exercise.

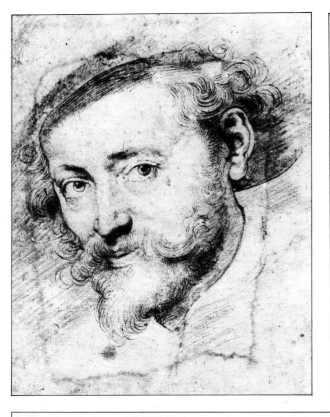

becomes more pronounced when the mus-
cles are contracted. The quadrate muscle of
the upper lip is actually made up of three
separate muscles, but they all work together
to elevate the lip and to dilate the nostrils.

The zygomaticus major, known as the
"laughter muscle", runs from the cheekbone
to the skin in the naso-labial fold. This
muscle draws the mouth up and out, swelling
the cheek and causing a small pinch to
become visible beneath the eye. If this muscle
is used alone, it produces an artificial-
looking grimace, but it is usually used in
conjunction with the quadrate muscles,
when the effect is a happy expression.

At the corners of the mouth are two
muscles, one of which is the elevator and one
the depressor of the mouth. The former is
known as the "comedy muscle" because it is
associated with laughter, although it is also
known as the "caninus muscle", being
particularly well developed in dogs, who use
it to bare their fangs. The latter is the "muscle
of tragedy"; it is used to pull down the
corners of the mouth, expressing sadness.
The elevator muscle of the chin is used to
draw it up, making it fold and dimple,
causing a hesitant or doubting expression.

The platysma is a thin sheet of superficial
muscle which extends from the side of the
face down the neck to the upper part of the
chest. These muscles become prominent and
cause the neck to stand out in a number of
longitudinal folds during times of extreme
exertion, for instance when lifting heavy
weights or running hard, and are also used to
express terror, when the mouth is pulled
open and down as well.

The nose is mostly made up of carti-
laginous tissue which dictates its shape. If
there is a marked angle where the upper
cartilages meet the nasal bone, then the nose
will be aquiline; a retroussé nose is the result
of a concavity between the upper and lower
cartilages. It is only at the bridge of the nose
that the shape of the underlying bone is
at all apparent.

At each side of the nose there are two
muscles, a compressor and a dilator, which
are used, usually in conjunction with the
elevator of the upper lip, to flare the nostrils,
as can happen in anger or fear. More
frequently noticeable for their effect are the
pyramidalis muscles, which can be felt just

Above Théodore Géricault's
studies for *The Raft of Medusa*
reflect the artist's impassioned
reaction to the aftermath of the
shipwreck; the faces are full of
horror and loss.
Left By contrast, a modern artist
has captured a carefree,
innocent expression of youth in
this sketch of a sleeping child.
No more than a simple outline
was needed to suggest her
expression.
Above right These two portraits
of women provide an interesting
contrast in their portrayal of
different ages. Hans Holbein's
preparatory sketch for a portrait
of Anne Boleyn is a clear
representation of youth: the
subject's skin is shown tightly
drawn over the bones of her
face. The modern drawing of the
old woman, however, shows the
creases of a skin that has lost its
elasticity.
Below right The vivid facial
expressions of the characters
from Rembrandt's *Foot
Operation,* which variously
show pain, compassion and
concentration, illustrate with
great feeling the tense
atmosphere of a seventeenth-
century operation.

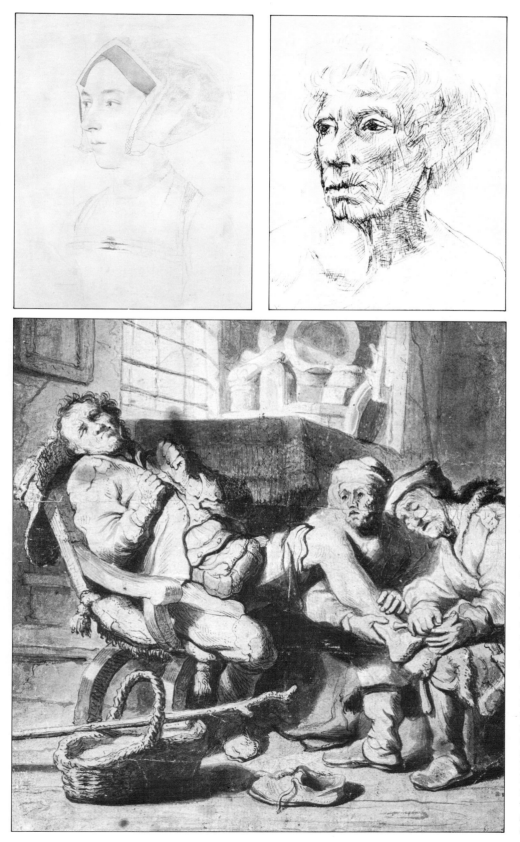

above the bridge of the nose. These pull the skin of the forehead down causing the eyebrows to overshadow the eyes in a menacing fashion. For this reason they are known as the "muscles of aggression" although, in conjunction with other muscles, they are also apparent when expressing pain or similar emotions.

The eyes can be simply described as spheres which are set into their orbits. They are protected by the upper and lower lids. The eye muscles are used to raise and lower these lids and to rotate the eye within its socket. The largest muscle of the eye is the orbicularis oculi, the sphincter or closing muscle. Because it is divided into two parts it can be used for the reflex blinking action which goes on continuously for protection, when concentrating hard, or when surprised, and also for the more positive action of closing the eye tightly. This causes the forehead to be drawn down and the cheek up and produces, in older people, the wrinkles known as "crow's feet".

Above the eye are the muscles which control the movement of the forehead and eyebrows. These work with the pyramidalis of the nose to cause the lowering of the brows which suggests obstinacy and opposition. The corrugator supercilii is a small muscle which can be felt under the line of the eyebrow and is used to pull it down and towards the nose. The larger frontalis muscle is the only one which can actually be seen on the surface of the face, and then only in thin people. There are two of these muscles, quadrilateral in shape and stretched from the upper orbital margin to the hairline, with a triangular interval between them over the bridge of the nose. These are the muscles which draw up the eyebrows to express surprise or horror, to show attentiveness or, when used independently of one another, to suggest quizzical amusement.

The effects of all these facial muscles can be studied by making faces into the mirror. This can be a worthwhile pastime; by exaggerating and noting the effects of one's own facial muscles, it becomes easier to read these expressions in others, even when they are less well defined.

Much of the character of the head is due to the hair which, even on subjects who are nearly bald, can effect the appearance to a surprising degree. This can be best recognized when a person makes a radical change of hair style and also in the difference which a head of hair can make to a previously bald baby. Whereas the shape of the skull is basically the same in most people, with minor variations, the way that hair grows varies enormously from one individual to another, and according to hair type. Light or dark, straight or curly, fine or coarse, long or

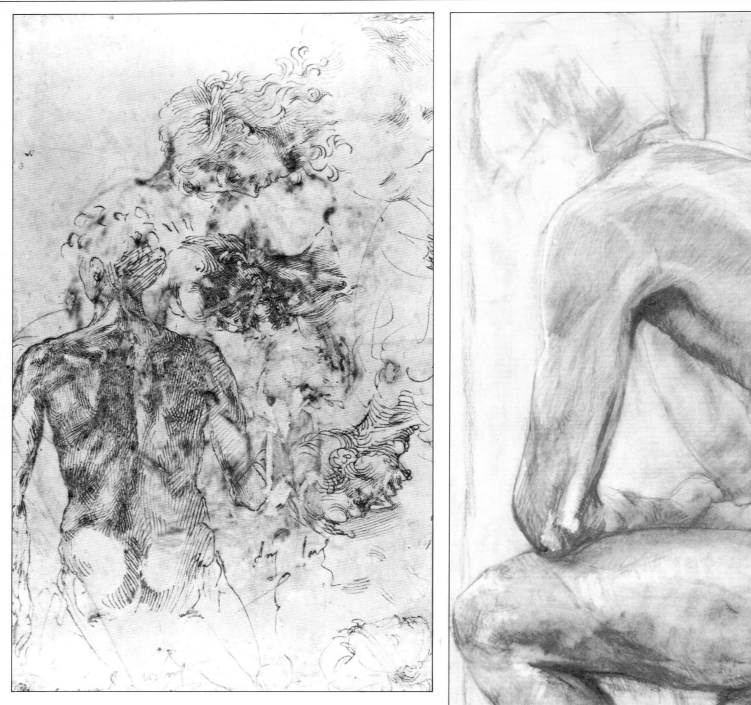

Above Michelangelo used the technique of hatching and crosshatching to create the effect of form in these sketches. His portrayal of a back view of a man's torso displays his deep understanding of anatomy. The trapezius muscles down the back of the neck to the shoulder and centre back, the deltoid muscles of the upper shoulder, the slanting latissimus dorsi and the external oblique muscles are all visible above the waist; the large, long gluteus maximus muscles are depicted in relief.

Right This modern pencil drawing of the male torso displays the same muscles from a different aspect and with the tensions in different places. It is an interesting sketch, shaded in detail to show the positions of the interrelating muscles.

short, and any combination of these will produce different directions of growth. When drawing, the hair is best treated, at least initially, as a solid mass, noting the position of the crown from which the hair usually radiates. Some people have a central, or even a double crown, while in others the crown lies to one side. This affects the way the hair grows, and if a parting is present it is usually taken from the crown.

Again, facial hair can either lend character to the face or it can disguise the features. As with hair on the head, it is best to treat an eyebrow, beard or moustache as a solid mass and to look for the overall shape and direction of growth.

The Torso

The central core of the body is the spine, which consists of 33 or 34 small bones known as the vertebrae. It is upon the first of these, the atlas (a name derived from Greek mythology), that the head rests. This is a shallow, ring-like bone with a dished hollow at either side to support the occipital condyle of the skull and allow it to rock backwards and forwards in a nodding motion. Into the hollow centre of the atlas is inserted the dens, a toothlike protuberance from the second vertebra, the axis. This allows the head to swivel easily through an angle of 180 degrees or more.

Of the vertebrae, the top 24 are known as "true" because they remain as distinctly separate bones. The lower, or "false", vertebrae are in fact fused together to form two bony masses: the sacrum or haunch bone and what remains of the ancestral tail, the coccyx. The 24 true vertebrae are divided into seven cervical or neck vertebrae, 12 dorsal or back vertebrae, and five lumbar vertebrae. Each bone consists of a body placed towards the front and an arch towards the rear, which acts as a protective housing for the spinal column. The vertebrae are held together by ligaments and thick cartilaginous pads which act as shock absorbers while allowing flexibility of movement.

Viewed from the side the spine can be seen to curve in a long S-shape. In the dorsal region there is an outward curve, which gives the back its slightly rounded shape, giving way to a hollowing in the lumbar region which is more pronounced in the female.

Attached to each of the 12 dorsal vertebrae is a pair of ribs. These are light hoops of bone which form a protective cage around the heart and lungs. They are jointed to the vertebrae at the back and the first seven pairs are bound by cartilage to the breastbone, or sternum, at the front. These are the "true" ribs; the next three pairs of ribs are known as "false" ribs because they are not attached directly to the sternum but to the cartilage of

the seventh rib. The remaining two pairs of ribs are not attached to the sternum at all and are known as "floating ribs".

Moving down the vertebral column, through the dorsal to the lumbar region, the character of the individual bones alters. The lumbar vertebrae become progressively broader and thicker and to these are attached the wide, flat muscles which, stretching up to the chest and down to the pelvis, surround the abdominal cavity. These lumbar vertebrae are supported by the wedge-shaped fusion of the sacrum, at which point the hip bones are joined to the spine. On each side of the sacrum is a wide semicircular bone known as the ilium which sweeps around towards the front to join the ischium.

Binding the ilia and the ischia together and meeting at the front are two L-shaped bones called the pubes. The basin-like shape produced by this collection of bones is known as the pelvis and it is here that the difference between the male and female skeleton is most noticeable. In the female, the pelvis is wider and shallower, causing the characteristic breadth of hip marked particularly by a more pronounced iliac crest and pubic ridge. Also, in the female, the sacrum is placed in a more horizontal position to allow greater space within the pelvic basin. Visible in both sexes but with better definition in the female, are two small dimples on the lower back which mark the position of the posterior superior spine. With the division of

The spine
The spine consists of 24 separate bones which together constitute a curving, flexible column. The bones are often divided into three categories: the top seven are known as cervical vertebrae, the next 12 as the dorsal, or sometimes thoracic, vertebrae and the remaining five as the lumbar vertebrae. Beneath these are the fused bones which divide into two masses known as the sacrum and the coccyx, or tail bone. Between each of the 24 true vertebrae is a disc of cartilage; these discs allow for a small amount of movement in each direction and act as natural shock absorbers.

the buttocks, these dimples form an inverted triangle which, as it remains visible even where the subject has an ample covering of fat, can be a useful point of reference when drawing.

To hold the body erect and allow it to move powerfully and sweepingly as well as in a more contained and subtle way, the trunk is clad with a complicated series of large and small muscles. Down the back, filling the hollows between vertebrae and ribs, are no less than five layers of muscles sheathed in fascia. Fascia is like a bandage; it is made up of connective tissue and forms protective sheets about the individual muscles, helping to retain their shape without interfering with the different movements of each.

On the upper part of the back the two major muscles to look for are the trapezius and the latissimus dorsi. The former are so named because, together, the two triangular muscles make the shape of a trapezium stretching from the base of the skull and inserted into the spine of the scapula. These are the muscles used to hold the head up and back and also for shrugging the shoulders. The latissimus dorsi, which is also triangular in shape, is a wide flat muscle. It rises along the base of this triangle from the iliac crest and sacrum at one end to the seventh dorsal spine at the other, where it is hidden beneath the trapezius. The apex of the triangle is drawn in and twisted around before being anchored to the underside of the upper arm bone, the humerus. This muscle, besides being visible across the back, can also be seen from the front as a knot of muscle under the arm, just as the trapezius can also be seen where it comes over the shoulder and is attached to the clavicle. The function of the latissimus dorsi is to draw the arm backwards and inwards.

Another important set of muscles to notice on the back are the deep erector spinae. These extend from the sacrum to the occipital bone forming two bands of muscle which run along either side of the vertebral column. Their purpose is to straighten the spine and hold it back and also to bend the trunk sideways. They are visible in the lumbar region as two rounded ridges which cause the deep spinal furrow in this area. As they pass up the trunk they are less apparent and become hidden by the other muscles of the back until they emerge again as two ridges on either side of the neck. In thin subjects this causes the back of the neck to have a squarish and slightly concave shape, while at the base of the skull, especially when the head is thrown back, there is a marked hollow.

Curving from the eight lower ribs and the iliac crest is the fleshy external oblique muscle visible from behind as a distinct bulge

at the waist. This muscle stretches around to the front of the torso where it flattens out into a tendon known as the aponeurosis and is also attached to the spine of the pubis by Poupart's ligament. The external oblique compresses the abdominal cavity, so helping with the action of breathing out and also pulls the rib-cage over and down, or the pelvis up.

The external oblique is one of a number of muscles which form the side of the abdominal wall. Without the protective structure of the rib-cage, the abdomen is dependent for its cavity shape upon layers of muscle which stretch from the chest above and the spine at the rear around to the pelvis below. Extending the entire length of the front of the abdomen are the flat rectus abdominis muscles. These are separated by a central furrow known as the linea alba, or "white line", which runs from the cartilage at the base of the sternum to the symphysis pubis. The two bands of the rectus abdominus are divided by three tendonous intersec-

tions which allow the trunk to bend forward and are visible, when the muscle is in action, as transverse furrows.

The large, powerful muscle which lies across the front and upper part of the chest is the pectoralis major. This is a thick, triangular muscle which arises, along its base, from the inner half of the clavicle, the sternum and the aponeurosis of the external oblique muscle. The muscular bands are drawn together and attached to the humerus allowing the arm to be drawn forwards and backwards. The two pectoralis major muscles are distinctly separated by the bony line of the sternum and at their lower edge they are particularly apparent because, even in males, there is an accumulation of fatty tissue in this area.

Beneath this ridge formed by the lower edge of the pectoralis major is the serratus magnus, or "fencer's muscle", so called because it is used for thrusting and lungeing movements of the arm. It arises from eight upper ribs and converges as it passes around

Left These sketches of some art students, a skeleton and a live figure together combine to give a modern artist's impression of a life class. Students are encouraged to assimilate information about the underlying structure of the human body, and to work as much from life as possible. This promotes an understanding of what makes a body look alive, how a body can be captured in a variety of positions from any angle and how movement can be simulated. The importance of working with a variety of media and experimenting with different approaches is emphasized. This has not always been the case. Until comparatively recently, teaching in art schools was strictly regimented. The first stage involved copying drawings and engravings by famous masters, and when the student reached a certain standard, he was required to draw from plaster casts of figures in classical poses. After this, he began to study the human figure, and take courses in anatomy and perspective. The emphasis was laid on truthfulness and authenticity, on representing the figure with scientific precision. Once drawing had been mastered, the student was permitted to move on to painting, although colour and tone were only expected to support the form.

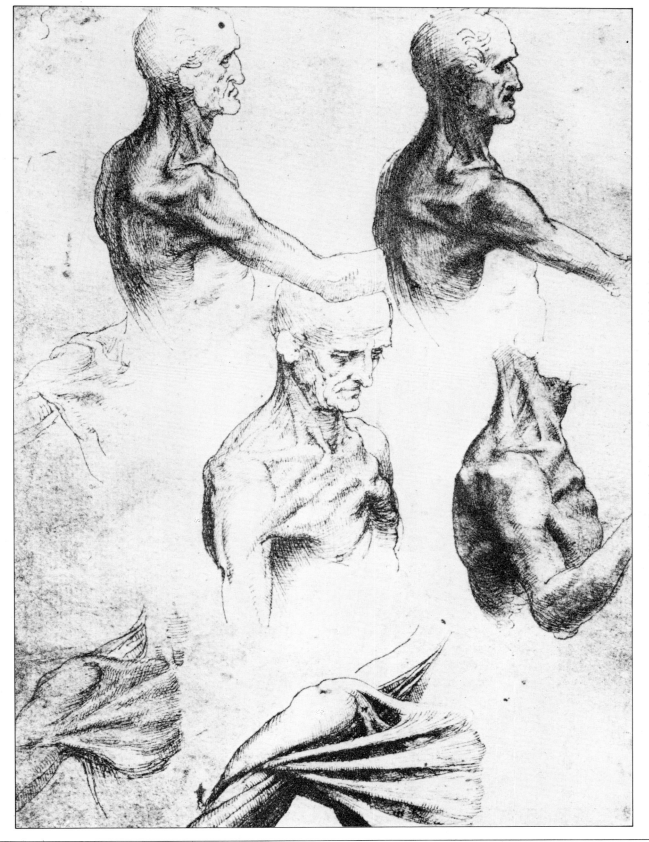

Left Leonardo da Vinci made extensive researches into the human anatomy, and filled a great number of notebooks with observations and drawings. In his studies of the human figure and other natural phenomena — particularly the movement of water and light and shade — science and art meet, although many people consider his scientific interests to have developed from his practice as an artist. It was important for him to understand not only perspective and geometric theory in order to represent the figure realistically, but also to "estimate the force and strength of muscles". He carried out the dissection of human bodies in order "to render my knowledge complete". The results of some of his studies can be seen here; they are remarkably accurate, well in advance of all contemporary work of the same kind. In these drawings of the upper part of the male torso we can see the neck muscles, the trapezius and the sternocleidomastoid, which join onto the clavicle and the sternum at the front. At the back the trapzius muscles are attached to the upper spine, being the muscles between the shoulder blades. Between the underarm, and placed diagonally across the body to attach to the dorsal part of the spine, is the latissimus dorsi; above it, on the top of the shoulder, is the deltoid muscle. At the front of the torso, particularly evident with an outstretched arm, are the pectoralis major muscles, which merge with the deltoid muscles.

Leonardo's sketches of the bones of the arm
Unlike many of his contemporaries, Leonardo believed nothing that he was told until he himself had made experiments or researched the subject. Supporting his drawings by lines of his curious "mirror" writing, Leonardo sketched the bones of the human arm and hand, with which he showed a great fascination in his paintings. He considered that the pose of the subject in his paintings should always reflect the thoughts of the person, so he often used hands to aid the expression of emotion. Quite apart from his skill in observation, is his ability to represent what was in front of him with incredible precision. These sketches of the bones of the arm illustrate his awareness of the joints as well as the bones themselves. From different angles, he describes the shoulder blade, called the scapula, the upper bone of the arm, called the humerus, and the lower bones, the radius and the ulna, which attach to the carpal bones of the palm of the hand. The carpal bones extend into the metacarpals and phalanges of the fingers.

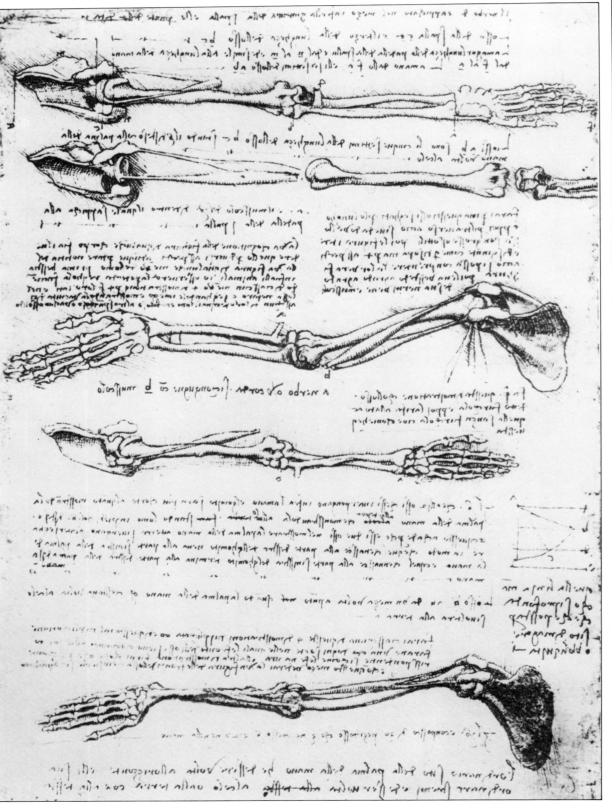

the rib-cage to be attached to the vertebral border underneath the scapula, and shows on the surface when the arm is raised.

One further muscle of importance to the appearance of the front of the torso is the sternocleidomastoid muscle. This pair of muscles, when acting together, draws the head forward or, when acting independently, pulls it to one side or the other. The sternocleidomastoid is a sinuous band of muscle which arises from the sternum and the clavicle and passes obliquely around the neck to attach at the back of the ear. It is plainly visible, when in action, as a rounded ridge. The jugular vein, which crosses this muscle, can often be seen standing out, especially when the heartbeat is fast at times of great effort or excitement.

The Shoulders and Arms

The scapulae, which have already been mentioned in connection with the trapezius muscles, are flat triangular bones which are found lying over the posterior surface of the chest. The spine of the scapula can be felt running from the vertebrae to the shoulder; when the arm is raised, it is seen as a depression between bulging muscles. At the shoulder the scapula becomes sharply

angular and is jointed to the clavicle or "collarbone", a slim, rounded bone which connects with the sternum at the front, and, being subcutaneous, is clearly visible in nearly everyone. The scapula has a shallow dish-like cavity into which fits the large head of the humerus, the bone of the upper arm. Because the head of the humerus is larger than this cavity, it is able to rotate with great freedom in almost all directions.

The shape of the shaft of the humerus greatly affects the appearance of the upper arm, being long, narrow and cylindrical. At its lower end it flattens into an irregular plate of bone, ending with a notch and a projection. Onto these are jointed the two bones of the lower arm, the radius and the ulna, the former articulating with the projection of the humerus and the latter fitting into the notch. It is the large, beak-like head of the ulna which, being jointed to the humerus, allows the arm to swing backwards and forwards. The ulna, which has a shallow S-shape, becomes smaller at its lower end, so that the bulk of the wrist is made up by the larger end of the radius. The head of the radius, on the other hand, is much smaller than that of the ulna and is shaped like a thick, flat button. It is able to roll freely over

the ulna, giving the forearm its ability to rotate. So the shape of the elbow is made by the meeting of the ulna with the humerus. The other end of the radius receives the eight carpal bones of the wrist. These close-fitting cubes of bone are arranged in two rows and have an interior concavity which allows the passage of the tendons for the articulation of the fingers.

The bones of the palm of the hand are the five metacarpals and these are attached to the phalanges, or finger bones. Each of the fingers contains three bones, and the thumb two. These are rounded except at the ends of the fingers where the bones are flattened.

The deltoid muscle, so called because it roughly resembles the Greek letter delta (δ), is used to raise the arm up and away from the side or to pull it back and forth. The rounded shape of the deltoid is apparent in the moulding of the shoulder. The two most important muscles of the upper arm are the biceps and the triceps. As their names suggest, these are two- and three-headed muscles which cover the front and back of the humerus, respectively. The large biceps muscle is responsible for pulling the arm up, the triceps for extending it in a forceful manner, for example when hammering.

Above Despite being a small part of the body, and placed at the end of a limb that has a position of its own, hands are of course vital to a complete representation of the human body. Their placement and angle will cement the impression of a movement or gesture already suggested by the position of the arm, but they can also be used to suggest something extra. For example, an outstretched arm with an extended hand may be conveying an offer of help or sympathy, but an outstretched arm with a cupped hand may be asking or expecting to receive help. Hands are capable of a great variety of movements; studying them and being aware of their potential can be valuable. It is worth noting that the fingers radiate from the wrist, but often easier, when making initial sketches, to treat the whole hand as one unified shape.

Above The arm is capable of a 180° turn; these diagrams illustrate different views as the arm twists. In the first, with arrows delineating the directions of tension, the full palm is displayed with the extended hand turned out of the natural hanging position towards the viewer. In the second, the inside of the arm is turned in, to show the strong lines of the extensor muscles and the back of the hand. The fourth takes that turn further round; the third shows the arm in a near-natural hanging position.

In the forearm, the muscles are fleshy near the elbow, becoming tendonous towards the wrist. This accounts for the greater size of the upper forearm whilst the wrist is slim and graceful. On the inner face of the arm are a group of muscles which are the flexors of the wrist and hand; on the outer face, and having higher origins from the outer edge of the humerus, is the brachioradialis extensor muscle. Also arising from the outer side of the humerus is the supinator longus, which continues to the front of the forearm. This muscle, which is closely allied with the long radial extensor, can be seen as a prominent bulge when the elbow is bent against opposition. Besides these two, there are a number of smaller muscles which are responsible for the movement of the fingers. The two main muscles to look for in the hand are the thumb eminence and the little finger eminence which are like cushions at either side of the hollow of the palm.

The Legs

The skeleton of the leg is similar to that of the arm in that it also consists of a single upper and two lower bones. On the outer edge of the pelvis is a deep bony cup, into which is fitted the thigh bone, or femur. The head of the femur is joined at an obtuse angle to the main shaft by a cylindrical neck. At the outer edge of this junction can be found the bony eminence of the great trochanter and at the inner and lower edge is the lesser trochanter. At the lower end of the femur are the inner and outer condyles which articulate with the head of the tibia, or shin bone. In front of the knee, is the small, disc-like bone of the patella which protects the joint and gives the thigh muscles greater leverage.

The tibia, with the fibula, makes a two-pronged fork which grasps the foot firmly while allowing freedom of movement. The tibia is the strong bone which transmits the weight of the body to the foot, while the fibula is long and very slender.

The foot, like the hand, is made up of three groups of bones, the tarsals, the metatarsals and the phalanges, but whereas the fingers are long and slim, the bones of the toes are short and thick. The tarsals of the foot are made up of seven bones including the talus or ankle bone and the calcaneum or heel bone.

The gluteus maximus is the largest and strongest muscle of the body which, with the gluteus medius and the gluteus minimus, make up the great mass of the buttocks. These muscles are associated with man's upright position and are the muscles of locomotion. They are used in walking and running and the gluteus maximus comes into play particularly when walking upstairs or downstairs and when raising the body from a

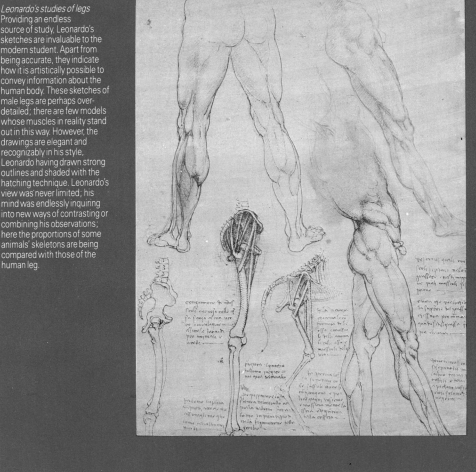

Leonardo's studies of legs
Providing an endless source of study, Leonardo's sketches are invaluable to the modern student. Apart from being accurate, they indicate how it is artistically possible to convey information about the human body. These sketches of male legs are perhaps over-detailed; there are few models whose muscles in reality stand out in this way. However, the drawings are elegant and recognizably in his style, Leonardo having drawn strong outlines and shaded with the hatching technique. Leonardo's view was never limited; his mind was endlessly inquiring into new ways of contrasting or combining his observations; here the proportions of some animals' skeletons are being compared with those of the human leg.

squatting or kneeling position.

There are several strong muscles in the thigh which are sheathed in the stocking-like fascia, which plays an important part in determining the surface form. The main muscles are, at the back, the semitendinosus and the biceps femoris which are used to bend the knee, rotate the thigh and turn the leg inward, and at the front, the vastus externus, used for rotating the leg outwards and the vastus internus for rotating inwards. Both these muscles are also used to extend the leg, while the long, strap-like sartorius muscle which runs diagonally across the front of the thigh is used to bend the leg inwards. It gets its name from the Latin *sartor*, meaning "tailor", because it is used when sitting cross-legged. The other main muscle of the front of the thigh is the rectus femoris which is used to straighten the leg after it has been bent.

Down the front of the leg and again sheathed in fascia, which thickens over the front of the ankle, are the tibialis anticus and the extensor longus digitorum. The former is used to raise the front of the foot towards the leg and can also be used to turn the sole of the foot inwards. The latter, as its name suggests, is the muscle used to extend the toes; it divides into four slips, each of which controls one of the toes. The big toe is controlled by another muscle of its own: the hallucis longus.

At the back of the leg is the prominent, double-headed gastrocnemius which bends the foot and raises the body in walking. Deeper and broader than the gastrocnemius is the soleus; these two muscles join to form the tendo Achillis which is the strongest and thickest tendon in the body. One of the functions of these muscles is to pull the heel up and point the toe. In its lower part, the Achilles tendon stands out as a prominent cord which becomes thicker and disappears as it becomes united with the soleus and gastrocnemius.

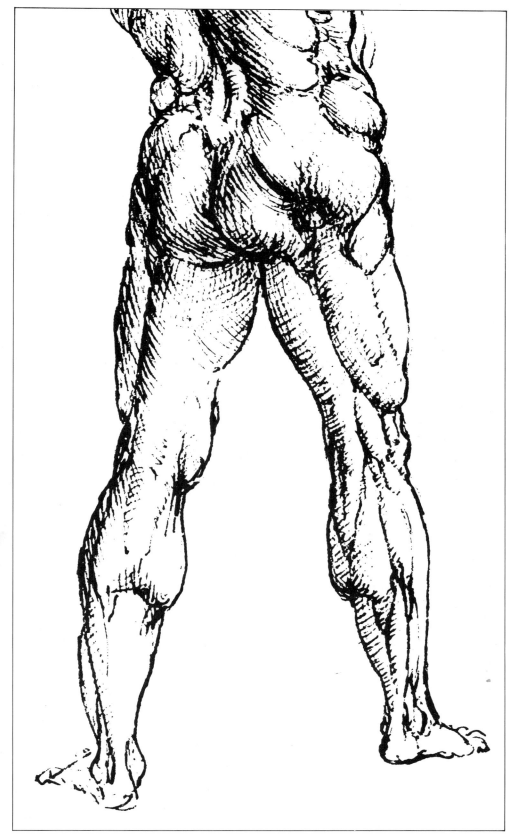

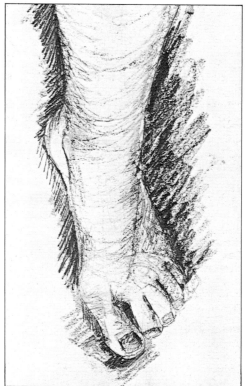

Left In this dramatic and confident pose, it is possible to make out a number of the prominent muscles of the lower limbs. Starting at the top, the waistline, which is comparatively lower in men than women being only just above the hip, is accentuated by tendons, and the bulges of muscle above it on either side are the external oblique muscles. The bulge on the hip consists of the gluteal fascia muscle and the muscles of the buttocks are called gluteus maximus. These are the largest and strongest muscles of the body. Visible on both legs between the hip and the knee down the outside of the thigh, although viewed from different angles, are the iliotibial tracts, which are extensions of the gluteus maximus. Underneath these on the inside of each thigh is a group of muscles which combine then split at the knee; one of these is the semitendinosus, and another the biceps femoris. Beneath the knee, the protruding double-headed muscle is the gastrocnemius, and the soleus is beneath that, running from the front of the shin round and down the length of the rest of the leg. Towards the heel, combining with the soleus, is the Achilles tendon. All these muscles are visible on both legs depicted here.

Above The bones of the foot are often irregular, and quite difficult to represent. The tarsals of the foot, which join with the tibia and fibula, are made up of seven bones, including the ankle bone and the heel bone. The metatarsals and the phalanges of the foot are organized in the same way as the bones of the hand, but the bones of the toes are very much shorter and thicker. The foot is a part of one's own body that is easy to draw without the use of a mirror, and it certainly provides some interesting problems of perspective.

THE CLOTHED FIGURE

Representative figure drawing depends upon the ability of the artist to see what is actually there, rather than what is thought to be there. Training the eye to discern the subject's true characteristics is of greater value than manual dexterity. When preparing to draw the figure, it is important to be aware of the qualities of the body's natural clothing, the skin, and of the drapes or clothes covering the body, at the same time as understanding the anatomy.

On healthy bodies the skin usually fits snugly, naturally keeping pace with increasing or decreasing size. Although on the very old or on people who have suffered a sudden weight loss, the skin tends to sag and hang loosely about the body, it is by nature elastic and resilient. However, at the back of the knee and the elbow and in the groin, where the joints under the skin allow movement of the individual sections of the limbs so the skin is constantly being pulled and relaxed, permanent creases can be seen on most people. These creases are useful points of reference; when making figure drawings many artists begin by mapping out their relative positions.

The quality and texture of skin varies from person to person, and this causes its appearance to differ. If skin is not protected from the elements by clothing, the style of which is often dictated by fashion or climate,

it tends to lose its naturally soft texture. When compared with the soft, new skin of a baby, for example, a sailor's weather-beaten face seems almost leathery. Areas usually exposed to sun and wind are naturally darker and often coarser than areas which are usually covered; skin will adapt and form protective layers when necessary. The dark skin of races from countries where the sun shines powerfully and more consistently has evolved to form a permanent protection against harmful rays.

Skin's texture also varies over different parts of the body. The facial skin of a lady from the last century, for example, who never allowed herself to sit in direct sunlight because beauty was partly measured by the fairness of skin, may even have been given translucent qualities by an artist who wanted to give depth to a painting. The palms of her hands could not have been treated in the same way, their skin probably being a little tougher and more textured. It is interesting that, probably as a reflection of the fashion for fair skin, conventions from the past have stipulated that a lady's skin should always be painted a paler colour than a man's.

The colour of flesh is, however, subtle and infinitely variable. Each person has an individual skin colouring, which itself varies from one part of the body to another. Over the years, many different formulas have been

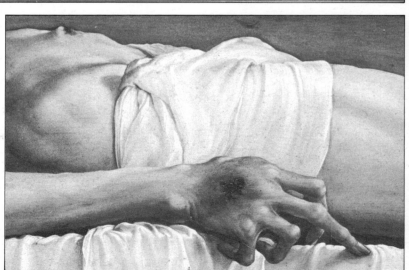

Right *Victorious Amor*, Michelangelo Merisi da Caravaggio. The outrage felt by some contemporaries at Caravaggio's worldliness and lifestyle must have been tempered by admiration for his outlandish skills as an artist. The enthusiasm he felt for life is reflected in the warm tones and extensive use of contrast and light and shade to create full-bodied figures and rich backgrounds. It is significant that Caravaggio worked directly onto the canvas from nature, using live models for his figures, rather than making the extensive preparations and revisions which were considered necessary at the time. With a well-controlled and detailed use of colour and tone, Caravaggio has achieved a lifelike and realistic representation of a young boy.

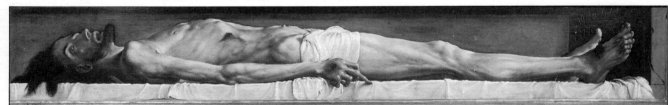

The Dead Christ or *Christ in the Tomb* (1521) by Hans Holbein. Holbein was already a prominent painter in Basel when he left for England in search of more work. He is most famous for his portraits, richly coloured character studies of such figures as Erasmus, Thomas Cromwell, Thomas More, and Henry VIII together with some of his wives. This painting dates from an earlier period than his English court portraits, however, and is a fine example of his religious painting, a theme he was later forced to abandon when religious works were banned in Basel as an effect of the Reformation. In this study, Holbein used a narrow range of colours — chiefly cool tints of green and white — to reinforce his sombre theme. Horrifyingly realistic, these subdued shades

also serve to draw attention to the only warm colour in the painting — the red of Christ's wounds. The detail shows Holbein's skilful draping of the loincloth and the precision of the anatomical detail. The colours, stark pose and masterly *chiaroscuro* combine to suggest the penetrating chill of the tomb — its confines dramatically reinforced by the unusual format. The painting is a good example of how the figure can be a vehicle for expressing universal themes.

suggested for the mixing and underpainting of skin colour to allow just the right hue to shine through subsequent glazes. Before painting, variations in colour and tone across the body must be carefully observed. Changes may occur depending on whether the bodily temperature or emotional mood of the model changes, or if he or she has recently been engaged in strenuous exercise.

An artist will often find that the surroundings also influence the colour of flesh. Because of the reflective quality of skin, the nude figure picks up colours from objects around it which in turn greatly affect the mood of the painting. By surrounding the model with a deliberately chosen range of colours, the atmosphere can be altered and controlled. Painters sometimes compare colours which they are mixing with white, a piece of white paper for instance. This makes it easier to judge tone and make adjustments until the colour is satisfactory.

An interesting example of the way in which colour can be used in emotional terms to convey a particular mood is the painting of *The Dead Christ* by Hans Holbein (1497/8 – 1543). Holbein placed the figure against a background of cool greens and whites which are reflected in the face and hand. This contrasts with the treatment of the rest of the body, which in the shadows retains some of the warmer tones associated with living flesh. The stark and uncompromising pose and careful attention to anatomical detail combine with the deliberately simple and sombre colour to convey a horrifying image of death.

Victorious Amor, painted by the Italian Caravaggio (1573-1610) almost 100 years later, demonstrates an entirely different handling of the male nude. This figure is a lusty, golden boy whose glowing flesh reflects the warmth of the surroundings. The composition is more complex in both tonal and linear terms, although, like Holbein, Caravaggio chose to use a narrow colour range to emphasize mood.

The use of drapery or clothing on the figure is, at its simplest, an extension of the skin and can be treated in a similar way. Just as with the nude there are certain bones and muscles which determine the surface form, so these continue to dominate the shape of the clothed body. Even when the figure is draped in an all-enveloping costume, the solidity of form can be retained by finding clues to the structure and concentrating on them more fully. Folds and creases often give an idea of the underlying structure. Drawing is a selective process; the trick is to know what to look for and to record those lines and masses which indicate the shape of the body while perhaps ignoring those which are merely transitory or superficial.

Manet's *Young Woman in an Oriental Costume*, painted towards the end of the nineteenth century, shows how, by adroit use of only a few simple folds, it is possible to imply the body underneath. The artist chose to paint this model in a costume which leaves only the head and forearms uncovered but is flimsy enough to allow tantalizing glimpses of the body beneath. The use of this sort of costume is a popular device because it allows the subject of the painting to retain a certain decency, whilst at the same time giving emphasis to the very parts which are concealed. A clothed or partly clothed figure may be more erotic than one which is totally nude, and especially so if the quality of the cloth itself is sensuous.

Just as the use of certain colours can evoke particular moods, so the choice of material clothing the figure can bring about differing emotional responses in the viewer. Some kinds of cloth are more clinging than others. The qualities of silk and satin are, for instance, not at all the same as those of wool or linen. The former are flimsy, lightweight materials which serve to cover the flesh while revealing the form, whereas the latter are thicker and retain much of their own character being less affected by the shape of the body underneath. The more tactile silks and satins are a popular choice when the female body is being represented as an object of desire.

The more robust types of cloth often reduce the figure to a simple outline which, depending on the purpose of the painting, can be satisfactory. Simplifying by a process of selection is common practice in all visual representation and made easier if the form is not complicated by elaborate, creasing clothes. Using large areas of flat colour can give greater impact to other parts of the picture which are worked in more detail.

Where portraits have been commissioned the artist will often have been required to paint the sitter in some kind of formal dress, and this will necessarily have become an important element within the picture. Some of the most sumptuous and elegant portrait paintings show the subject displaying various signs of wealth and status. It is not surprising, after all, that the sitter should

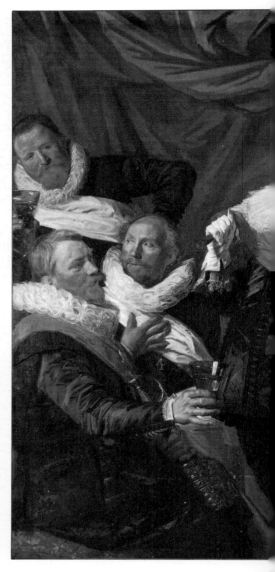

Right *Girl with Shuttlecock*, Jean-Baptiste-Siméon Chardin (1699-1779). Chardin has provided much inspiration for many artists of the twentieth century in his natural handling of ordinary realistic forms. Apart from his stature as one of the greatest still-life artists, he is also famous for his treatment of modest, middle-class subjects. This reserved study of a young woman owes its charm to his skilful use of white, the simple, formal drapery complementing the cool, settled pose.

Above right *Mealtime of the Officers of St Jorisdoelen*, Frans Hals. One of the great Dutch masters, Hals is primarily known as a portraitist. This group picture of civic guards is one of five he painted between 1620 and 1630, at the peak of his popularity. Hals is renowned for his ability to capture fleeting expressions; this group portrait suggests in its composition the ease and camaraderie of the guards. The drapery and clothing are an important part of this effect, the overall rhythm aided by the crisp angles of the starched ruffs, the texture and weight of the costly materials and the creases and directionals of the hanging cloth behind the figures.

Cloth studies
These details of cloth from Hals' *Mealtime of the Officers of St Jorisdoelen, Haarlem* illustrate the artist's mastery of paint. The rich heaviness of the furled silk banner, the almost transparent quality and delicacy of the two ruffs, their contrasting shapes emphasizing the artist's proficient handling of detail, the texture of the suede with its brilliant gold-embroidered decoration, and finally the luxurious sheen of the thick sash, are carefully evoked with tiny, almost invisible brushstrokes. The sense of realism and liveliness in the scene is enhanced by the volumes and textures of the various cloths.

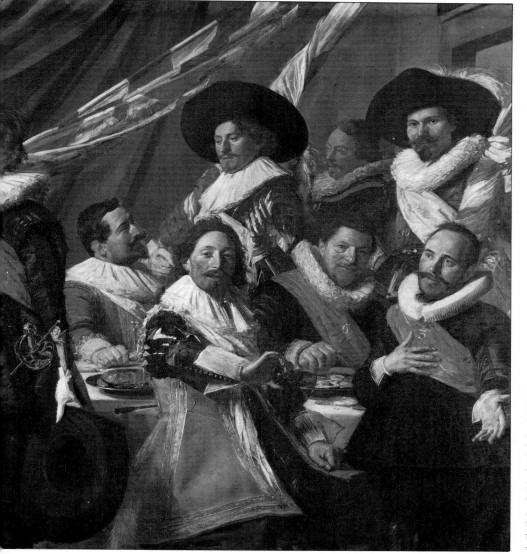

wish to be viewed by posterity looking at his or her best. In this type of work, the costume can dominate the painting, making a rich and intricate pattern of folds and pleats in a variety of textures and colours.

A typical example of highly elaborate costume is the portrait of Louis XIV by Rigaud (1649-1743), painted in 1701-2. The mood of artificiality in this painting is due partly to the obvious posing of the Sun King and partly to the overwhelmingly rich and heavy garments he is wearing. The painting is a flamboyant gesture, not only of the wealth and power of the subject of the painting, but also of the virtuosity of the artist. He shows his skill in representing fur, velvet and lace with great conviction and careful attention to minute detail. Although it was intended as a gift for his grandson, the King of Spain, Louis was so delighted with this image of himself that he decided to keep it.

Because of the constant changes in the world of fashion, paintings which portray clothes in the style of the time are important pieces of historical documentation. From this point of view, "genre" paintings, which show ordinary people doing everyday tasks, are even more valuable sources of information since they are not dependent upon the approval of the person paying. The artist has complete freedom to show reality even in its less attractive aspects. Hals (1581/5-1666), whose ability to produce elaborately detailed and highly finished paintings shows in such works as *Nurse and Child*, was probably at his best when producing genre paintings, when the freedom of his brushwork and masterly use of paint rival the Impressionists of two centuries later. In his painting *Malle Babbe*, Hals indicated the subject's clothing using broad strokes of colour which suggest the form without describing it in detail. Her white cap and ruff are painted in high contrast to the dress which, like the rest of the painting, is dark and sombre. This throws the head of the figure into sharp relief and gives emphasis to the almost maniacal expression on her face. The artist's use of white paint to pick out the highlights in energetic and jerky brushstrokes seems very much in keeping with this study of drunkenness and vulgarity.

It has been common practice for centuries to paint figures in contemporary costume in order to update old stories, so making them more relevant to the ordinary man or woman. Pre-Renaissance and Renaissance artists employed this device in their religious frescoes which helped to carry the message across to the illiterate faithful, showing characters from the Bible as ordinary people such as they might meet any day. This meant that the farmers, artisans and shopkeepers of the time could identify more easily with their

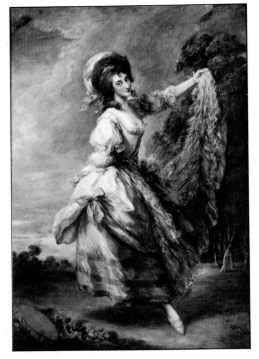

Biblical counterparts and recognize them as mortals rather than saints. It also meant that local dignitaries could increase their self-importance by modelling for the more illustrious characters represented.

Often, however, costume portrayed little contemporary or historical accuracy and was used simply as a means of giving structure and unity to a complicated composition. Mannerist painters from late sixteenth-century Italy, for instance, used swirls of drapery to give dramatic emphasis to the movement and gestures of their figures, filling the picture plane with activity. They included trailing swathes of cloth as an important element within the composition, rather than an accurate rendering of a garment which could actually be worn. These large and energetic paintings full of tumbling figures rely upon their curving masses of drapery to hold them together and, incidentally, to fill gaps which would otherwise reveal miles of landscape. The conviction with which the artists represented cloth hanging or billowing in the breeze is often countered by an air of unreality because of the bright, even brash,

colours and the overwhelming grandeur of the scenes.

To draw or paint the figure with conviction requires a sound working knowledge of its anatomy; similarly, the artist must investigate and become familiar with the anatomy of cloth to be able to make full use of the way its folds can emphasize or conceal. Artists' preliminary drawings often include careful studies of pieces of drapery. Numerous investigative sketches of this sort will encourage increasingly confident representations of a variety of textures and qualities. By noting how sharp creases give way to soft folds and by observing the differences between the character of free-hanging material and that which is draped over a solid object, the artist acquires a repertoire of visual language which can be used to inform paintings of the clothed figure.

An interesting experiment in drawing, and one that is frequently given to students in art schools, is to set up a still-life group using objects that have a clearly defined shape, such as boxes or bottles, and then to cover it with a plain piece of cloth. By softening the outlines the artist is forced to give greater consideration to tonal qualities and to treat the group of objects as a single, solid form in space. Individual details will be lost but a unity and monumentality will compensate. A very ordinary collection of objects can become mysterious and interesting when presented in this way. In the visual, as in other fields of art, the statement is often given greater potency by that which is left unstated.

Repeating this experiment but using, instead of the plain piece of cloth, a number of different, coloured pieces, preferably with very positive surface patterning, will demonstrate how the entire effect can be changed although there is no alteration in the structure of the group itself. The character of the objects underneath will be dominated by the noisy chatter on the surface. By emphasizing the decorative quality of the cloth, the volume and solidity which were so positive in the previous group become far less apparent, and sometimes unrecognizable. It is easy, at this point, to move away from objective realism into the realms of abstract painting. Paint applied as flat areas of bright colour will tend to destroy any illusion of depth. Using colour and tone skilfully, an artist can control the level of abstraction. Many painters employ a system of simplifying and flattening shapes to arrive at pictures which, although figurative at the outset, no longer have any apparent link with the reality. Some find this a fascinating area for study and have devoted a great deal of time and energy expanding on this theme.

These same experiments can be tried using

Above *Giovanna Baccelli* (1782), Thomas Gainsborough (1727-88). In this full length portrait, the clothing is an important part of the composition, helping to convey a sense of movement and vitality. The pose, visible brushstrokes and blending of the figure into its landscape setting all increase the sensation of spontaneity and gaiety. In later life Gainsborough often painted his models using an unusual method — he placed his canvas the same distance away as his model, to form an angle of 90° between sitter, painter and canvas. Using a pair of fire tongs to hold his brush at arm's length he would then make marks on the canvas. The purpose of this technique was to lessen control over the brushmarks and to force himself to see the portrait in the same way as he saw the person posing in front of him. Gainsborough's understanding of character and anatomy was as profound as his love of landscape. It is interesting to note that, unlike other painters of the period, he painted all the drapery himself.

Right *The Clown Don Sebastian de Morra*, Velazquez. The unusual and direct pose of this dwarf, a jester from the Spanish court, reveals the strong human understanding and sympathy Velazquez brought to the art of portraiture. The warm background, lack of props and use of light and shade are all characteristic of his work.

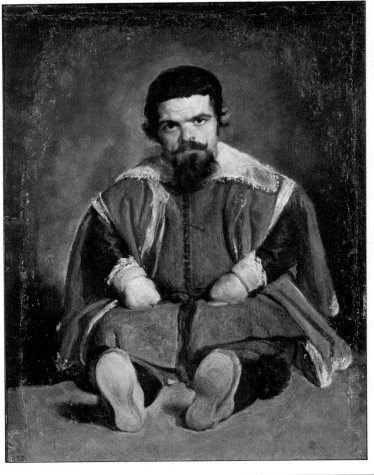

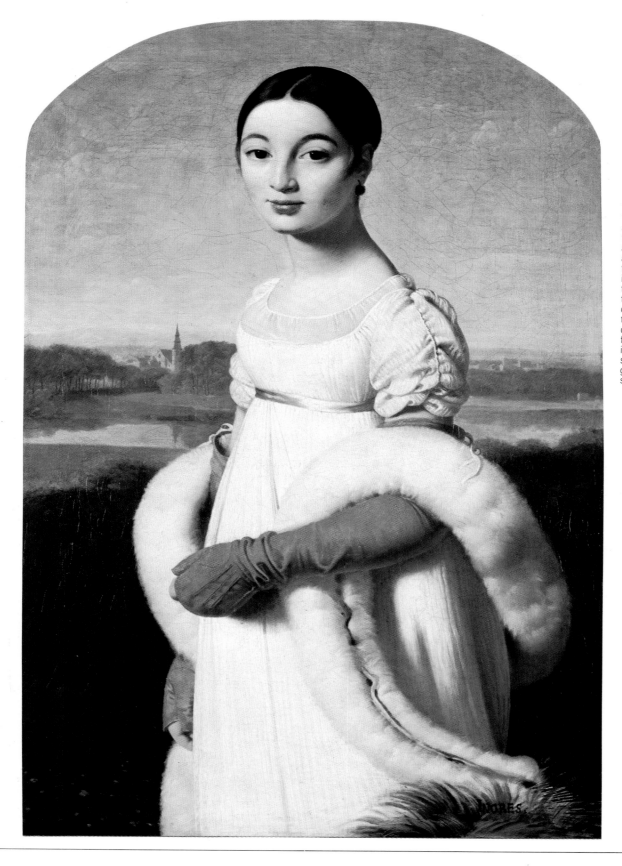

Left *Mademoiselle Rivière* (1805), Jean Auguste Dominique Ingres. Typical of many portraits Ingres made of well-to-do sitters, this painting shows a sensitive treatment of the contours of the body, with the lines of the figure accentuated by the folds in the thin material of the dress. The angle of the elegant, long neck and uncovered chest, with the face turned towards the viewer, invites an inquisitiveness into the quality of her skin, the texture of which is made to contrast with the luxurious textures of the fur and satin. The curve of the fur reinforces the form of the face and shoulders, its delicate softness juxtaposed sensuously against the wrinkled gloves and the sheen of the satin ribbon.

people instead of objects underneath the drapes, and similar effects can be observed. A model posed in a reclining position will take on new dimensions when entirely covered by a large sheet. The interpretation of reality can become much more personal when the immediately recognizable aspects of the figure are hidden. Having learnt how to represent the figure as a working machine, the artist is free to focus attention on particular areas which can be distorted or disguised at will; the figure can be used as a starting point only, before moving on to highly subjective and fantastic images. The parallel between the draped figure and a gently rolling landscape has been exploited by a number of artists, some of whom have chosen to use this as a deliberate visual metaphor. When the viewer is forced to see the human figure from a new angle, its very familiarity makes it exciting.

Again, with a figure instead of a still-life, the disintegration of form which is caused by the imposition of a highly decorative covering can be used as an area for exploration and discovery. The ambiguity of solid form combined with flat pattern has stimulated the interest of many and prompted artists such as Pierre Bonnard (1867-1947), Paul Gauguin (1848-1903) and Henri Matisse (1869-1954) to make paintings which investigate the various possibilities. The strong influence of Orientalism which pervaded art of the nineteenth and early twentieth centuries is at its most apparent here. The emphasis is decorative and calligraphic and the figure becomes merely incidental. Gauguin considered a sense of mystery and decorative design to be two of

the most important elements in art, and felt these aspects were being left behind by an age which was becoming increasingly mechanized and over-sophisticated. The scientific approach that had so excited the Impressionists had become, for Gauguin, a mere copying of nature, simple statements of fact which left little room for the imagination. He used the system of simplifying forms and colours until they made a decorative pattern in their own right and himself termed it "abstraction".

Gauguin's sojourn in the South Pacific was to have a profound effect on his work, bringing out essentially intuitive responses to what he saw. Guided by his respect for non-European art, he broke with the traditions laid down by the artists of the Renaissance and started the movement towards Expressionism and Surrealism. The paintings which he made during his time among the people of Tahiti, where he lived for some years between 1891 and his death, are concerned with creating a symbolic atmosphere without providing a logical explanation. He painted figures whose brightly patterned native dress argues with the exotic landscape in which they are set. The distinction between figures and background is minimal since Gauguin's love of strong colours and simple shapes makes for some paradoxical tonal and spatial relationships. His admiration of the savagery of primitive art forms combined with his passion for harmony and simplicity led him to make paintings which were lyrical and moody and yet hinted at religious and superstitious beliefs. His contemporaries found these results difficult to accept. During

Right This cheerful study by Goya captures the subject arrested in the course of her movement. The treatment of costume here provides a vehicle for exploiting the contrast of light and dark, an interest Goya derived from his two greatest influences, Velazquez and Rembrandt. The straightened back and happy pose are emphasized by the hang of the clothes.
Centre *Autoritratto* (1910), Egon Schiele (1890-1918). The artist was 20 when this drawing was made; only 28 when he died. At this point, his style is characterized by an Expressionist concern for emotional content. The clothing in this example is used to delineate the form beneath, the distortion and emaciation of the figure given added poignancy by the way the material gathers about the body.

his lifetime he remained largely misunderstood and it was not until after his death that Gauguin's contribution came to be fully recognized and admired.

Gauguin died in 1903. His influence became apparent within a few years when a number of young French painters, including Matisse, Derain (1880-1954), Vlaminck (1876-1958) and Rouault (1871-1958), became known as the Fauves or "wild beasts" because of the intense savagery of their colours and images. In Germany, a group of Expressionist painters called *Die Brücke* aimed to create a new and anti-naturalistic form of painting. They represented the human figure in a deliberately brutal way using costume to slash in areas of colour.

Matisse was the most important and influential painter among the Fauves and had a more deliberate and less spontaneous approach to painting than the Germans. Even so, his work, being fundamentally intuitive, fell within the Expressionist ideal. Like Gauguin, Matisse had a high regard for Oriental art and was concerned with the concept of simplicity. He painted his figures in simple lines and flat colours, often using a single colour, such as red or blue, to give the painting a great intensity of mood. He saw costume as a way of introducing ornamental pattern, although his aim was not simply to decorate but to express life itself.

In his later paintings he became almost obsessed by the nude figure although he retained the individual decorative quality of his paintings by setting them against brightly coloured backgrounds. His *Pink Nude*, which was painted in 1935, moved close to total abstraction: the figure itself is a stylized outline, filled in with a hot pink with only arbitrary variations in hue. This is set against a large geometric area of brilliant blue and white checks, with further decorative elements being introduced by a strip of red and pink, a blob of bright yellow and more checks in green and white, all occupying the top third of the painting. Matisse said that his paintings used "beautiful blues, reds, yellows, matter to stir the sensual depths in men". He may be considered to have used the voluptuous colour to symbolize the sexuality of his model.

Left *The Washerwoman* (1888), Henri de Toulouse-Lautrec. Around 1888, Lautrec became fascinated with portraying the ordinary people of the cafés, streets and theatres of Paris. The flat patterns and strong outlines of Japanese prints in this charcoal drawing of a washerwoman display another interest he developed at this time. The figure is treated almost as a silhouette, with the clothes serving to outline the overall shape and express character.

1. *Lorette VII (L'Echarpe Noire)*, Henri Matisse. The suggestive pose of this model is given added piquancy by the clinging, transparent material covering her body. Throughout his life, Matisse was particularly interested in the decorative aspects of pattern and colour; in this painting the two strong patterns argue with each other, ironically allaying the interest in the nude figure glimpsed teasingly.

2. *Seated Woman in a Chemise* (1923), Pablo Picasso. The monumentality and calm grandeur of this figure almost gives it the appearance of classical sculpture. The angle of view helps to produce this effect as does the relative distortion of the hands and head. Another equally important element is the clothing; nominally a chemise, the thin drapery is arranged and depicted in such a way as to bring to mind the thin coverings of classical figures.

3. *Ea Haere la Oe* (1893), Paul Gaugin. Gaugin produced his finest work during his sojourns in the South Sea island of Tahiti. Here the costumes worn by the native women are derived from the real world, rather than the artist's imagination, the patterns on the material reflecting the natural surroundings, leaves, fruit and flowers. The painting gains its symbolic and emotional power through the tension which exists between the real activity portrayed by the artist and the action on the flat surface of the canvas — the way the colours, shapes and patterns work together.

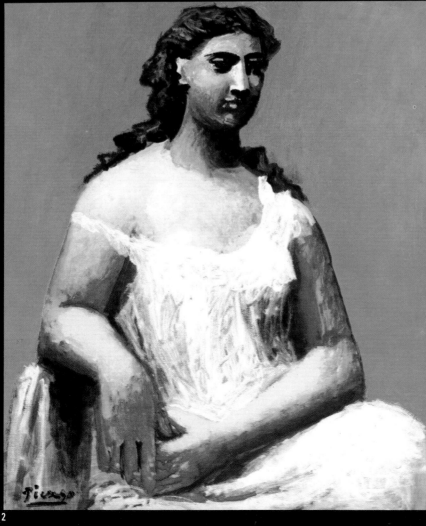

2

3

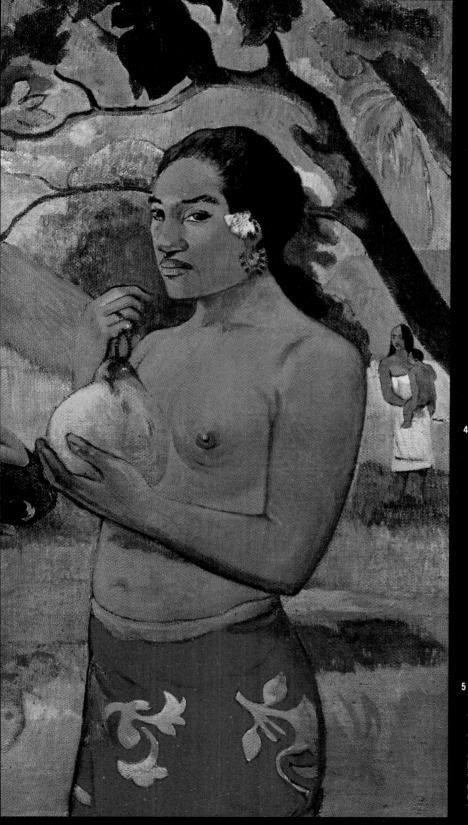

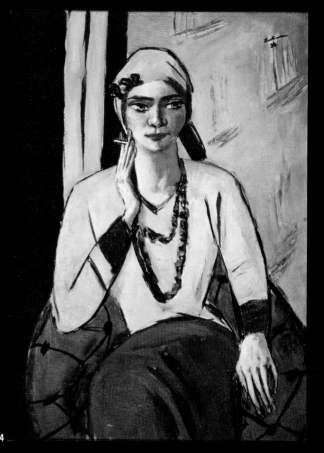

4

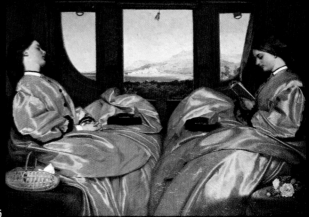

5

4. *Quappi in Rosa* (1932), Max Beckmann. This portrait owes much of its power to the full integration of tone, colour, composition and brushwork. Although the woman is in 1930s dress, this does not detract from the strong emotion or timeless quality of the painting.

5. *The Travelling Companions*, Augustus Egg (1816-1863). An outstanding feature of this painting is the delight with which the artist has observed the dresses. The composition is a subtle play on a mirror image, the eye being led from figure to figure to spot the small differences.

Matisse and those who followed him became increasingly excited by the abstract qualities in their work and for a time figurative art was not a popular element in modern painting. However, having taken abstraction to its logical conclusion, many artists have found it to be too limiting and have returned to figurative representations with a renewed interest.

How the artist chooses to dress a model today will be dictated to a large extent by the sort of painting he or she intends to produce. If it is with the human body itself that the artist is primarily concerned, then simple drapes will probably be preferred. This will allow a study of the way in which form is revealed by the rhythms of the cloth and the ways in which the figure exists as a solid object in space. To emphasize the bulk and volume of the figure, a single light source can be used which will reveal the model as a mass sculptured by light and tone.

It may be that the artist is interested by particular types of dress. Pablo Picasso (1881-1973) was fascinated by the theatricality of costume. He made paintings of Pierrots and Harlequins, often contrasting the gaiety of dress with the apparent melancholy of the model: the sad clown image. Edgar Degas (1834-1917) was another painter who was interested by theatrical dress. He made numerous studies of ballet dancers, which exploited his skill as a draughtsman, and also visited the racetrack where he became engrossed in the particoloured jockeys set against the green of the turf. Henri de Toulouse-Lautrec (1864-1901) frequented the circus where the combination of bright lights and garish costumes became a source for several of his paintings. Athletes, footballers, fighters and sportsmen are a favourite choice of subject matter, both

Right *Three Figures in an Attic.* In this modern oil painting of three figures in a garret room, the artist has created a still, cool atmosphere by establishing a single light source which bathes the models. Their stillness is further emphasized by the plain cut and sombre colours of their clothing set against the steeply receding patterned carpet and bed, which isolate the figures from each other. The light-coloured clothes of the man on the left emphasize his height, complementing the strong horizontals of the walls and door and the steeply angled diagonal over his head. A divorce is created between the standing figure and the two on the bed, not only through the positions and expressions on the faces but also through the contrast between the light- and dark-coloured clothing, and the fact that the light falls most strongly on the standing figure.

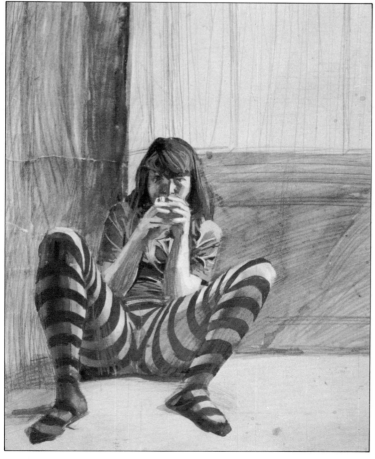

because of their decorative attire and because they show the human body in action and, usually, in the peak of condition.

An interest in modern costume would obviously prompt the artist to find a model whose style of dress was up-to-date. Fashions are always changing and, to a certain extent, everyone is influenced by the mood of the moment. It is, however, the way in which individuals adapt current trends which gives the clue to personality. The artist who wishes to present a modern image would need to paint from a model whose dress sense is naturally lively and modish. This kind of painting can be both a portrait of the person and of the age.

The one constant element in all these approaches to painting a clothed model, regardless of whether the artist intends to emphasize decorative, tonal or linear qualities, is that the underlying structure is the human body. Even though deliberate distortion, using as a basis a sound knowledge of anatomy, has frequently been used to develop a particular idea or theme, anatomical mistakes as a result of ignorance, even where it is not part of the artist's intention to give an accurate rendering of the figure, will almost inevitably jar. Painting is a form of communication and has its own visual language. To make a visual statement with authority requires a thorough knowledge of the way in which this language works. There are no short cuts: the rules have first to be learnt before they can be broken.

Above left *Seated Girl.* The model in this oil painting is wearing a loose jersey over a red shirt and jeans. Light comes from the upper left illuminating the sitter's reflective expression and strongly modelled features, and the red jeans throw her arms and clasped hands into relief. The casual clothes create a sense of naturalness and informality.

Above *Figure in a Courtyard.* The artist has placed his model in the strong, shimmering light of day, and a hot, dazzling effect has been achieved with the light reflecting off the white background. Form is dissolved in light, the broken outlines emphasizing the glare and the broad stripes across the sitter's chest contrasting with his darker clothes. Although the sitter's face is obscured, his quiff and shirt with upturned collar denote his youthful, trendy dressing.

Left *Girl in Striped Tights.* This watercolour and gouache painting is strongly dominated by the bold, curving lines of the zebra tights which the sitter is wearing. These demonstrate the artist's desire to delineate the volume and structure of the figure and its muscle formation in an unusual way.

GIRL IN GOLD WAISTCOAT AND BOOTS

mixed media on paper 15 × 10 inches (38 × 25 cm)

A rich sense of pattern and an extravagant concern to wear a variety of materials were the obvious characteristics of this model. When interpreting a strong arrangement of colours and textures, care should be taken not to let such things dominate the personality of the model, unless a sense of decoration or ambiguity is the artist's intention. The various textures of mixed media are used here to reflect the variety of clothes, while, at the same time, the clothes enhance the model's personality, which included feelings of delight, indulgence and nonchalance.

The personality is also brought out in the way the model is posed. The positions of her arms are contrasted: one is relaxed along the arm of the chair, the other raised. The legs are crossed so as to bring both shoes into view at an interesting conjunction. The shoes are given due exaggeration to stress their uniqueness. Contemporary dress is often as bizarre as dress from previous historical periods, providing an interesting area for exploitation.

1

The model is viewed from above in order to emphasize the angles of the arms which create a tension across the main diagonal of the body. The slanting view also enables emphasis to be given in the finished picture to the shape of the boots, the sharp corners of their heels and turnups echoing the elbows and, together with the angles of the knees, forming a pleasing compositional structure (1).

2

Using pencil on cartridge paper, the model's eyes are drawn in some detail, the rest of her face and shoulders following (2). The eyes act as an anchorage while drawing, a point of reference for the relation of the other details of the face, also the jewellery, sunglasses and the shape of the waistcoat lapels. A thin black watercolour wash is laid for initial shadows, the black being mixed with a minute amount of Indian red to give it some warmth. With delicate washes of yellow ochre, warm green and burnt sienna, colour is applied to the clothes, and when dry, a more complex sense of form and texture is achieved with touches of darker tones and further black delineation. A flat wash is laid for the shadowed areas of the legs, the spontaneous brushmarks describing the tension along the thigh (3). Outlines of the arms, hands and trousers are pencilled in and blatantly corrected, and details such as the watch, wristchain and cushion are solidly described (4).

3

4

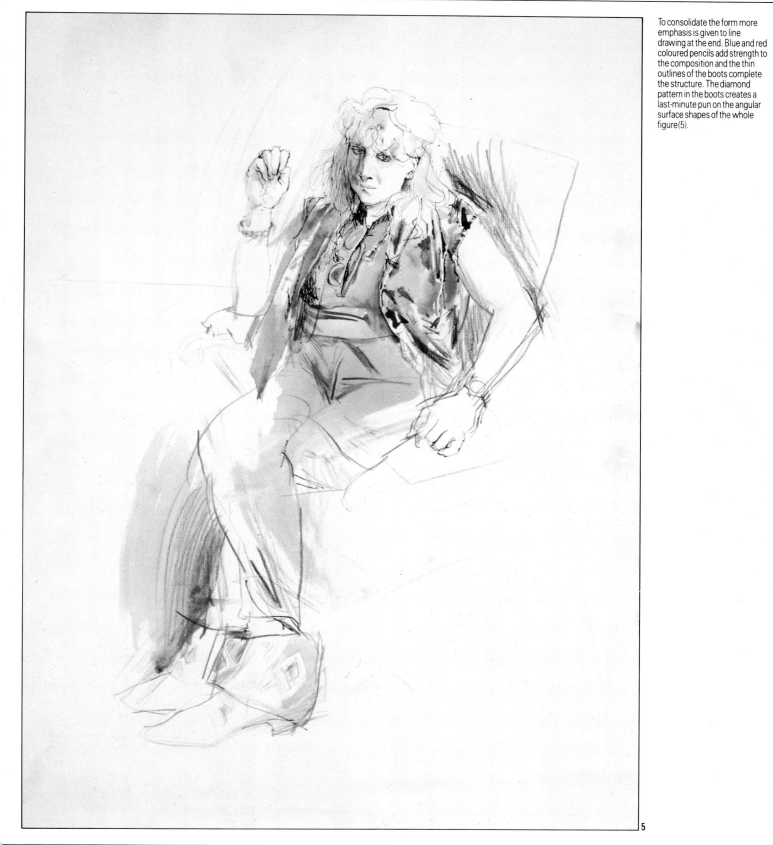

To consolidate the form more emphasis is given to line drawing at the end. Blue and red coloured pencils add strength to the composition and the thin outlines of the boots complete the structure. The diamond pattern in the boots creates a last-minute pun on the angular surface shapes of the whole figure(5).

5

GIRL IN FEATHERED JACKET
pastel on paper 23 × 32 inches (58 × 81 cm)

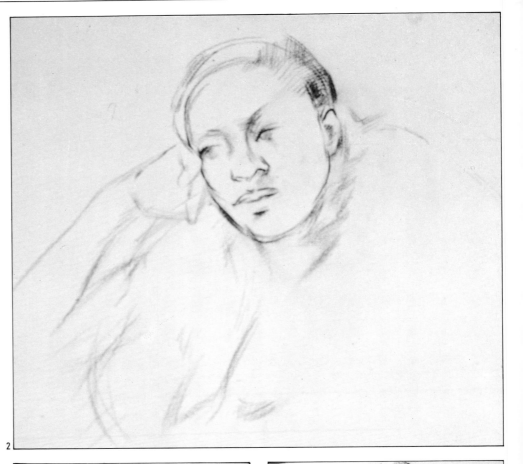

The richness and subtlety of the pastel medium enables the artist to work with freedom, making a variety of marks at the same time as maintaining and reinforcing the initial drawing. It is possible to establish a wide range of shades and tones using different techniques, including hatching and crosshatching, and overlaying and blending colours. Otherwise, if a multi-toned effect is not required, a large number of different colours and shades are readily available in art suppliers. The real beauty of the pastel medium is its purity. It is one of the most direct ways of applying pigment to a surface, being only lightly bound in gum. The resulting brilliance of each colour and the way pastels allow artists to work directly in blocks of colour or with a linear approach are the most obvious reasons for the popularity of the medium. Its disadvantage is that pastel tends to crumble easily, and need delicate treatment and frequent fixing at all stages.

Ascertaining a subject's tonal values is important in any medium, particularly with pastels because it is worth taking advantage of the wide range of colours and tones available. Viewing a subject with half-closed eyes cuts out a certain amount of detail and allows tones in the subject to be matched and contrasted. The main problem in this drawing involved relating the predominating areas of mid-tones – the skin, jacket and background all being of a similar intensity.

The model is in a relaxed and comfortable pose, semi-reclined on cushions, her head resting easily on a crooked arm and her legs pulled up towards her. The artist chooses to view the subject by placing himself to one side, so that the model's left shoulder gains prominence. The structure of the composition is nicely balanced, with the crooked arm and the bent leg almost creating a vertical symmetry (1). The focal point of the composition is the slightly angled head, and the artist establishes this area by drawing quickly in soft, brown pastel. Outlines are drawn first, but the artist fills in the face in considerable detail to get a feeling for this crucial area of the composition (2). This linear approach allows the relationships between the model's face, fingers and the open neck of the feathered jacket to be built up spontaneously. The artist chooses to represent the shaded areas not by filling in the appropriate shapes with flat, dark tones, but by overlaying loose, broad strokes so that each line retains an individual character.

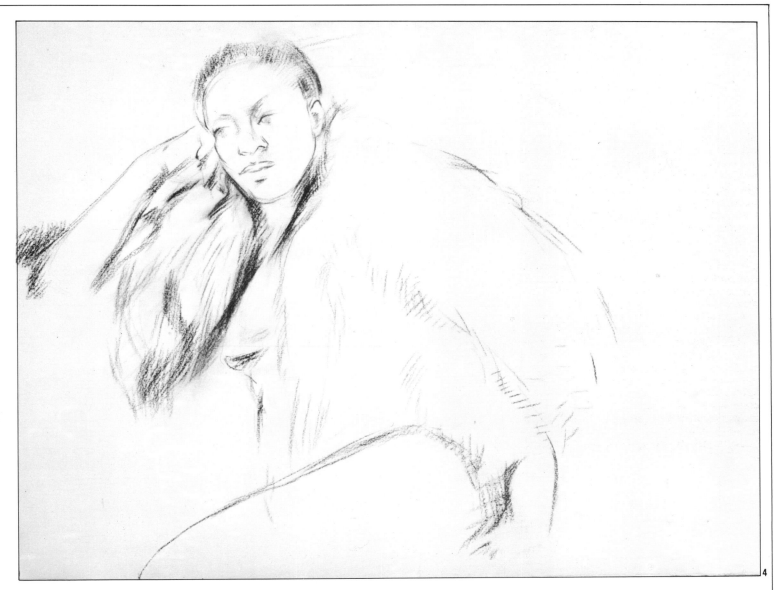

4

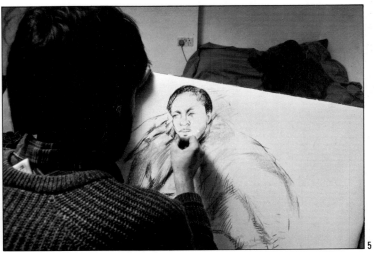

5

This gives the drawing a liveliness and depth and helps to establish a wider tonal range. The rough texture of the paper shows through, also giving an added sparkle and vivacity (3). With the key section of the drawing firmly described, the next stage is to block in the rest of the form. The importance of the line of the crooked arm, which leads the eye to the subject's face, is reinforced by the line of the bent leg, giving an overall harmony to the composition. Even at this early point in the work, the quality of space is well defined, the positive and negative shapes having equal importance. The lines describe not only the form of the figure, but make the undrawn areas on the paper work as well (4). The problems of successfully rendering form with light and shade are acute whatever the colour of the skin. At this point the artist is concerned with developing tonal qualities and bringing out the contrast between the smooth flesh of the model and the interesting texture of the feathered jacket. The dark areas of the hair and neckline are reinforced. The subject is sitting in natural light, which is coming from the lefthand side (5).

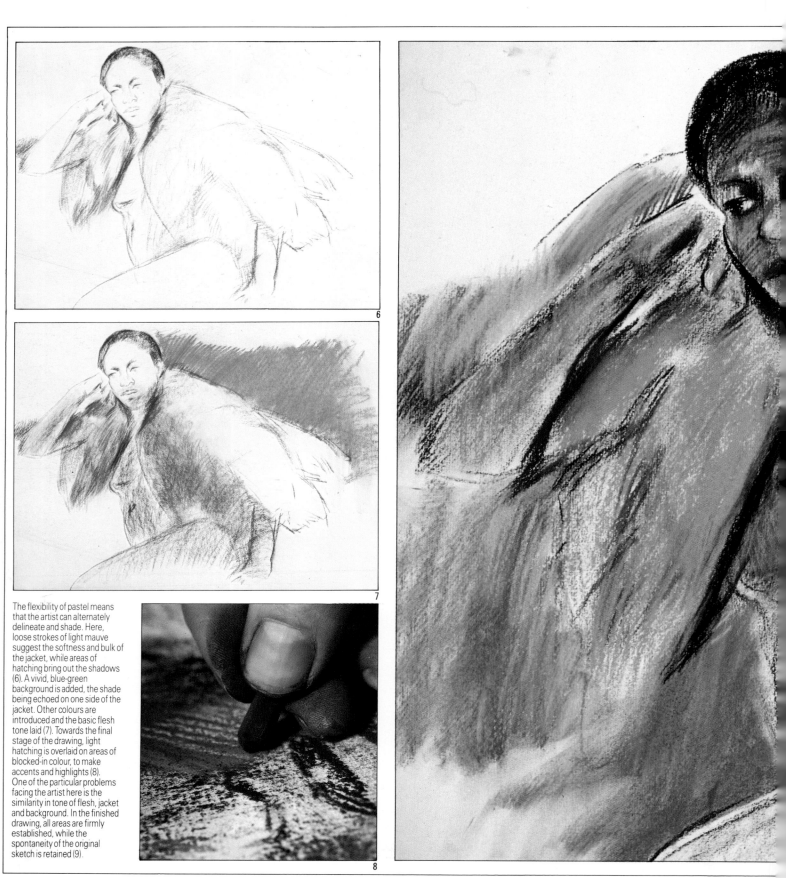

The flexibility of pastel means that the artist can alternately delineate and shade. Here, loose strokes of light mauve suggest the softness and bulk of the jacket, while areas of hatching bring out the shadows (6). A vivid, blue-green background is added, the shade being echoed on one side of the jacket. Other colours are introduced and the basic flesh tone laid (7). Towards the final stage of the drawing, light hatching is overlaid on areas of blocked-in colour, to make accents and highlights (8). One of the particular problems facing the artist here is the similarity in tone of flesh, jacket and background. In the finished drawing, all areas are firmly established, while the spontaneity of the original sketch is retained (9).

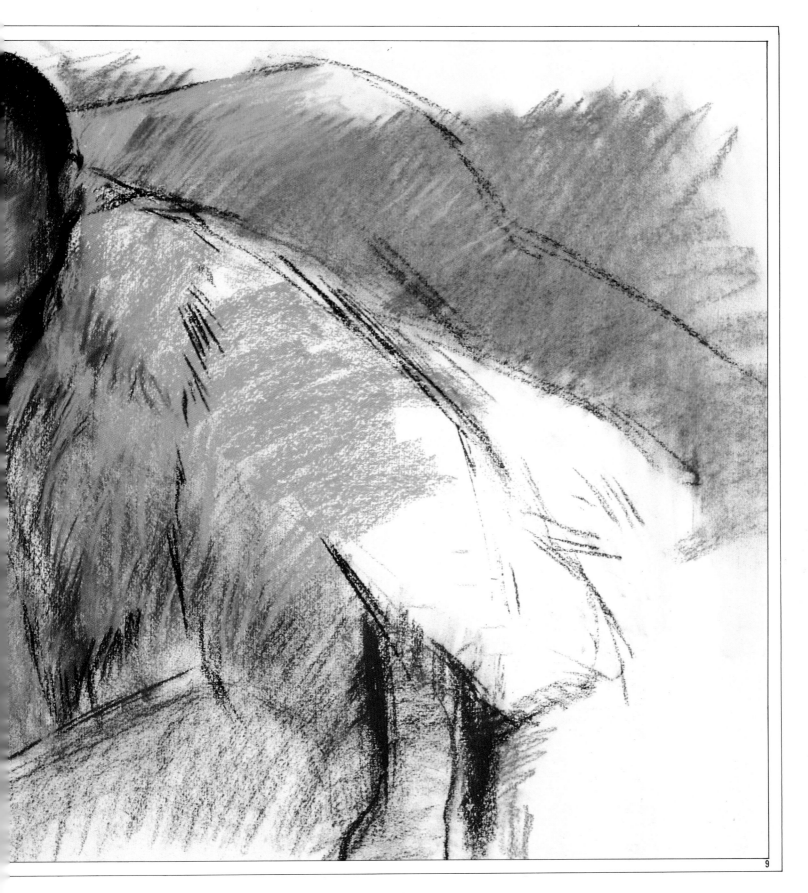

FIGURE IN MOTION

Artists have attempted to represent the moving figure in various ways. The element of realism in a picture of figures, for example, gives an impression of motion by inference; if the figure seems real then the observer will attribute human qualities to it, including the fact that a body is never absolutely still. Similarly, if a body is represented in an attitude which a body would not take if it were asleep or dead then the observer will assume that the subject was moving both before and after the depicted split-second. Some artists in this century have expressed motion in an abstract way, the movement itself being more important than the figure.

A convincing portrayal of the figure in motion is based on the artist understanding the still figure, its anatomy and its potential movements. But it is not only the principles that are important: an artist with a personal view to express in paint probably needs the confidence that only drawing practice can give. Drawing can be seen in relation to painting as grammar is to a language; confidence with the basic skills leads to a fluency in handling the figure and an ability to produce the desired result, an individual vision. The fact that fluidity of line and vitality are more easily expressed in paint if they have been rehearsed in drawing does not mean that a painting should necessarily be composed in pencil first. It is simply that drawing is a good way of loosening up and it is a cumulative process. It is a way of learning and storing visual information and constant practice will lend confidence and spontaneity to the painted mark.

The greatest innovating artists of the past had all mastered the techniques of previous artists before giving work their individual interpretations. Studying the great masters and learning from their work is a valuable way of understanding how different approaches and techniques are successful in different ways. The following survey will give some idea of the developments made by artists through the centuries.

The great revolution in art which culminated in the Renaissance brought with it a thirst for understanding and a desire to represent objects realistically. New-found knowledge of anatomy and perspective freed artists from the restrictions and conventions of the Dark Ages; the flat, static quality that had characterized medieval painting gave way to breathtaking demonstrations of virtuosity in the rendering of form and space. But the artists of the early Renaissance still had not overcome the problem of how, convincingly, to represent the idea of movement within their pictures. For all the painstaking accuracy of their portrayal of anatomical and architectural detail, there is an air of unreality about these paintings.

Uccello's *Rout of San Romano* is an ideal illustration of the Renaissance position. The artist spent long hours grappling with the problems of foreshortening, drawing the figure from angles which, to other artists of the time, must have seemed very difficult. This picture, painted between 1454 and 1457, illustrates a battle which took place some 20 years earlier between the people of Florence and of the neighbouring state of Siena. It is one of three panels, and assiduously accurate in every detail. Each element of the painting is considered separately and constructed with mathematical precision, while the composition of spears, lances and trumpets is used to emphasize the receding planes. Even so, the unreal and wooden quality persists, particularly visible in what critics have labelled the "rocking horses". This is partly because of the theatricality of the colour which is reminiscent of medieval pageantry, and partly because of the way the figures and animals fail to interact with one another. Uccello exploited linear perspective fully, but made little concession to atmospheric perspective and the way in which tone and colour are diminished by distance. Also, his white horses do not reflect the colour which their proximity to flags, banners and other horses suggests they should. His figures bear themselves with the calm dignity of a military procession rather than the passionate agitation of a real battle. There is, of course, no suggestion that Uccello intended it to be other than a highly decorative expression of his own frequently voiced feeling: "How sweet a thing perspective is!"

As the secrets of anatomy gradually unfolded and artists became familiar with the way the body works, so their rendering of the human figure became less stiff and more human, a quality in painting which implies continuous movement. *Primavera*, by Sandro Botticelli which was finished in 1478, shows how concerned the artist was to portray his figures as living, moving beings, despite the highly decorative and tapestry-like background. The artist's use of subtle colours and sinuous lines in waving hair and drapery suggest a fluidity not apparent in the work of previous artists. Although the subject matter of this painting is allegorical and the setting owes much to fantasy, the figures, especially the Three Graces, have taken on a new, fleshy quality.

It is worth remembering that Botticelli worked in tempera which is an exacting and difficult medium to control and tends to give a dry and brittle finish. It was Leonardo who, experimenting with the more elastic oil paint, which was already being widely used by artists in northern Europe, invented a technique called "sfumato". This literally meant a smoking, or blurring, of the edges

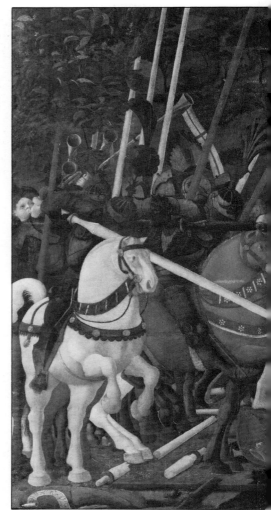

which imbues form with mystery and contrives to suggest that the figures have been caught between one movement and the next. By blending one form into another and breaking up the severe outlines which had featured in Uccello's paintings, Leonardo was able to give the impression of light and air around his figures. The softening effect of these hazier outlines conveys the transitory quality of light and implies movement and the passage of time. This invention was quickly seized upon by other painters of the time and was used to great effect by Raphael, Giorgione (1475-1510) and Michelangelo.

Titian, working later than Leonardo, developed his individual wide-ranging styles with an innovative mastery of colour. He used colour and light to restore unity to paintings in which his contemporaries considered him to have broken all the rules of composition. The paintings are lively because, although he was intensely concerned by the internal structure, they are not symmetrical, as was normal at the time, and

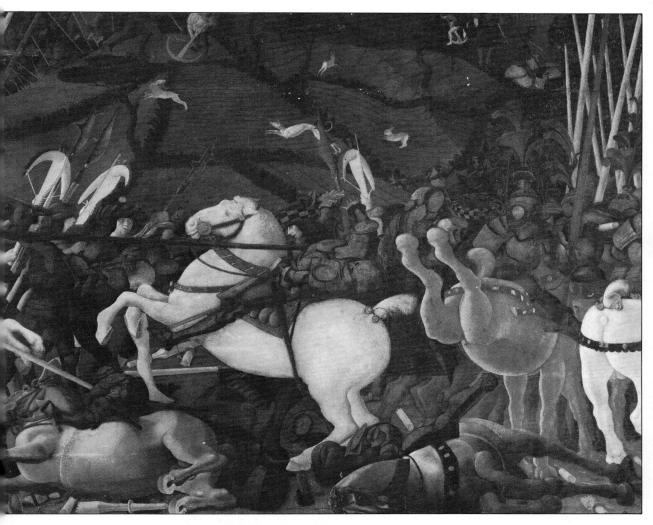

Left *Rout of San Romano* (1454-57), Paolo Uccello. Uccello's experiments with perspective rendered him one of the great names of the Italian Renaissance. Together with Brunelleschi, Donatello and Masaccio, he pioneered the use of a geometrically calculated space to create the illusion of movement and depth on the flat picture plane. Lances bring the spectator's eye into the picture; dead horses litter the foreground; behind, carefully placed figures and an oddly fore-shortened bucking horse lead the eye back into space. Abstract patterning combined with geometrical construction lends a strangely suspended and unreal air to the decorative scene.

Below left *Archers Shooting at a Mark*, Michelangelo Buonarotti. A sculptor, painter, architect and poet, Michelangelo was one of the greatest artists of the Renaissance. This red chalk drawing shows his mastery of anatomy and although realism is disregarded in the overall design, each figure is meticulously observed, its powerful muscles and curves redolent of violent movement. The artist has fully exploited the medium in line and tone.

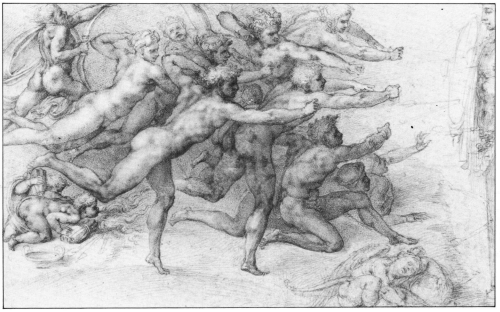

the characters portrayed are interrelated while not being in their expected positions. His control of colour and composition and portrayal of complicated groups of figures in action are well illustrated by his painting of *Bacchus and Ariadne*, painted in the early 1520s.

Caravaggio, with less regard for grand schemes and structures, took the use of light to a harsh extreme. He used flickering light and extreme tonal contrasts, often with strong shadows throwing up selected shapes into clear relief against the hidden light source, to give his paintings an unnerving and uncompromising intensity and reality. The life within these paintings exists in the subject matter, where light is a vital element making the characters live and move. It also exists in the fact that Caravaggio modelled the people, and more importantly the saints and other religious figures from less than perfect human beings – a scandal at a time when the Church was trying to impose a tighter morality on society.

Above *The Raft of Medusa* (1817), Théodore Géricault. This painting caused a storm when it was exhibited at the Paris *Salon* of 1819 because of its political overtones and realistic treatment of its macabre subject. Having studied in Italy, Géricault was much impressed by Michelangelo and the Baroque, elements of which can be seen in the drawing of the bodies and the extremes of human emotion. The complex figure composition, based on a double triangle with lines sweeping across, ensures a sense of constant, swirling movement as the eye is guided around the picture.

Right *Primavera*, Sandro Botticelli. One of a group of late fifteenth-century Florentine painters who rejected the naturalism of Masaccio's art in favour of a more linear and ornamental style, Botticelli relied, solely it appears at times, upon line to express emotion and graceful movement in a deliberately archaic manner. In this painting, hair and drapery flow, with outline and colour conveying a fluid and rhythmic sense of movement.

The influence of Caravaggio can be seen in the paintings of Rembrandt, Velazquez (1599-1660), de la Tour (1593-1652) and Le Nain (c.1593-1648). The great Baroque sculptor Bernini (1598-1680), whose medium was marble, also represented the human figure with enormous vigour. Like Caravaggio, his influence was strong and his vision new. The figures he moulded are expressive and dramatically conceived, flowing within their self-imposed structures.

It may generally be seen that, until the nineteenth century, figures successfully represented in motion are made to look lively and realistic by the artists using perspective, colour and light, and sometimes by depicting them in active positions. Michelangelo's figures display the artist's mastery of the human anatomy, and often seem taut with imminent action and latent energy. The action of the figure on its own, however, is not enough to create an overall impression of energy. The surface structure needs to be similarly tense; the stresses within the composition, created by line and by the juxtaposition of colour, can be used to relate the space and the activity and create a larger atmosphere of movement and vitality. Michelangelo's *Archers Shooting at a Mark* demonstrates the importance of structure; each figure separately possesses a minute amount of the whole sense of movement.

The Mannerists were a group of painters, including Bronzino (1503-72) and Vasari (1511-74), who followed in the wake of the High Renaissance. They turned their backs on the classical ideals of balance, harmony and perspective and concentrated on the grand gesture. The results are huge, flamboyant compositions portraying scenes of drama and turbulence. The surface structures of these compositions are vital to the movement and spirited liveliness in these paintings, and are emphasized by vibrant, often brash colours. To further exaggerate the flow of movement within the picture plane, the Mannerists were prepared to contort the form of the human body and often echoed these shapes in clouds, trees or drapery. The twisted, writhing figures are typical of this period of painting.

The Raft of Medusa by Théodore Géricault (1791-1824) is a fine example of the importance of composition. The painting has a strong surface structure, based on a double triangle with crossing rhythms. Shapes are repeated; for example, the billowing sail is echoed in the restless waves and clouds. The force of the wind and the forward motion of the boat are matched in the hope created for the survivors by the sighting of a distant ship, all stressed by a strong, curving diagonal. The vitality of this painting was inspired by the artist's feelings of outrage against the naval authorities, whose incompetence he blamed for the shipwrecked *Medusa.*

A painting technique which has been used to emphasize dynamism is the "gestural brushstroke", where the action of the artist actually laying paint on the canvas remains visible. Fragonard (1732-1806), painting in a light-hearted manner, used broad though well-controlled brushstrokes to give an impression of spontaneity and movement. Some of the paintings by van Gogh (1853-90) display similar energy with strong brushstrokes describing the forces at work in nature in, for example, *Landscape with Cypresses.* In a different medium, Matisse used scissors to cut out paper for his collage

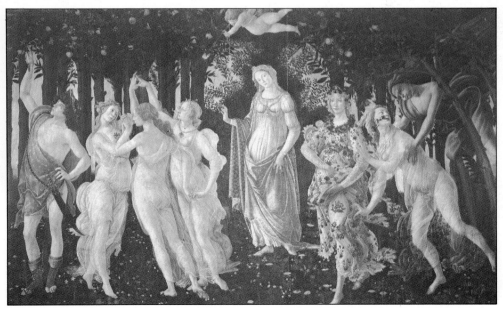

compositions. Each cut was final and vital to the whole and may be similarly considered as having been made in "moments of creativity". The figures in *The Swimming Pool*, for example, despite being abstract, could not be doing anything but moving in the peculiar, frantic manner of swimmers delighting in their surroundings.

The invention of the photograph was one of the most important innovations for artists of the nineteenth century. Photographs could be used as a valuable aid to composition, giving detailed impressions of possible surface structures and the relation of forms, and could also be used to assess tonal values. The *camera obscura* – a rectangular box with a lens at one end and a reflector placed at an angle of 45° to direct the image received through the lens onto a plate of ground glass which could be traced over – had been used by artists for similar reasons since its invention in the sixteenth century. Artists' reactions to using the *camera obscura* as an aid to drawing and painting had, however, always been divided. Hogarth (1697-1794), for example, felt that the animation of reality was lost with the artist copying no more than a lifeless imitation of the original scene. Others criticized the way the image was too intense in colour and tone, and therefore false. The same arguments were propounded against the use of the photograph, which was considered by some a more dangerous invention as it was capable of fixing the image, freezing the lifeless imitation. There were, at the same time, fears that photography would become a substitute for painting.

It cannot be denied that the first photographs brought a new perspective to the art of capturing scenes from life on a flat surface. In some ways, photographs seem to portray a greater degree of reality than paintings. Whether they were capable of capturing movement and liveliness in the same way as paintings was the subject for some intense debating.

Eugène Delacroix (1798-1863), despite being enthusiastic about the invention, was aware of its limitations for the artist. He presented two angles of the debate in 1850: "The study of the daguerreotype if it is well understood can itself alone fill the gaps in the instruction of the artist; but to use it properly one needs much experience. A daguerreotype is more than a tracing, it is the mirror of the object. Certain details almost always neglected in drawing from nature, there – in the daguerreotype – characteristically take on a great importance, and thus bring the artist into a full understanding of the construction. There, passages of light and shade show their true qualities, that is to say they appear with the precise degree of

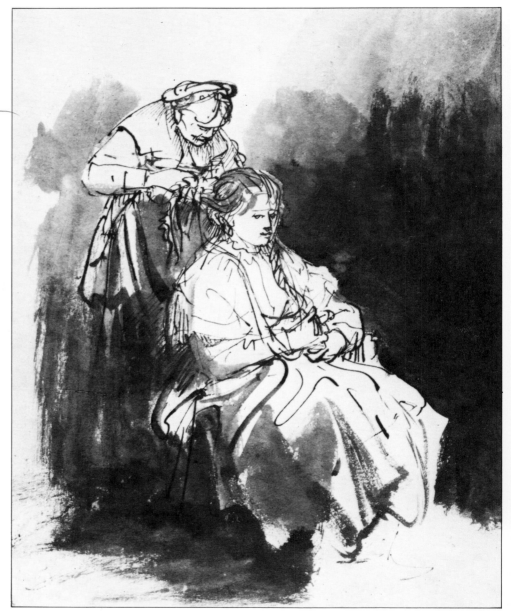

solidity or softness – a very delicate distinction without which there can be no suggestion of relief. However, one should not lose sight of the fact that the daguerreotype should be seen as a translator commissioned to initiate us further into the secrets of nature; because in spite of its astonishing reality in certain aspects, it is still only a reflection of the real, only a copy, in some ways false just because it is so exact . . . The eye corrects, without our being conscious of it. The unfortunate discrepancies of literally true perspective are immediately corrected by the eye of the intelligent artist; in painting it is soul which speaks to soul, and not science to science."

Auguste Rodin (1840-1917), commenting on the ability of painting and sculpture to present an original approach, presented a similar point of view when he said:
"It is the artist who is truthful and it is photography which lies, for in reality time does not stop and if the artist succeeds in producing the impression of a movement which takes several moments for accomplishment, his work is certainly much less conventional than the scientific image, where time is abruptly suspended."

With these arguments in mind, it is easy to understand why Gustave Courbet (1819-77) and other Realists were dependent on photography to some extent. They sought to

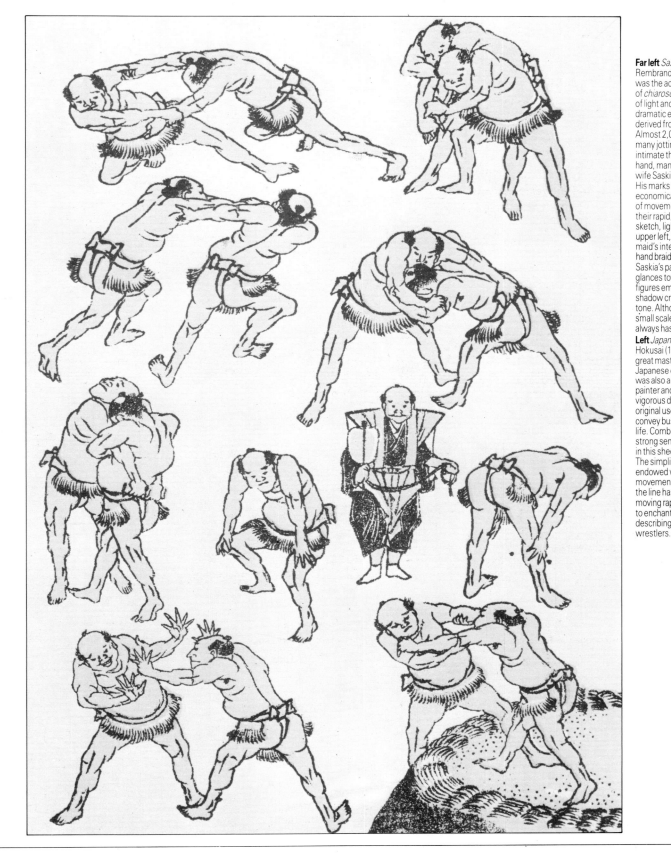

Far left *Saskia at her Toilette*, Rembrandt van Rijn. Rembrandt was the acknowledged master of *chiaroscuro*, or the depiction of light and dark to create dramatic effects, a method derived from Caravaggio. Almost 2,000 drawings and many jottings of precious, intimate thoughts exist in his hand, many of them of his first wife Saskia, who died in 1642. His marks are scratchy and economical but convey a wealth of movement and emotion in their rapid, broken lines. In this sketch, light comes from the upper left, highlighting the maid's intent expression, her hand braiding Saskia's hair, and Saskia's patient face as she glances towards the artist. The figures emerge from the shadow created by washes of tone. Although generally on a small scale, Rembrandt's work always has a sense of grandeur.

Left *Japanese Wrestlers*, Hokusai (1760-1849). One of the great masters of the *ukiyo-e* or Japanese colour print, Hokusai was also a book illustrator, painter and print designer. His vigorous drawing and strikingly original use of colour vividly convey bustling Japanese city life. Combined with these is a strong sense of humour, evident in this sheet from a sketchbook. The simplified forms are endowed with power and movement rarely equalled in art; the line has many functions, moving rapidly across the paper to enchant and engage whilst describing the action of the wrestlers.

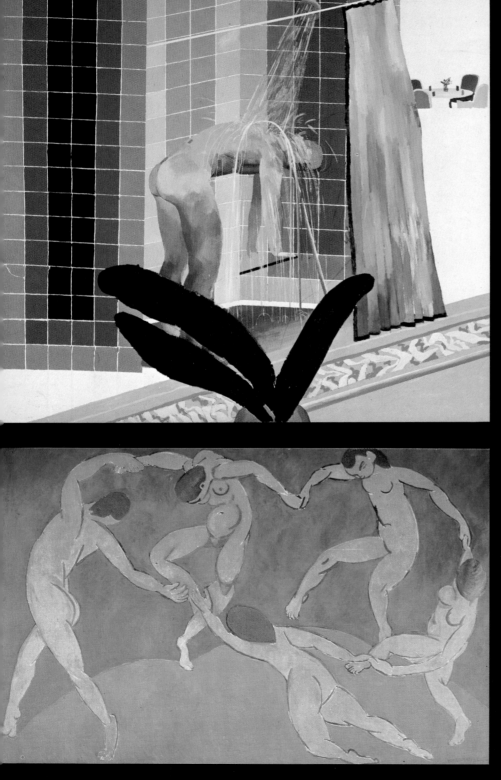

1. *Man Taking a Shower in Beverly Hills, May '80,* David Hockney. Hockney is a representational artist and uses strong, light colours, generally in flat acrylic paints. Fascinated by the play of light on reflective surfaces, Hockney paints interiors which are always light and sundrenched. The body is strongly silhouetted against the tiles and the slashes of water are a lively quotation from comic book convention. Colour contrasts, bold verticals, horizontals and diagonals create a constant sense of movement.
2. *The Dance,* Henri Matisse. Matisse was the foremost artist of the Fauves group of painters whose works were executed in strong violent colours, flat patterns and distorted forms. For him, colour, drawing and composition were inextricably linked and could be used to express emotion. In *The Dance,* brilliant, pure colours are juxtaposed to create a lively, rhythmic sense of movement.
3. *The Cinema* (1920), William Roberts (1895-1980). Roberts was a member of the Vorticist group, the name of which was taken from Boccioni's statement that artistic creation had to originate in a state of emotional vortex. Roberts sets his figures in a series of diagonals, horizontals and verticals, to convey a zigzag movement which is emphasized by placing strong colours against each other. The angular machine-like forms of the audience are emphasized by their violently stupid expressions as they watch the Western, a monochrome version of themselves.
4. *Nude Descending a Staircase,* Marcel Duchamp. A combination of Cubism and Futurism, this painting shows the influence of the chronophotographical experiments of Marey and Muybridge. The colour range is severely restricted to blacks and browns, and the segmented figure reduced to simple geometric and semi-mechanical forms. The subject is fused with the surroundings, and multiplied and elaborated to suggest the spiralling movement of the figure.

escape from the artificiality of classicism and romanticism by representing scenes from everyday life with a total frankness and objectivity of vision. Ironically, Courbet's *Return from the Fair* was dismissed by a public used to the graceful, impressive academic art of the time as "a banal scene worthy only of the daguerreotype". Another of his paintings was described as one which could be "mistaken for a faulty daguer-reotype". This was only the reaction of outrage; Courbet's paintings are sincere and powerful expressions of reality as he saw it. Photographs of similar scenes might have recorded the details more scientifically, but would not have the same feeling.

The camera was not able to take the place of the brush, but photographs have proved a valuable aid to painting. Walter Sickert (1860-1942), for example, dismissed as "sheer sadism" the idea of demanding more than one sitting for a portrait when a good photograph of the face sufficed. During the next few years, improving photographic techniques made it possible to capture moving as well as still images. The instantaneous image, available from about 1860, revolutionized the way in which human and animal figures in motion were represented by artists and also the way in which ordinary people recognized what they saw.

In many ways, painting had become stylized in its depiction of movement. Certain conventions had grown up, a good example of which is the way that horses were shown moving at a gallop. Géricault's painting *Horse Racing at Epsom* (1820) demonstrates how the misconception about the way that horses move had become accepted; in fact, when Degas began to paint them as they really move, his new images were rejected as unnatural and unrealistic.

The photographer who drew attention to these and other discrepancies was Eadweard Muybridge (1830-1904). He had become interested in the continuing debate about whether all the legs of a horse come off the ground together at any point during galloping. Muybridge set out to make photographic proof of the locomotion of a galloping horse and his astonishing results were published in 1878 and 1879. In a series of consecutive photographs it was demonstrated that all the horse's legs were in the air at once but that, instead of being extended, after the manner of Géricault's painting, they were drawn up beneath the body of the horse. What the human eye is not quick enough to perceive was irrefutably proved by the camera. As the photographer himself observed about the image:
"We have become so accustomed to see it in art that it has imperceptibly dominated our understanding, and we think the representa-

tion to be unimpeachable, until we throw all our preconceived impressions on one side, and seek the truth by independent observation from Nature herself."

Muybridge went on to further investigation and later published *Animal Locomotion* which was an impressive study of the movement of humans and animals. This collection of photographic sequences shows people and animals involved in a variety of everyday activities and continues to provide an excellent source of reference on movement for artists.

The French photographer Etienne Marey (1830-1904) also assisted artists towards an understanding of movement. He developed the technique of chronophotography – a system of producing multiple images on a single plate so it was possible to record the second-by-second movements of a bird in flight, of a man walking or a child jumping. Marey drew graphs from his chronophotographs tracing the patterns and rhythms of movement, and these became a source of inspiration for a number of artists, the most notable of whom was probably Marcel Duchamp (1887-1968). Early in the twentieth century, Duchamp had become fascinated by the idea of simultaneous representations which made it possible to give the impression not just of movement within a given space, but also of the passage of time. He made no secret of the fact that Marey's chronophotographs and diagrams provided the initial impetus for the paintings he produced on this theme. The studies of *Nude Descending a Staircase*, painted in 1911 and 1912, are clearly derived from the work of Marey although the influence of Cubism is also apparent. The geometrical treatment of the fragmented figure which spirals diagonally across the canvas is a highly successful representation of movement.

While Duchamp's nude is still recognizably human, the repetition of the partially abstracted form gives the painting a mechanical feeling which heralds the reverence that the Futurists felt for machines and their function. Formed in Italy in 1909, the Futurist movement was expressed by the painters Umberto Boccioni (1882-1916), Giacomo Balla (1871-1958) and Gino Severini (1883-1966), among others. They believed the solid materiality of objects to be diffused by movement and light, and felt that movement could be more realistically represented by presenting successive aspects of forms in motion simultaneously on canvas. The resulting sense of motion in some of their paintings is unique.

It should be remembered that not everyone welcomed the arrival of photography with enthusiasm. There were many artists who chose either to ignore it or to work in

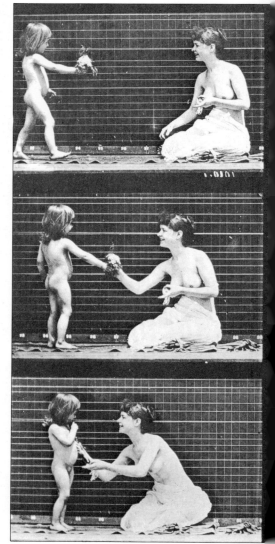

conscious opposition to the ideal of photographic realism. The work which Henri Matisse was producing around the same time as Duchamp was painting, makes an interesting comparison. Both artists were concerned to represent movement, energy and vitality; both artists chose to work in a manner that would not be considered realistic in the normal sense of the word. But whereas Duchamp communicated his ideas in an intellectual and scientific way, the paintings of Matisse are expressive of almost pure emotion. *The Dance*, painted in 1909, is an ecstatically vibrant representation of movement. The intense, pure colours, the quality of line and simplicity of form are expressive of great excitement and vitality. Years later, Matisse is recorded to have said that he painted "to translate my emotions, my feelings and the reactions of my sensibility into colour and design, something

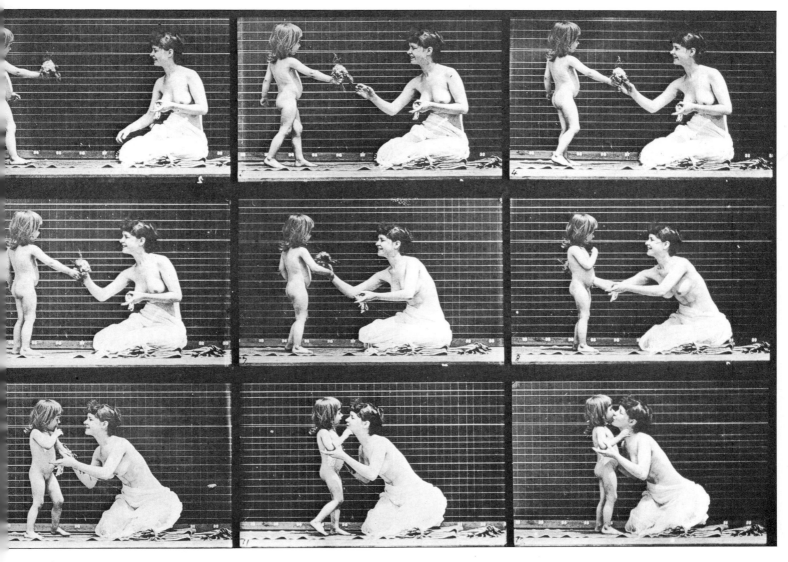

that neither the most perfect camera, even in colours, nor the cinema can do".

Studying the variety of approaches to the problem of successfully suggesting movement is instructive for artists today. A great number of effects are possible with different techniques, which, once mastered, can be manipulated to suit the individual artist. Presenting the figure is partly a question of the artist being fluent with the chosen media, and understanding the anatomy, the movements of the body and the principles of perspective.

Representing movement is also a question of the composition. One of the most important elements to consider is the surface structure of the work. The figures and objects should interact and flow, and if the sense of movement is to be emphasized then the composition should always take the eye in one main direction. If a composition is too formal, however, the figures will stiffen.

The use of colour is vital to the structure and the mood of a painting. Colours can be subtle, with graduating or contrasting tones an important element, suggesting changing light; or they can be bold and solid which often gives a more vibrant impression. "Sfumato" – fusing the outlines – is one of the many varied techniques which can be efficiently used to suggest figures in motion.

To capture movement by drawing or painting requires constant practice. It is worth watching people move and noting positions of tension, which would, on paper, best illustrate a certain action. Capturing the split-second position is not simply a matter of seeing and presenting that particular position on paper or canvas; just as the model must have moved to it and out of it again, so the artist must understand and imply the whole motion.

Above *Child Bringing a Bouquet to a Woman* (1885), Eadweard Muybridge. Muybridge was one of the first men in the nineteenth century to successfully analyze movement in photography. Preferring not to photograph artists' models as "their movements are not graceful", he managed with difficulty to persuade non-professionals to pose nude or nearly nude. These beautiful photographs are in fact of the wife and daughter of the Principal of the Philadelphia School of Industrial Art, and were taken with a special camera with 12 lenses, each of which made a separate image on a glass plate so that it was possible to photograph 12 stages of a particular sequence with one camera.

NUDE WITH CIGAR
oil on hardboard 4 × 3 feet (122 × 91 cm)

The technique of painting in oils has been practised for so many hundreds of years that there is a tendency to think it straightforward. In fact, the principles are fairly simple to grasp, but with the benefit of a little experience, the artist discovers a number of rich possibilities which can be adapted to help develop and enhance his or her style of painting. First, the choice of support, whether it is canvas, hardboard, millboard or wood, influences the types of size and primer to use. For use on ready-sized supports, emulsion primers are relatively porous in comparison with gesso grounds which are made without oil and zinc oxide and dry hard and smooth. Both white and coloured oil-based or acrylic-based primers can be bought or prepared at home.

A tinted ground will allow the artist to work both down to the darks and up to the lights, and can prove very useful as long as the chosen tone is of a neutral cast and is sympathetic to the overall mood of the work. A raw sienna, for example, can be used for a nude figure painting. White priming allows warm shadows to be laid in to contrast with cool lights and highlights; darks can be painted in several layers and lights can be left as a thin staining with the white showing through subsequent glazes. The resulting luminosity adds an authentic sense of light to this picture which includes a large window.

1

The process of making a picture inevitably includes a great number of decisions followed by revisions, then further changes of mind and readjustments. Oil paint is well suited to accommodating these changes without necessarily clouding or muddying except where .

desired. The three stages which lead to picture 4 are shown here as an illustration of work in progress.
Some areas of the gesso ground are carefully left uncovered and the rest washed with a mixture of Payne's grey and turpentine. The figure, whose

white outline describes the light coming through the window, is worked in dark browns, terre verte and yellow ochre, and background details carefully delineated and filled. The use of ultramarine gives the interior space a coolness and haziness(1).

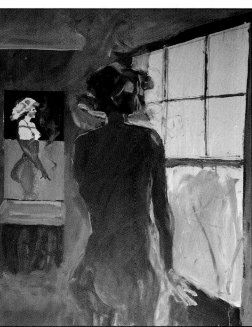

Next, a smokey white glaze is worked over the floor and the figure given stronger white and yellow highlights. The focal point is shifted to the mirrored reflection, where a criss-cross pattern echoes the structure of the window frame (2). Another change of mind causes the form of the body to be reinforced with some darker greens and browns Masking tape prepares for precise lines to be added to the window frame, and the towel gains highlights (3). Finally, brighter lights are added to the figure and the haziness is recreated with another thin, white-blue glaze.

The woman's fingers catch direct sunlight, and the towel becomes flatter in tone with decorative red stripes. The most important change, however, is in the basic construction of the picture. Right at the end, the ceiling is heightened and the top of the window straightened to increase the spaciousness of the room (4).

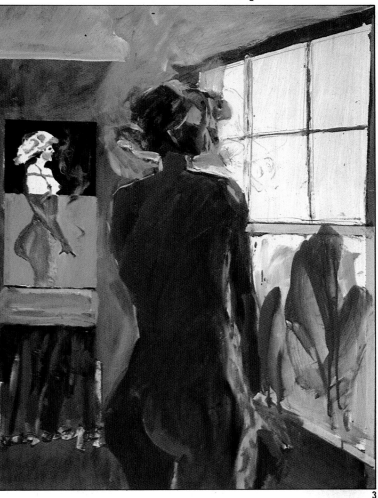

4

3

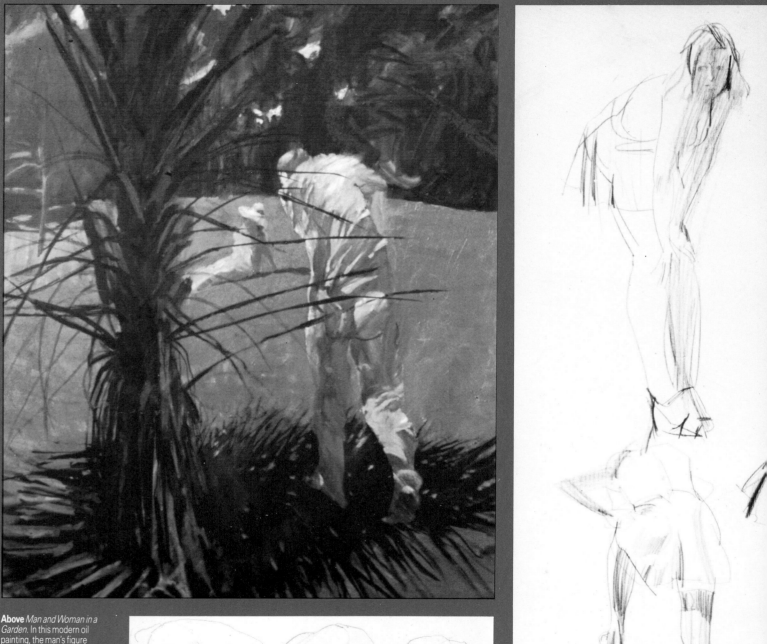

Above *Man and Woman in a
Garden.* In this modern oil
painting, the man's figure
emerges from the shadows into
the light, the sense of
movement created by the
broken outlines of the body as it
is obscured by the green of the
tree, and contrasting with the
absolute stillness of the woman
sitting in the full glare of the
sunlight.

Left *Runners on the Beach (No 2)*. The movement of these cardboard cut-out figures, deliberately depicted in a naive, semi-geometric style. is achieved by the several figures, all in obvious running positions, being crowded together, and by the juxtaposition of the colours.

Far left These three thirty-second pencil sketches of a girl taking off her stockings demonstrate how a few simple lines can give the impression of movement. Short poses are good practice, teaching the artist the ability to react quickly to small movements and forcing the description of instantaneous impressions while walking around the figure.
Left These rapid sketches show how the artist has captured the essence of the movement of the figure in simple lines.
Above *Girl Lying in a Window*. The artist has brilliantly captured the sense of the model rolling over, ecstatically kicking up her legs. The figure is placed within the yellow embrasure of a window, its darkish form outlined against the window and the gold of the cornfield, with the light falling on its contours. This painting, the result of much overpainting as the model's position changed, demonstrates the liveliness of the oil medium.

NUDE BY BALCONY
oil on hardboard 3 × 4½ feet (91 × 137 cm)

A board or wood support is solid enough to take a hard gesso primer without fear of the primer cracking as it would on canvas. The gesso ground, a mixture of whiting and size, is applied thickly in four layers, each layer being rubbed smooth before the next is added. Beneath this, rabbit skin glue size is applied in two coats and left to dry. In this particular work, the first laying in of colour was in oil paint, diluted with genuine spirit of turpentine. When dry, the surface was developed by overpainting, with a little more linseed oil added to the turpentine at each stage. The artist took care to leave certain designated areas, parts of the floor for example, completely white. The process of building up the colour, and elaborating and enriching using increasingly thick paint on subsequent layers, can be taken further by using stand oil instead of linseed in the later stages. If it is felt that some parts of a work are inconsistent with others because the colour seems to be "sinking in", then retouching varnish applied with an atomizer will bring any colour back to its true liveliness. This very diluted varnish can also be obtained in aerosol spray cans. It does not leave a harsh, shining surface to make overpainting difficult and is a useful aid when a picture has been left between stages for some time. This picture took some extensive compositional changes, making overpainting essential.

The initial oil painting is made with a limited range of colours. Cobalt blue and Payne's grey are used for the background, while shades of green and yellow are used for the figure and the main areas of shadow. A large proportion of the painting is left white to suggest the strong sunlight streaming through the open door. All the main shapes and relationships are established at this stage, but there is considerable scope for change (1).
Details are built up in all the background areas of the painting. A lace curtain is added at the window to the left of the picture; the artist is here experimenting with ways of balancing the strong diagonal created by the left arm as it slopes down to the floor. A vivid pattern is overpainted on the bed and a large pillow added behind the figure's head, easing the conjunction with the wall. These decorative details serve to create a surface interest on the blocks of colour (2).

1

4

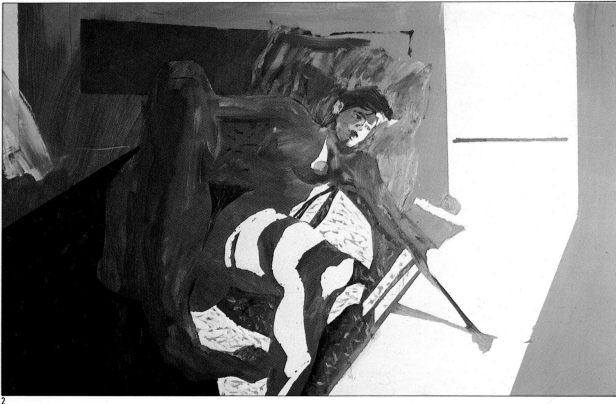

2

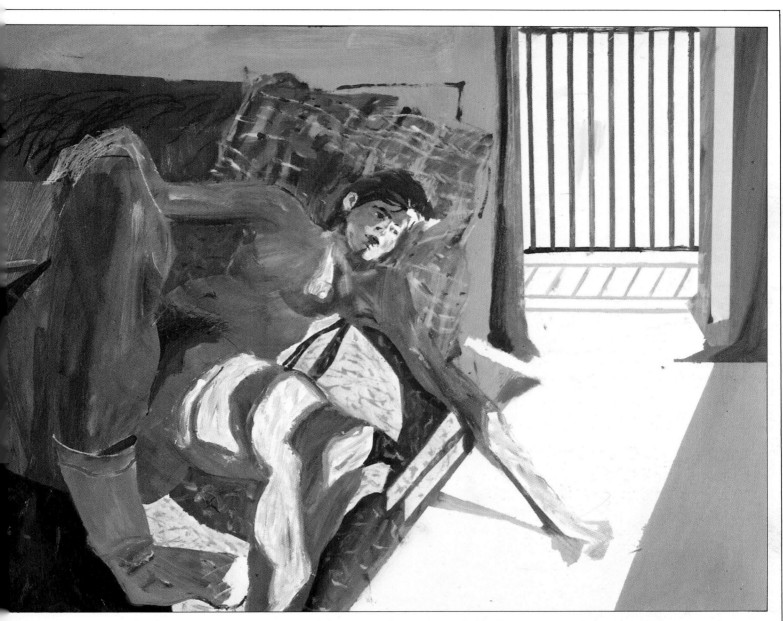

More detail is built up in the background of the picture. Strong vertical lines indicate the balcony railings; these are painted with the use of masking tape to ensure straight edges. Curtains elaborate the door frame and the lace curtain is extended up into the window area. The areas of white in the painting are almost entirely constituted of untouched, gesso-primed board; they maintain the high contrasts (3). The next stage of the painting begins to show evidence of a change in the artist's basic intentions. The red and yellow added to the highlight area on the left leg and arm suggest a later time of day in that the

intensity of the light has modified. The introduction of these colours alters the overall mood of the painting, softening it. The artist decides to remove the lace curtain and strengthen the window area to match the severity of the door frame. A hint of green in the view from the door suggests that further interest will develop here. The figure, too, is in the process of readjustment, with an attempt being made to interrelate arms and legs more closely. Such changes have a surprisingly dramatic effect on the overall atmosphere of the painting. Although the basic shapes have remained constant, additions to the colour range have altered

3

our perception of the monumental form of the figure and the shape of the highlights and shadows. The decorative details have also added a new dimension. One great advantage of painting in oils is that it allows for such major changes in emphasis; considerable experiment can be accommodated within one painting (4).

FIGURE IN CONTEXT

The context of a painting is, in a pure sense, any suggestion of a background or setting which locates the figure in space. It is possible to represent the figure without indicating surroundings, but when it comes to finished works, particularly paintings, artists are inevitably involved with some notion of context. The background may be abstract, even of a totally plain colour; more usually, the artist places the figure in a setting which gives an idea, sometimes very precise, of the world the figure inhabits. The details of the setting may also imply the world the artist inhabits, as they often provide essential clues to man's self-image at any one time, revealing certain moral and ideological preoccupations. In this country, in an age of relatively free expression, they tend to reveal the artist's personal viewpoint.

Artists have not always had the freedom to present the figure in any chosen manner, as is generally considered possible now. Social and moral constraints have at times proved too powerful to be ignored, and have often prevented artists from being honest or explicit. The artist of the Middle Ages was little more than the humble bearer of God's word. Since then, classical notions of beauty and the purity of the human form, derived from Greek representations of the body, have provided both an enduring artistic ideal and a convenient excuse for portraying the naked form during periods when such exposure was frowned upon. In the same way, religious, mythological or historical themes could be called upon to furnish safe backdrops for artists to display their primary interest.

In the Renaissance, the beauty of the human figure was openly appreciated as it had been in Greek and Roman times, although it was still felt that the themes of paintings, whether they included nude figures or not, had to be based in either myth or religion. Carrying this tradition into the nineteenth century, Jacques-Louis David (1748-1825) painted the nude figure with the notion that it was justifiable if the figure "represented the customs of antiquity with such an exactitude that the Greeks and Romans, had they seen the work, would not have found me a stranger to their customs". Under the patronage of Napoleon, the politically motivated work of this artist came to be highly influential, reflecting the new cult of devotion to duty and austerity in France at the time.

Another French painter in this classical mould was Ingres (1780-1867), who studied in David's studio. Despite the apparently detached quality of his work, he was an emotional and imaginative artist and came to be accepted as the champion of a classical idealism, completing works with titles such as *The Triumph of Romulus over Acron* (1812)

and *Apotheosis of Napoleon* (1853).

Two centuries earlier, in mid-seventeenth-century Spain, the great Velazquez painted his only nude, the *Rokeby Venus*. Spain was particularly slow in relaxing the strict moral code of the Middle Ages, and the work must have been considered severely shocking. In spite of its classical disguise which led Velazquez to add, as an apparent after-thought, a cupid holding up a mirror into which the reclining nude is looking, there is a freshness and lack of idealization in the painting. This is partly due to the unusual pose, with the figure seen from behind, which allowed her a freedom from coyness because the viewer is unapprehended. Mirrors are often considered useful props; they allow the viewer to glimpse the subject from another angle, so reinforcing the three-dimensional sense of space.

By contrast, in the mid-eighteenth-century French court of Louis XV, blatantly erotic

nudity was accepted and encouraged. Works by François Boucher and Jean Fragonard for example, show little attempt to render the indecent decent in mythological disguise; even the pretence of classical respectability was abandoned. These paintings reflect the taste for frivolity and exaggerated gallantry prevalent in the French court at that time.

In northern Europe the desire to be rid of pretence and disguise manifested itself in a different way, and led to a fashion in genre painting exemplified by such Dutch works as *Boy Removing Fleas from his Dog* by Ter Borch (1617-81) and *A Woman and her Maid in a Courtyard* by de Hooch (1629-83). The paintings of Jan Vermeer of Delft (1632-75) are in a similar style although they demonstrate his particular mastery of colour and the effects of light falling into a room. He often chose everyday, domestic scenes for subject matter, such as *Maid Servant Pouring Milk* or *Music Lesson*.

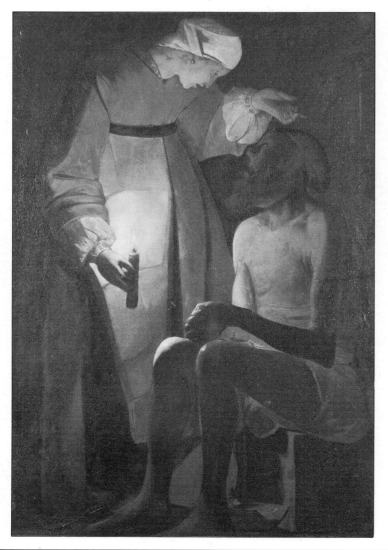

Left *Job Mocked by his Wife*, Georges de la Tour. The subject of this painting is not the figures, which would have little interest taken separately out of context, but the emotion expressed between them. This is emphasized by the single candle, its light creating a world for them and cutting out the background. Sympathy for Job's vulnerability is evoked by his wife's overbearing attitude and the gesture of her hand as well as his nakedness and low position. The simplified forms of this painting give it a deceptively modern appearance; in fact, they are often considered to reflect a revival of interest in the Franciscan way of life which took place in Lorraine, where de la Tour worked, in the early seventeenth century.

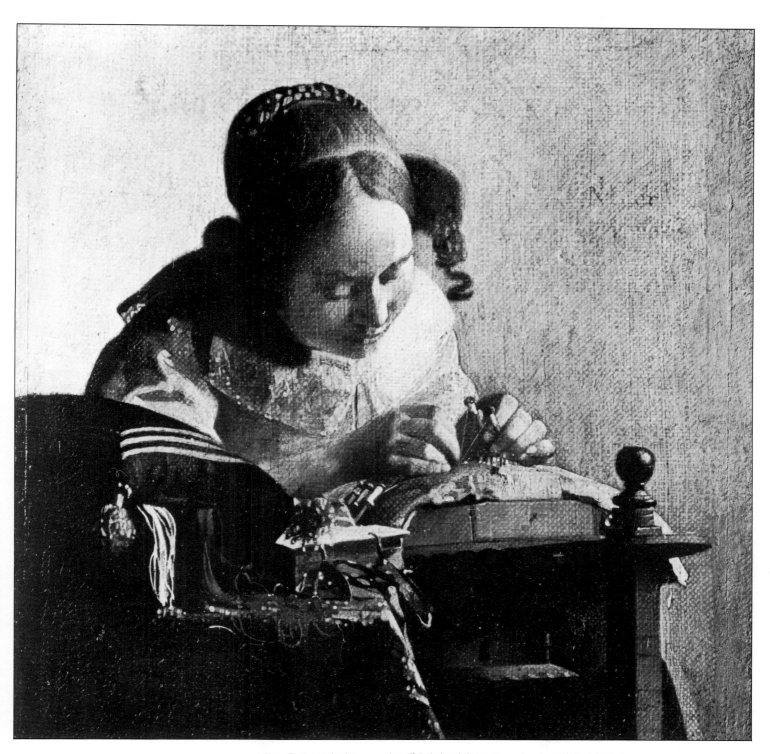

Above *The Lacemaker,* Jan Vermeer of Delft. The context of this genre painting is domestic, and the scene is informal and unpretentious, with the lacemaker's accoutrements scattered in seemingly haphazard disarray. The composition is, however, beautifully designed: the strong lines of her hair, collar and arms, of the cushion and the edge of her worktable are all directed towards her hands, to the action she is making, so allowing the viewer to share her concentration, as if sitting just in front of her. The portrait is charming and intimate because the subject and the setting are natural; it is a simple comment on the everyday life of a young girl.

A similar authenticism was propounded by the self-named Pre-Raphaelite Brotherhood painters in Victorian England. The founder members of this group, Dante Gabriel Rossetti (1828-82), Holman Hunt (1827-1910) and John Everett Millais (1829-96), stated their aim as a desire to return to a more natural life than the new enthusiasm for machinery allowed; their inspiration was the world of medieval romance. In their determination to present verity they worked a great deal from life and included careful detail in their paintings. Hunt, in particular, produced work of great seriousness and historical accuracy, even travelling to Palestine in order to give his pictures an authentic flavour.

Working at the same time in France was Gustave Courbet. He began painting in the age-old classical tradition that, in the shadow of David and Ingres, was still prevalent in early nineteenth-century France, but soon began to develop the individual style that was to cause an uproar among contemporary art critics. The classical tradition had grown stale, and much painting could be classified as either pedantically academic or sweetly sentimental; in reaction to this, Courbet set himself up as the leader of the Realist school of painting. He chose subjects from contemporary life, not excluding what was usually considered ugly or vulgar. He deliberately rejected the intellectual and premeditated approach to painting, preferring instead to react instinctively to the power of nature. He made numerous paintings on the themes of woman as an organic earth-mother figure, of the sea and of the fruitfulness of nature shown best by mighty trees at harvest time. He was a great believer in the joy and glory of life. However, by highlighting the plight of the ordinary working man and giving significance to mundane activities, Courbet was as good as asking for the inevitable abuse which continued unabated through much of his life.

Another painter whose work could be classed as Realism in a similar vein was Honoré Daumier (1810-79), although he was more politically motivated than Courbet. He used his paintings and caricatures to bring the plight of the poor into public consciousness, vesting the humblest of themes and the meanest of situations with weight and dignity.

The nineteenth century was a time of upheaval in Europe, mostly due to social and economic changes. Reflecting the turbulence, some artists assumed a similar role to that of modern photojournalists, deeming that art should mirror all aspects of life. Goya (1746-1828), a Spanish painter, produced the dramatic *Shooting of the Rebels on May Third*

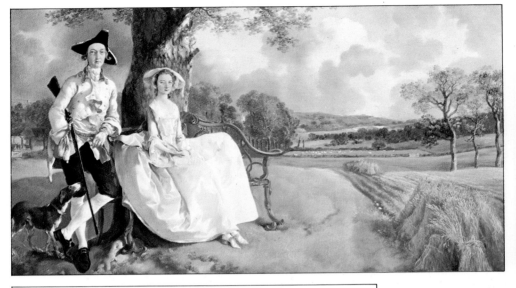

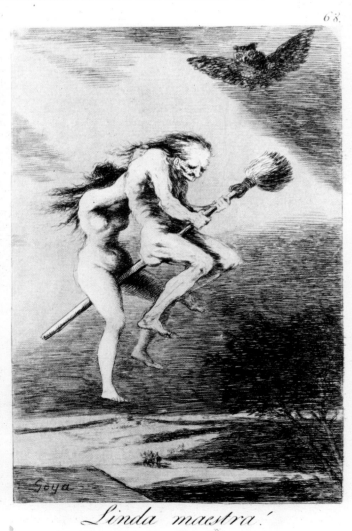

Above *Mr and Mrs Andrews,* Thomas Gainsborough. This painting of local gentry in a landscape setting has an elegant and carefree atmosphere. The richness of the countryside and the play of light over the grass enhance the context, and perfectly match the mood of the couple. Gainsborough's style was well suited to the pastoral fashions and tastes of the eighteenth century, and his artistry was much in demand.

Left *Linda Maestra,* Goya. The eerie, night setting of this bizarre etching provides an evocative background for an unusual subject. The coarse wispiness produced by the etching technique reinforces the texture of the witches' hair and the twigs in the broomstick. Despite a lack of detail, the weird and macabre impression is powerful.

Right *The Awakening Conscience* (1853), Holman Hunt. The Victorian setting of this picture is rich and colourful, full of strong, mixed patterns and ornate detail. Hunt's portrayal may be viewed as a realistic representation of a middle-class interior; however, the lavish detail may also be seen to make a mockery of the girl's position as the man's mistress, over-emphasizing her material gain at the moment that she realizes her folly. There is a strong moral emphasis in this Pre-Raphaelite painting.

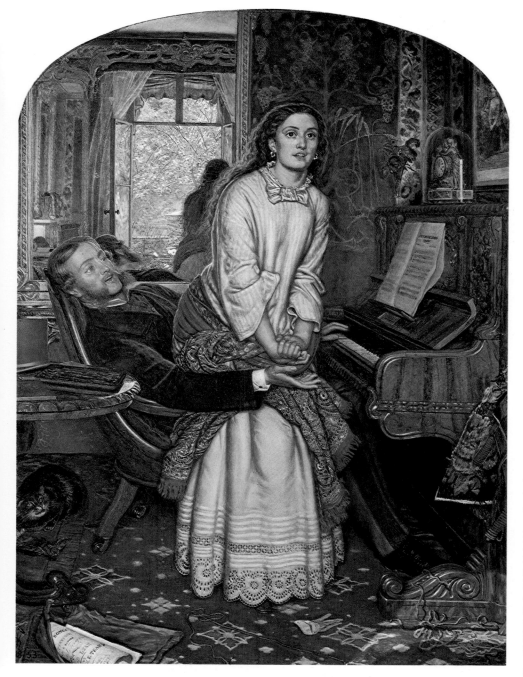

representing scenes of everyday life in cafés, restaurants, on the street, by rivers, in bedrooms, bathrooms, and dining rooms, and recent developments in photography led them to compose their pictures in a spontaneous and inconsequential manner reminiscent of the snapshot. Figures were often presented half out of the picture. But more important than the content was their technique. It had become known that all colour and form is perceived as a series of patterns on the retina, and the eye does its own colour mixing. Their aim was to recreate the brilliance of sunlight and the effects of light on local colour. The intensity of their colour harmonies was due to the use of complementary colours in the shadows. If the light part of an object was green, for instance, then the darker areas would display red. They expelled black from their palettes.

The direct and painterly way in which the Impressionists expressed their ideas and the vitality and freshness of their work created a new mood in painting. They were concerned with "truth", but they shifted the emphasis away from content. They wanted to take no moral or religious stand; it was therefore important to paint people or things where no meaning other than the purely visual impact was implied.

Because the eye can only focus on a relatively small area at one time, these painters were obliged to dispense with fine detailing in order to convey the general impression. Some of the Impressionists, Monet in particular, became so involved in the pursuit of the ephemeral effects of light that solid form became dissolved in the total atmosphere of his paintings.

Often the Impressionists' paintings of the nude figure are sensual but unerotic. This is largely because the quality of sensuality is as much to do with the handling of the paint and the artist's obvious joy in the effects of light as it is to do with the represented nature of the model. Even so, the sunlight dappling across female flesh in some of Renoir's paintings, and the delicate backlighting behind the nudes by Bonnard provide effects that are more tactile than intellectual.

Seurat (1859-91) took the Impressionist ideas to their logical extension – Pointillism. In some of his paintings, including *The Bathers*, he totally abandoned the use of colours mixed on the palette, covering his canvas instead with tiny dots of primary colour in varying combinations, leaving the eye of the viewer to mix them optically. He was also aware of the phenomenon of "irradiation", of any colour in nature being surrounded by its complementary colour, and used this theory in his pictures.

Seurat's "divisionist" technique involved calculating the quantities of various colours

1808 inspired by his resistance to French military rule which existed under Joseph Bonaparte between 1808 and 1814, and also produced 65 brutally savage etchings entitled *The Disasters of War*. David, who was in active sympathy with the French Revolution, painted three portraits of the martyrs of the Revolution – Marat, Lepeletier and Bara. These and other paintings are visual documentation of political events. Goya and David took Realism to an extreme, intending to record and shock.

With Courbet painting scenes from everyday life, and great scientific progress being made through the nineteenth century, the path was paved for the Impressionist painters, such as Monet (1840-1926), Renoir, Manet and Pissarro (1830-1903). Their struggle against classicism is evident in Renoir's *Diana* and Manet's *Olympia;* however, the most important aspect of their painting was their use of light and colour. This was a revolutionary, scientific approach to painting. They became famous for

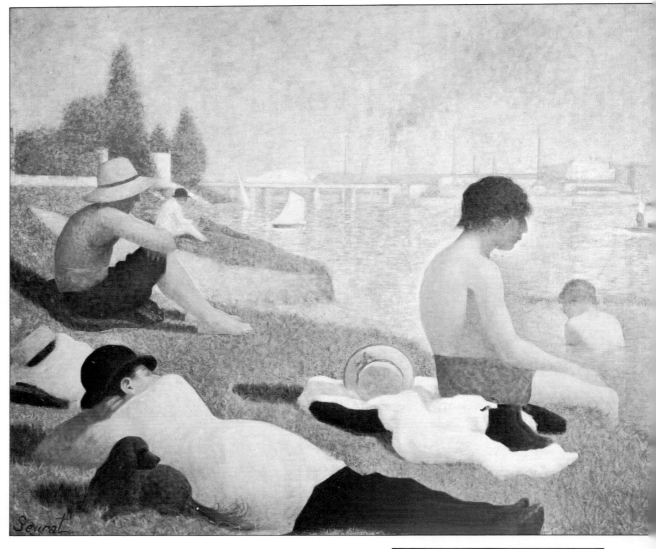

Right *The Bathers*, Georges Seurat. Partly as a result of reading Chevreul's book on colour theory (first published 1839) and Charles Henry's observations on the aesthetics of light, Seurat evolved his "divisionist" technique. He built up the figures in his paintings with a great number of dots or strokes of local colour combined with the colours from the sky and surrounding objects; in shadows he included the complementary colours of proximate areas of light.
Far right An illustration for *The Rape of the Lock*, Aubrey Beardsley. Recognizably in Beardsley's linear style, this black and white drawing displays some exemplary eighteenth-century details, such as the decorations on the table and the style of the wall mouldings, to place the figure in the context of the poem by Alexander Pope. The almost abstracted area of the gown, stippled with a floral pattern, makes a strong, flat contrast against the blocked-in floor.
Below right *The Restaurant Entrance*, Jean Louis Forain. Much in the style of Honoré Daumier, Forain delighted in making satirical comments on society in his paintings and drawings. Strong emotions are expressed in a few simple lines and washes in this watercolour painting.

present and placing them as separate dots on the canvas. The picture so produced had then to be viewed from the correct distance, when the dots would appear to mix and blend, achieving greater luminosity than would be possible had the colours been mixed on the palette.

Although Impressionism began as a lively and forward-looking movement, it quickly staled. The artists involved had so whittled down scientific naturalism to a purely optical matter that there was no further progress to be made. By the end of the nineteenth century, influenced by the real threat of the camera, there was a strong reaction against the idea that the artist is a copier of nature, and instead there was a feeling that the artist should use paint as a means of self-expression.

The paintings of Vincent van Gogh were dedicated to making people think and to

bring them to understand the comfort and warmth of love. He wanted to express through his paintings the universal power of light. He learnt from the Old Masters and from the Impressionists but eventually developed his own style, working from the observation of real things and real people, in a highly subjective manner. He simplified form and exaggerated the drawing and the colour. His real sympathy for the peasants who had to scratch a living from the land is apparent in the way he emphasized the squareness and solidity of a workman in order to give expression to the idea of hard labour. The warmth of his emotions and his reaction to the wonders of nature are expressed by his vibrant use of orange to represent sunlight. Like the Impressionists, he was fond of using complementary colours and found that he could set one off against the other to further intensify the emotional

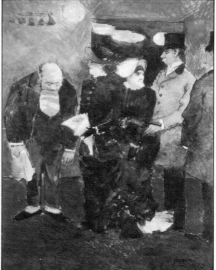

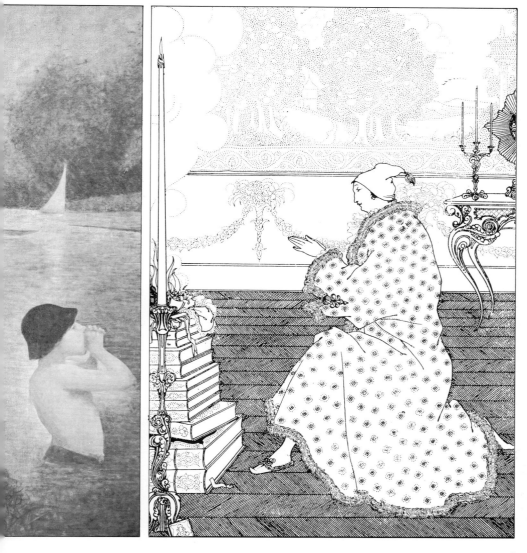

was indifferent to this subject, and produced large figurative works. Throughout his life he was obsessed by the theme of bathers. His early studies, which he made directly from the model, were coarse and frequently erotic. He attacked the canvas with great ferocity, laying on the paint in thick slashes with a palette knife. His unconventional approach to drawing prevented him from ever fulfilling his ambition to paint more academic nudes after the fashion of Delacroix. In his old age he painted distorted and stylized figures from photographs or from the imagination. His simplifications of the female nude, which often seem less than human, nevertheless conform to classical compositional devices. His large painting *The Bathers*, which he was working on in the years leading up to his death, has a triangular composition into which are fitted apparently clumsy and shapeless female figures. Cézanne defined form and structure by an infinite variation of tone, and space by the use of well regulated receding planes. If the underlying geometric structure sometimes makes his work appear severe, then the subtle variation of line and tone lend it a lyricism which has been admired and emulated ever since.

The Fauves, a group of French painters working at the beginning of the twentieth century, were so called because their treatment of day-to-day scenes was considered wild and animalistic. In their use of rhythmic line the influence of Cézanne can be discerned, but their use of bright colour and pattern was more cheerful and decorative. Their paintings of the figure were energetic and uninhibited. The aim was to produce compositions which were expressive as a whole without relying on details.

At the same time Georges Rouault was painting more violently Expressionist pictures than other French artists. He was a religious artist who is best known for the stained-glass effect of his paintings with bright colours outlined heavily in black. Between 1904 and 1910 he painted brutal pictures of prostitutes, corrupt judges and so on, using sour, dirty colours and shockingly incorrect drawing.

The development of graphic art has greatly influenced painting in this century. At the end of the nineteenth century, there was less of a distinction between "fine art" and "graphic art". Many important artists of this time were not only painters but also poster designers. The flat pattern quality which had been such a feature of the work of Gauguin and was being exploited so well by Matisse, Kandinsky (1866-1944) and Rouault, was particularly suitable for printed designs. Printing techniques, in turn, played an important part in the final decision to reject perspective in favour of surface shapes; this

content. By working in this purely subjective way, he found that his use of drawing and colour was becoming more symbolic and that this in turn was leading to a flattening of the picture plane.

Van Gogh's treatment of the human figure was one of sympathy and passion. His own anguish and suffering which led to his eventual suicide were expressed in his paintings as a feeling of isolation. He often painted single, stolid figures which seemed to suggest that they were more at home with the soil than with one another. The autobiographical element is strong in his paintings. He felt that what he had to say would only have significance if it was born of his own experience. It was this which led him to abandon ambitious themes such as *Christ's Agony in the Garden* and replace them with more personally relevant ones. His emphasis on personal feeling marked him out as one of

the forerunners of Expressionism.

Gauguin, also working expressively, did not use colour as a purely visual record of the effects of light. He was more interested in the way that colour can be used to evoke mood and emotion. Working with large areas of flat, unbroken colour, his pictures became mysterious and decorative designs. His paintings of the figure demonstrate an authority in drawing which was subjugated by his feeling for pattern and colour. The inherent savagery which is present in all his paintings, particularly his self-portraits, prepared the way for the Fauves.

However, the most influential Post-Impressionist was Paul Cézanne (1839-1906), who believed that personality could only be developed to the full when in close contact with nature. Although Cézanne is remembered for his sensitive treatment of landscape, in his early years as a painter he

Above *Mr and Mrs Clark and Percy* (1970), David Hockney. All the objects depicted in this scene are naturalistically represented to give a subtle impression of their volumes and their positions in space. There is a fine, lyrical quality to the white lilies. However, the lack of surface detail seems to imply that Hockney deliberately abstracted the forms, choosing certain features specifically and leaving others out; also that the objects themselves were deliberately chosen. The result is an inconsistent view of reality, an example of the artist's Expressionist style of painting. The Clarks were painted in their home, in a sunny and relaxed setting, with the viewer in the position of a guest.

Far left *Nevermore*, Paul Gauguin. With great sympathy for the subject, Gauguin painted this intimate portrait of a young girl asleep. All the paintings of his later life have an extreme individuality of style, partly because the subjects and landscapes are those of the South Sea islands where he lived, which, being so different from his native France, greatly influenced him. He painted the people and the landscapes not just for the sake of recording them, however, but also to record his reactions to the primitive lifestyle. He was sensitive to the tropical colours and unusual patterns and forms and incorporated them to create powerful images of natural innocence and simplicity.
Left *Harlem* (1934), Edward Burra (1905-1976). The city context of this watercolour painting was inspired by a visit that Burra made to New York in 1934. The vivid impression of the lifestyle of the native New Yorkers is conjured up by the brittleness of the medium and the juxtaposition of harsh and soft textures. The brick, tarmac, paving and iron contrast with the clothes, the blue jacket, pink shirt and green Homburg hat, and also with the fur. Simplified forms and a peculiar perspective which almost implies that the upper windows are stuck to the wall instead of being a part of it, are all part of the disjointed atmosphere.

Right *Shelter Scene,* Henry Moore (b.1898). The dreariness of waiting out the air-raids in shelters and underground stations during the Second World War is emphasized by the sombre colouring of this drawing. Despite the monumentality with which Moore characteristically imbues his figures, the setting is crowded and a feeling of claustrophobia is implied by the heavy, overlaid lines.
Far right *The Call of Night,* Paul Delvaux (b.1897). The dreamlike quality of this painting by the Belgian artist who was influenced by de Chirico and Magritte, is typically Surrealist in style. The references within the picture, despite being meticulously painted, are denied any consistency and therefore coherence. The picture describes a totally unrealistic and contrary scene, for example, the trees are bare while the nudes are growing long bushes of leaves from their heads. The viewer is mystified and prompted to question reasons for the existence of the objects and the relationships between them.

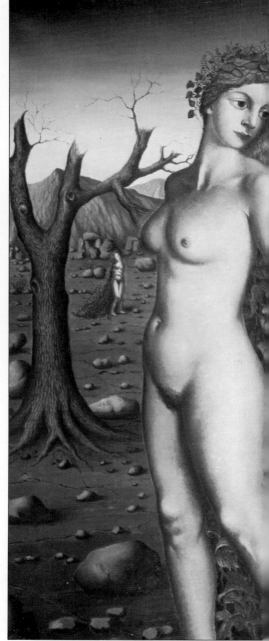

led inevitably towards total abstraction of form. Artists such as Henri de Toulouse-Lautrec and Aubrey Beardsley (1872-98) were primarily interested in the figure but represented it in a way which was already halfway towards the abstract. Beardsley's black and white drawings use elongated and attenuated forms and contrast large and simple shapes with areas of fine detail. Toulouse-Lautrec dispensed with modelling in depth in favour of emphasizing the surface plane. His use of the calligraphic line and bright splashes of colour produced images which are both decorative and sensitive descriptions of the human figure.

As artists experimented with new and exciting media the distinction between painting and sculpture became less obvious. Cubism, developed at the beginning of the century by Pablo Picasso and Georges Braque (1882-1963), became, in its final stage, a mixture of drawing, painting and collage. The Cubist method of treating the composition as an arrangement of geometrically shaped planes related to the rectangular plane of the picture was a clear influence on abstract art, but however abstracted their work became during certain periods, Picasso and Braque never lost interest in the human figure as a source of inspiration.

Picasso treated the backgrounds of his Cubist paintings in the same way as the figures. The form is fragmented and so is the space, making it difficult to translate. But Picasso does provide visual clues which help the viewer to recognize his familiar environment in the painting. In *Les Demoiselles d'Avignon* the figures are surrounded by what, at first, seem to be incomprehensible shapes. Then at the bottom of the canvas is a small still-life of fruit: a melon, pears and grapes. Suddenly the figures seem to be enclosed by folds of drapery, which are perhaps curtains. The eye and brain demand meaning from the visual work and where something is not fully explained, the imagination takes over.

The abstraction of some of Henri Matisse's paintings often does little more than give an implication of surroundings. In *The Dance,* for instance, there is no more than a simple division of the canvas into two shapes. In the lower half is a mound-like form which can be seen as a grassy hillock, although the only real basis for presuming as much is that it is coloured green. Similarly, the rest of the canvas is a deep and intense blue, which may be the sky. The conventions of childhood insist that grass is green and sky is blue and the instinctive reaction to these colours being used in conjunction with the figure is to interpret them accordingly.

Some painters choose to keep the background simple but to include certain selected items almost in the way that a stage director uses props to set the scene for a play. Otto Dix (1891-1969), whose work is particularly interesting because he used mixed media including egg tempera, employed this contextual device. He painted figures against a background flooded with almost flat colour, and then included a small number of pertinent details: a carefully painted marble table top, a cocktail glass, a box of matches, a packet of cigarettes. All the details are rendered with precision and are

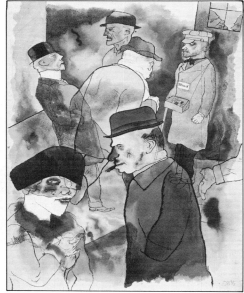

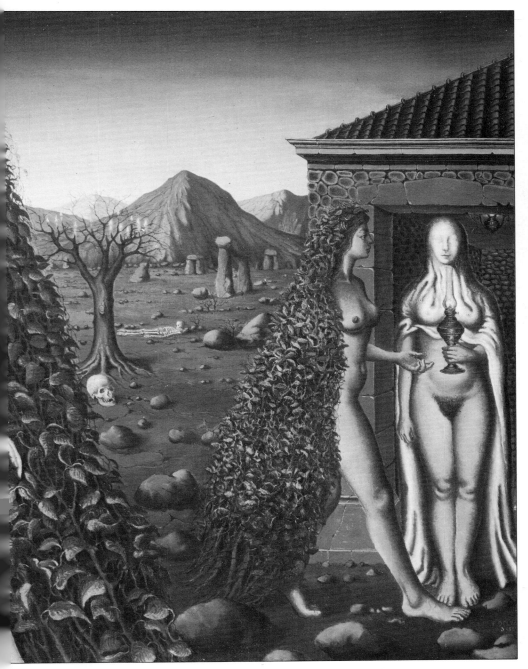

Above *Dammerung 22,* George Grosz. Strong reactions to Germany's social corruption prompted Grosz to draw brutal caricatures; society reacted by persecuting him with some frequency for insulting public morals. This watercoloured drawing ironically juxtaposes two people of questionable character conversing in the foreground with a veteran who is forced to sell matches for a living.

chosen because they are immediately evocative of a particular atmosphere.

Cézanne and Matisse were both fascinated by bathing figures, and the backgrounds they included often gave only minimal information. An indication of a tree or a suggestion of figures dressing or undressing are sufficient to suggest the subject matter. David Hockney (b. 1937) has continued this technique using Beverley Hills swimming pools as the background for a number of his paintings. Again, there is not a great deal of visual information. He fills his canvas with large areas of blue and white, finding hard-edged shapes in the ripples and splashes of water.

Surrealist painters, by contrast, used deliberately complex backgrounds to suggest eerie and mysterious atmospheres with no firm and comprehensible linking references. De Chirico (1888-1978) produced strange effects using strong tonal contrasts and several eye-levels. *Secret and Melancholy of a Street* shows a solitary girl playing in an empty street, but at the far end an unseen figure casts a long shadow across her path. Painters such as Magritte (1898-1967) placed their figures in incongruous situations to create similar feelings of discomfort.

Artists reflect their personal vision in paintings, but also the age in which they live. Some artists are aware of the need to place figures against a truly contemporary background. This idea directly opposes the idea behind abstract paintings which contain no particular reference, so implying a universal context. The problem of creating contemporary settings is much greater now than ever before, as objects and styles become dated and tend to look old-fashioned increasingly quickly against the pace of progress. By including a symbol of the modern age such as a television, which was used by Richard Hamilton (b. 1922), a modern atmosphere can be conveyed. However, changing styles of interior decoration make it easy to date a television from the 1960s, and a painting becomes emphatically out-of-date because of the very technique used to create the opposite effect.

One solution to this problem, which might be considered a gimmick, was found by the artist Michelangelo Pistoletto (b. 1933), whose pictures of life-size figures are painted onto a mirrored surface which reflects the surrounding space. In this way, the figures are always in a contemporary context.

SEATED NUDE BY WINDOW
pastel and chalk on paper 20 × 15 inches (51 × 38 cm)

Pastel is a delicate medium, providing a range of brilliant colours and the possibility of working one over others until the result almost looks white. Chalks are more incisive, harder and produce fine lines, allowing the artist to draw with a vigour impossible in pastel. Both these media allow the artist to work light over dark and make changes or adjustments while work is in progress. Models are likely to move, however subconsciously or surreptitiously, while they are posing, and in order to keep the picture alive, the artist must be able to respond to these changes. Often, a particular pose will not suit a model and he or she will move to a more natural, comfortable position. This encourages the creation of more natural and lively drawing. Such changes need not totally obliterate the original work.

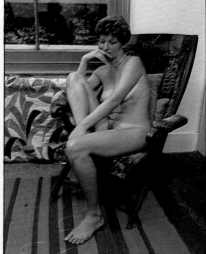

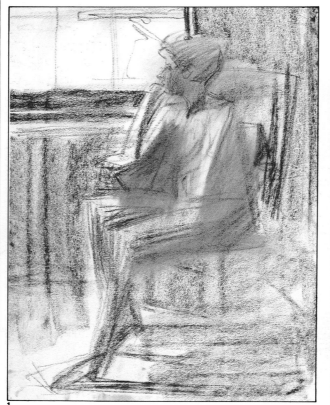

1

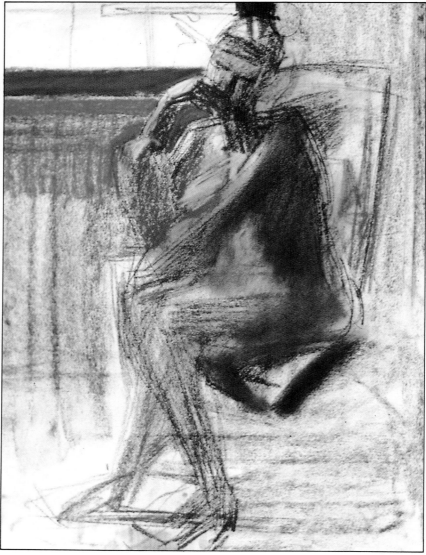

2

The model's first pose, with both feet touching the floor and her head twisted to look out of the window, proves uncomfortable, and despite the initial drawing already being established, the model moves to a position in which she can relax. The two strong lines of her back and her left leg need only slight readjustment and the positions of her neck, head, arms and right leg are changed, although the points of reference remain constant. The first sketches are made in blue pastel, the artist feeling for the pose and quickly relating angles and positions (1, 2). With some solid work in shades of blue and red, areas of the figure are shaded and the form fills out.

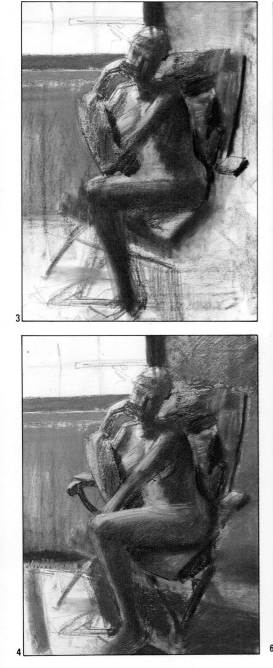

3

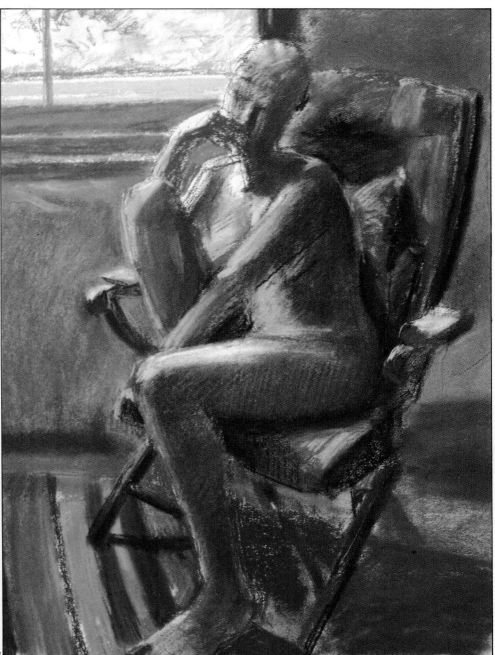

6

4

The whole picture is worked using a complex system of laying and overlaying colours in different combinations, so that the underlayers show through. The result is an overall sense of unity and a subtle feeling for form. Positive background shapes are laid in blocks of colour (3).
The patterns of the background cloth are ignored, and a single colour is implied, with brighter pastels used nearer the light source. Using the heavier

chalks, earth reds and browns are added to bring out the form of the figure, and build up the arm of the chair over the background blue (4).
Chalks and pastels combine for the bold stripes of the carpet, which provide a tension with the diagonal of the chair. White and yellow highlights in both pastel and chalk, which is illustrated in this close-up (5), give a strong impression of the indirect sunlight falling into the room. Some of these are blended and

smudged into the colours beneath, with further lights added in the final stage. Hatching with contrasting pastels over the already blended and fixed colours creates final subtle shading. Indigos and blues are used over the left thigh, and pinks over the chest and left arm (6).

5

NUDE ON GREEN BED

oil on canvas 3 × 4½ feet (91 × 137 cm)

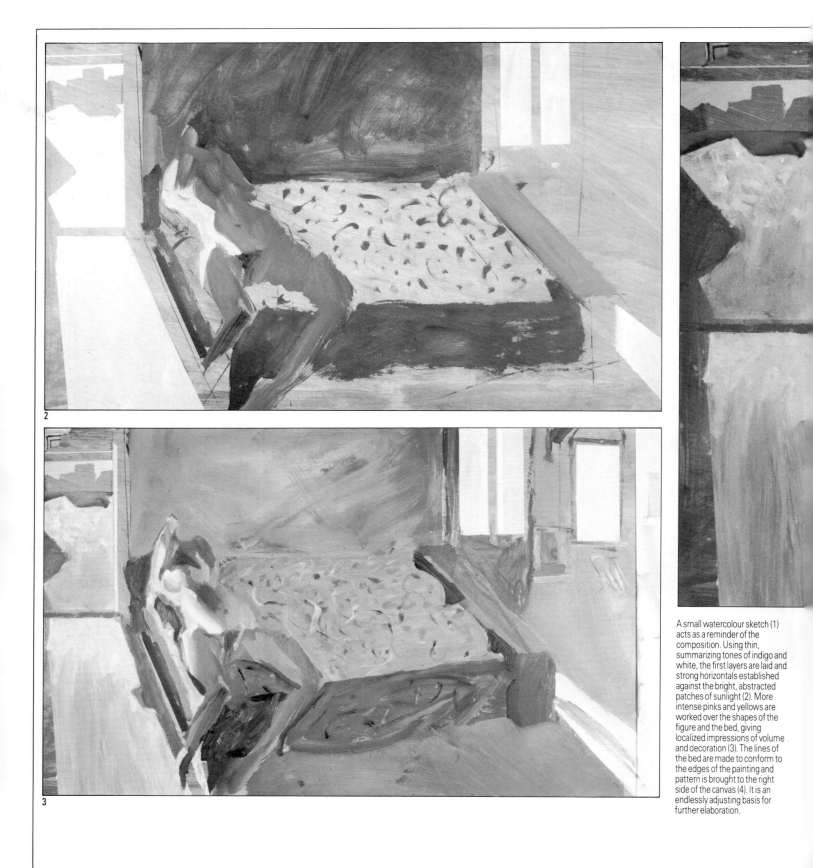

A small watercolour sketch (1) acts as a reminder of the composition. Using thin, summarizing tones of indigo and white, the first layers are laid and strong horizontals established against the bright, abstracted patches of sunlight (2). More intense pinks and yellows are worked over the shapes of the figure and the bed, giving localized impressions of volume and decoration (3). The lines of the bed are made to conform to the edges of the painting and pattern is brought to the right side of the canvas (4). It is an endlessly adjusting basis for further elaboration.

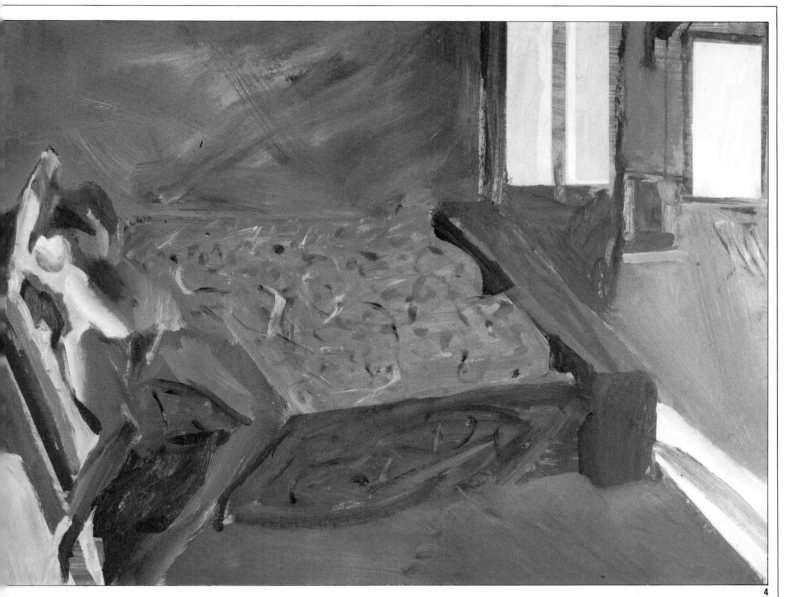

4

1

Making a sketch in watercolour to record information about a situation is an efficient way of preparing for an oil painting, particularly if the subject or the light is transitory. It also helps the artist to establish tonal values spontaneously and decisively as watercolour is a more demanding medium in this respect, changes being difficult to make after a wash has been laid.

Later, using oils on a fine, well-primed canvas, the artist decided to change the composition of the painting from the vertical proportions of the original watercolour to the horizontal, while also reducing the size of the figure in relation to the size of the support. By using a long horizontal, a feeling of calm relaxation is gained, reflecting the pose of the nude girl, and the composition balanced by the addition of a light-source on the right. Basic decisions regarding shape and size of supports should not be lightly dismissed, as emotional reactions to different proportions vary. The shape of a tall, gothic spire, for example, often suggests an urgency and symbolizes high ideals or aspirations. The square, the circle and rectangles of all proportions carry inescapable emotional associations, often dependent on individual experiences. Similarly, particular compositional rhythms are better suited to particular overall shapes. A simple rectangle to the proportions of one to two, or two to three, suits strongly structured surface patterns using diagonals. Such compositions bring with them noise and energy, which is in marked contrast to the calm and quietude employed in this work. The mood is enhanced by the use of a limited palette.

GIRL BY WINDOW WITH BLINDS
watercolour and gouache on paper 18 × 28 inches (46 × 71 cm)

The pose is arranged to obtain a quick study of light quality. The upper part of the model, leaning against a cushion, is silhouetted against a white wall. The hard lines of the Venetian blind form diagonals and contrast with the softer shapes of the bed and the figure of the model (1). The first ideas of the composition are mapped out lightly in watercolour on fine-grained Ingres paper stretched out on a board with a gum strip (2).
The green sap of the trees is painted over the broken brown lines which show through the watery green wash, emphasizing the dissolution of forms in light (3).

This is an example of watercolour being used, mostly in its pure form, to describe the effects of light in a bright and airy room. The white of the paper shines through the thin washes giving the painting a luminosity which also existed in reality.

Attention is divided between the window and the figure, both potentially being the subject. Light-sources are often more difficult to control inside the picture than outside when the effects of light can be exploited without including a dominating rectangle of light. However, including a window or open door presents a large number of challenging compositional structures and effects.

Here, the artist holds the shape of the window by enclosing it in darker tones, the window itself being mainly represented by the untouched white of the support. The strength of this image and the shimmery effect of the blinds provide a strong basis, allowing the painter to present a sympathetic interpretation of the seated girl in the interior.

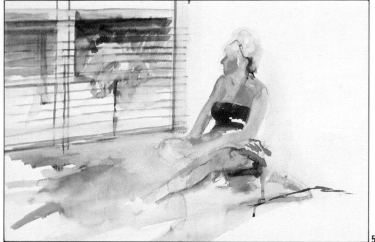

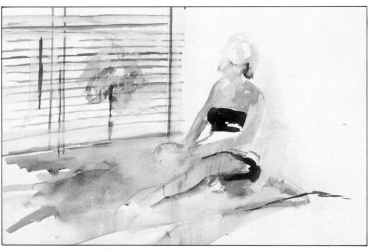

The two basic themes, the shimmering effect of light on the trees through the blinds and the light on the bed and the model, are elaborated by building up thin washes of blue and flesh tones. Verticals are added to create space and structure (4).
A strong slate blue wash is painted in at the top of the blind with lighter diagonals below, forcing the light through the lower half of the window. Broad areas of cadmium orange are applied to establish the body and the vermilion skirt begins to appear (5).

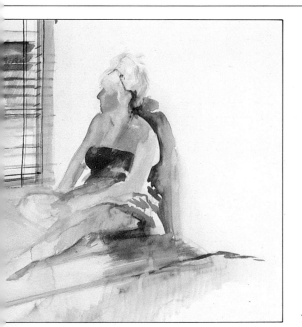

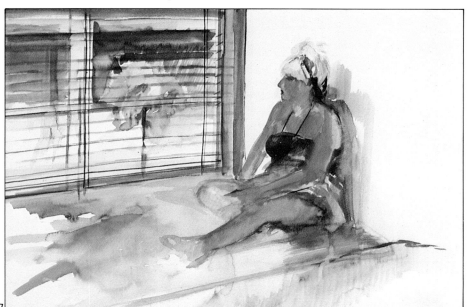

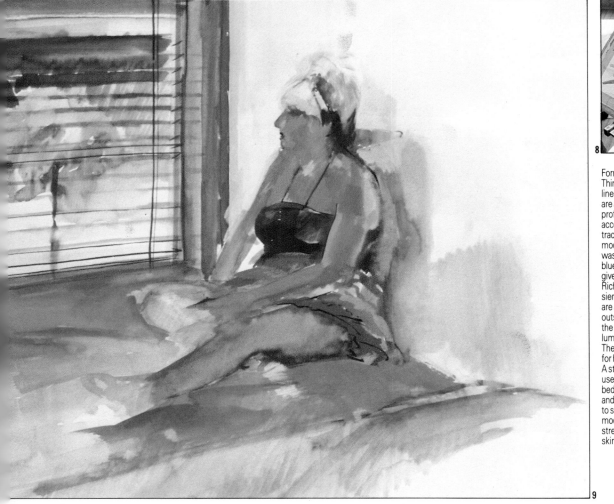

Forms are made solid in space. Thin black vertical and diagonal lines and a stronger brown one are added to the blind. The profile and upper arm are accentuated and a strong line traces the contours of the model's left side. A slate blue wash forms her shadow while a blue wash with a striped effect gives the bed height (6).

Rich strong flesh tones in raw sienna, plus white in the face, are applied to the body. The outstretched leg is modelled, the white of the paper giving luminosity (7).

The artist adds gouache white for highlights (8).

A strong blue gouache wash used with white establishes the bed. Further shadow is built up and deep pink flesh tones added to strengthen the body's modelling. More vermilion and a streak of lemon are added to the skirt (9).

DRAWING THE FIGURE

Characteristics of Drawing

The dictionary defines drawing as the art of making pictures with pencil or pen and ink. This is a perfectly adequate explanation, but drawing can be both much simpler and much more complicated than that. Any mark, made deliberately onto a flat surface, even if it is only a line drawn into sand with the finger, can be described as drawing. At the same time, the distinction between drawing and painting is not always clear. As a general guide, drawing can be distinguished from painting because the former is primarily concerned with line while the latter has more to do with tone and colour, even though many drawings contain elements of all three. A painting, however, often makes use of tone, colour and form to create a total illusion; to make the viewer believe, momentarily, that the frame of the painting is a window through which the painted scene can be observed as if it existed in reality. A drawing is much more a statement about reality than it is an attempt to copy it. Although an artist may represent three dimensions in a drawing by using solid modelling, many drawings are nothing more than a simple outline which separates one area of the paper from the next. The space defined and enclosed by line in some mysterious way takes on a dynamism of its own; existing in a self-imposed context.

While it is this linear quality which helps to distinguish drawing from painting, the line also distinguishes drawing from reality. In real life nothing has a line drawn around it. Things can be perceived because they are made up of solid, light-reflecting masses. Their apparent outlines change as either they, or the viewer, move from place to place. The drawn line is a visual symbol, standing for the difference between a solid shape and the space surrounding it. It is not the line which receives attention, but the shape of the space or mass which it implies. Even so, the line does have a quality of its own and this inevitably influences the feeling of the drawing. Paul Klee (1879-1940) talked of "taking a line for a walk" and was very aware of its intrinsic energy. By experimenting with different drawing media it can soon be seen that even an abstract line has a character of its own. A line drawn with a stick of charcoal will have a vigour and urgency that cannot be suggested by a delicate pencil.

Most people see drawing as a form of visual record or a type of documentary. This categorization encompasses everything from the briefest of sketches, intended only to note an idea for later development, to finished studies. Michelangelo made hundreds of drawings to investigate the figure in different positions and from different angles. Despite the fact that these drawings were part of the process of painting and sculpting, they are also works of art in themselves. Similarly, Rembrandt, Rubens, Raphael, and many others made numerous studies of the head. While these may have been made with particular paintings in mind, the studies demonstrate powerful artistic curiosity. This type of drawing is a way of finding things out, of seeing how they look, of discovering how the quality and intensity of a line can be used to interpret the texture of surfaces.

However, in order to understand more about the nature and power of the line, it is worth examining different types of drawing where the line takes on a special significance beyond its capacity to define forms in space. Cave drawings, picture languages and the stylized drawing of children all help to demonstrate the more expressive aspects of the line.

The oldest works of art which survive are drawings. Examples in France and Spain, dating back to the paleolithic period, include animal figures drawn onto the walls of caves. These drawings were probably made with lumps of earth or clay which may have contained traces of minerals such as iron oxide or may have been burnt to enrich the colour. The exact purpose of these drawings is not known, but it is assumed that they were part of the ritual of the hunt and it has been suggested that by marking the image of a creature on the wall, primitive people felt that they had gained power over the beast or tamed it in some way.

Drawing has also played a large part in the development of the written language. Some scripts today, such as Chinese, still retain a pictorial quality. Early writings, such as Ancient Egyptian hieroglyphics, closely resemble strip cartoons. The Egyptians made little distinction between their paintings, which were really coloured drawings, and writing. The purpose of their tomb paintings was to convey information, not to create the illusion of reality. Egyptian sculpture and some of the less formal paintings show that they were quite capable of imitating real life, but this was not their principal intention.

In the light of these "primitive" examples, it is interesting to trace the development of drawing ability in children. When infants first begin to express themselves using paper and pencil there are certain typical stages through which they pass. The basic urge to draw appears to be instinctive; children with no paper or pencil will use sticks and stones to scratch marks on the ground. Not until they are much older does it occur to them that the marks they make should bear any resemblance to reality: a young child draws simply to make a statement. Nevertheless, children are selective and everything that is represented has a special significance.

Many studies have been made of the early years of a child's development and it has been suggested that the first thing a child learns to distinguish is the face of its mother. Later, the overwhelming fascination of this face is represented in simple terms when the child begins to draw. First pictures of "Mother" often consist of a large circle containing smaller circles indicating eyes and mouth.

Right The earliest surviving works of art are pictorial. These Ice Age paintings were found in the caves at Lascaux in southern France. Many of the figures are grouped and the scenes apparently anecdotal in character. Hunters and bisons, drawn in a strong curvilinear style, move across the wall in a mysterious ritual, their execution both artistically and technically of an extremely high standard.

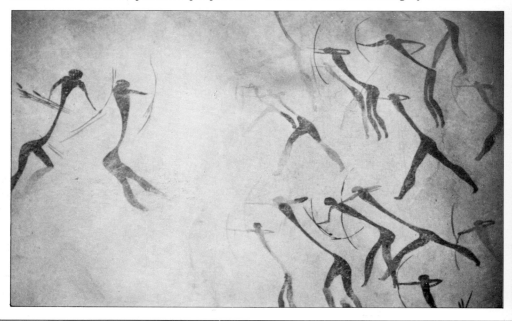

Children's drawings
Drawing is the child's first artistic creation and is his instinctive response to the visual world. His first visual reality will therefore be his mother's face, and as this two-year-old's drawing shows, the eyes and nose are of particular significance. Single lines are used to represent the legs and feet (1).

As the child's visual and mental perception develops, so does his ability to note down what he sees. This drawing by a five-year-old includes more details. Note the preoccupation with the hands, particularly the differentiation between the thumb and fingers (2). The awareness of his hands is probably due to the fact that children of this age learn many new manual skills, particularly writing.

2

1

3

This drawing by a child of two and half years shows the figure contained in a mandala form, the age-old instinctive way of representing the human figure, perhaps a security motif. The child has balanced the design by adding arbitrary squiggles (3). The more developed drawing, by a thirteen-year-old, shows a strong awareness of composition, and an acute observation of everyday things, such as the necklace, lamp and bottom of the table. A good attempt has been made to depict the fingers realistically (4).

4

The power of this image is such that, at this stage, the child will often make no attempt to include the body.

The next typical stage is the drawing of the figure where arms and legs are shown radiating from a circular head. Again, the elements which are included reflect their importance at this point in the child's development. Someone who has only recently learned to walk will be very aware of the function of the legs. The child records this milestone in his development by acknowledging limbs on paper, usually with a single pencil line, but often culminating in big feet. Similarly the hands, over which the child has only imperfect control, may be disproportionately large in his or her drawings.

Like paleolithic man making pictures of animals in order to assume control over them, children attempt to reinforce their identities through drawing; in this way, they can exercise control over the environment in the act of recreating it. As children become more aware of surroundings, other elements begin to appear in the drawings. Sky and ground are often represented by two lines, one above and one below the figure. Sometimes a single line is used which completely encloses the figure in a secure mandala, a feature which has been observed in the drawings of children of all races, both primitive and civilized. The implications are fairly obvious: the child is using the line drawn around the figure as a symbol for security, a protection against the unknown.

The way in which children draw figures in action is often interesting. A running figure may be drawn with legs which are no different to those of a standing figure, except for the fact that they are twice the size. In a manner reminiscent of medieval painting, the child is drawing attention to the function of the legs by enlarging them out of proportion to the rest of the body.

It is not always easy to interpret children's drawings except by being present while they are being made. Children usually draw attention to the significance of marks they make, although they may later forget what the marks were supposed to represent. Usually they do not take more than a few minutes to complete each drawing and once it is finished it will be set aside and forgotten. It seems as though the actual process is of far greater importance than the result.

It is only as the child grows older that he begins to want to make drawings which are less subjective and more a literal imitation of the visual world. This comes partly as a result of observations of other people's drawings and paintings. It is also at least partly due to the expectations of adults who will ask, "What is it meant to be?" and will even call upon the child to justify the contents of a picture. It is then that it becomes important that it should fall within the conventions accepted by the adult world. A child who has quite happily portrayed "Mother" with a frizz of red hair when really it is straight and dark will suddenly see the drawing as "wrong". At this stage, the naivety of the child's drawing begins to be replaced by sophistication, but many artists have tried to recover the naive quality of children's drawing in their own work.

Just as when children draw they are not seeking to imitate reality but to say something about it, so artists may choose to concentrate upon a particular aspect of their subject matter. If they are interested in facial expressions then their drawings will not be the same as if they were interested in investigating anatomical features. At its most extreme, this preoccupation leads to exaggerated caricature.

The drawings of George Grosz (1893-1959) are sensitive and emotionally charged representations of some of the less desirable of human characteristics. Nobody would suggest that his drawings attempt to portray

Right *St James Led to his Execution,* Andrea Mantegna (1431-1506). Mantegna first worked in Padua, the centre of Humanism in north Italy, which helped to determine his style. His knowledge of classical archaeology led him to depict the human body on a monumental scale, sculpturally modelled with archaeological precision. In this sketch for the destroyed fresco in Padua, the figures are well placed in relation to each other, showing Mantegna's preoccupation with design, and movement is rendered by the strong verticals and diagonals.

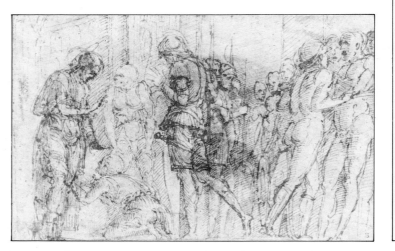

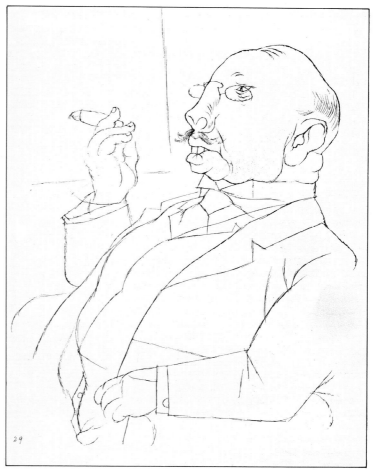

these qualities through lifelike imagery. The manic and savage expressions of his characters are conveyed almost entirely by line, the occasional suggestion of tone being incidental to the linear quality. The variety and intensity of the line makes his work very expressive. Grosz people are animalistic in their desires and fears, both of which are nakedly apparent on their faces. Although his drawings are humorous in tone, Grosz illustrates the human condition in a peculiarly realistic way. The fact that this "realism" is not photographic does not in any way detract from the significance of the drawing. In fact, the language chosen to convey this particular message is exact, apt and evocative of the seedy world his characters inhabit.

Drawing is a highly subjective activity; the way in which different people draw is as recognizable as their handwriting. The finished work is partly an objective record of what artists see and partly a record of how they feel about what they saw. This instinctive response to the visual world is as different and various as there are individuals; this is one reason why there is always something new to draw.

Left *Death Cycle: Death Holding a Girl in his Lap* (1934-35), Käthe Kollwitz (1867-1945). In this lithograph, the artist has achieved a marvellous marriage between subject and technique, the sweeps of expressive line and areas of dark, heavy tone creating a strong sense of pathos and compassion. A graphic artist and sculptor, Kollwitz lived in the slums of Berlin and her work displays her concern in emotive line.
Above *Face of a Man*, George Grosz. The apparently simple, fluid lines of this caricature display a consummate knowledge of draughtsmanship. Each line is made up of short, broken strokes which imbue the well-observed portrait with energy, and exude Grosz's hatred of the bourgeoisie.

Paper

The choice of drawing materials available to the artist is very wide and an enormous range of effects can be achieved. The first consideration must be the sort of ground which is to be used. Since the time of the first drawings, executed on the walls of caves, man's ingenuity has brought all sorts of improbable surfaces into use. Clay pots, notably those from Ancient Greece and Rome, were a favourite recipient for the drawn mark and today provide evidence of the life of those civilizations. Wood, bark, leaves, papyrus, silk, vellum and parchment were all used as drawing surfaces by primitive peoples. Precious metals, stone, shell and wax tablets all have had designs engraved upon them.

Paper, however, remains the most common choice. It provides a good and regular surface for drawing, is relatively cheap and readily available, and is convenient and easy to transport. Although most drawings are done using a dark line on white or light-coloured paper, there is no reason to abide by this convention. It is also possible to make drawings onto dark paper using a variety of implements, such as light-coloured pencils, pastels, chalks, crayons or pens with white ink.

Paper has not always been the inexpensive and easily available commodity it is today. The first known use of paper was in China as long ago as the second century A.D. Its use gradually spread through Islam and Byzantium until, by the thirteenth and fourteenth centuries, it was available in certain parts of Europe.

Papermaking was a skilled craft which involved pulping fibres of vegetable origin in water, which was sometimes mixed with some form of adhesive binder. The fibres were collected on a perforated frame and then allowed to dry. It is only comparatively recently that wood-pulp has replaced other vegetable fibres to become the most commonly used ingredient in papermaking. More expensive paper is still manufactured from fine linen or cotton rag, and silk and rice paper continue to be made, mostly in Japan and China.

Paper is available from stationers and art suppliers in standardized sizes and a variety of weights and surface textures. The old paper sizes, now partly replaced by A sizes, were Demy (20 × 15½ inches), Medium (22 × 17½ inches), Royal (24 × 19 inches), Imperial (30 × 20 inches), Double Elephant (40 × 26¾ inches) and the enormous Antiquarian (53 × 31 inches). With the new system of A sizes, each measure is half as much again as that of the previous one. The categories range from AO (841 × 1189 mm), through the popular A4 size (210 × 297 mm) to A10 (26 × 37 mm). This means that although paper sizes may vary, proportions are always the same. Some people might consider this a disadvantage. There is no reason for the artist to accept these standard sizes and formats as they are. It may be that a particular subject would be better drawn on a piece of paper that was more square in proportion or more oblong. Large sheets of paper can easily be cut down into a number of smaller ones offering a variety of formats.

The three most commonly available paper surfaces are: Hot Pressed or HP, which is smooth and shiny; Cold Pressed or Not (meaning *not* Hot Pressed) which has a medium smooth texture; and Rough, which is often handmade and preserves the natural, granular surface. Today, paper is usually bleached or artificially coloured and fillers such as chalk are used to improve the surface. Hot Pressed paper is ideal for drawing in pen and ink because its smooth surface allows the pen strokes to move across the paper without impediment. For pencil work, the slightly rougher texture of Cold Pressed paper is usually considered to be preferable, while the surface of Rough paper is at its best when used for the broader strokes of chalk or charcoal.

Although paper is a fairly cheap material, particularly in relation to the other types of surface, the price and quality can vary a good deal. Cheaper paper is perfectly acceptable for everyday use, but bears no relation to the quality of good handmade paper, which is naturally much more expensive. Many qualities of paper come in a choice of shade and colour, with quite a wide range available. The choice will depend very much upon the sort of drawing to be done. A drawing which emphasizes linear aspects or dwells upon detail would be better on a white or pale neutral paper. Tinted papers are best used for tonal drawings as this will allow both the light and dark areas to be positively defined against the mid-tone of the paper. Some draughtsmen respond better to one type of paper than another. Experimenting with different types of paper is well worth the effort and time.

For a pen and wash or a watercolour drawing it is often better to stretch the paper. This is done by soaking the paper for a short time in cold water and then attaching it to a drawing board with drawing pins or gummed paper strips. As the paper dries it acquires a taut, drum-like surface which is pleasant for drawing on and does not wrinkle when wet paint or ink is applied.

Media

Charcoal

One primitive drawing implement which is still popular today is charcoal. In earlier times, stubs of charred wood would have

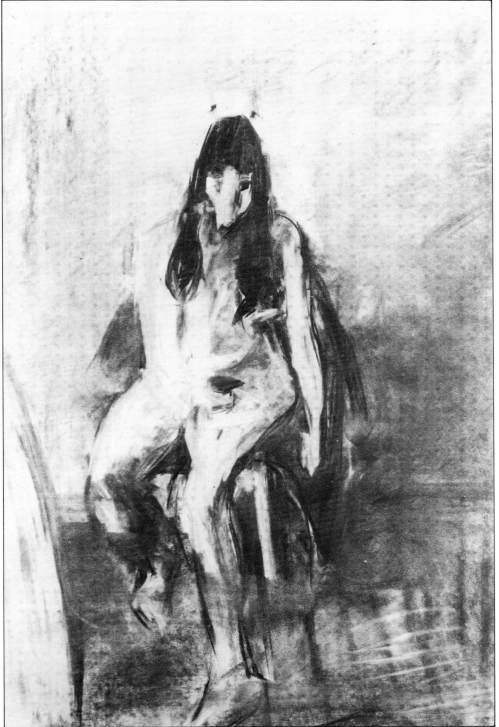

Papers, pastels, chalks and crayons
Several manufacturers produce good watercolour papers, examples of which are shown here. When buying paper, attention should be given to its weight, tone and texture. Although a good selection of tinted papers is available, tinted washes can be applied to white paper to obtain the exact colour required. The amount of white required to show through the paint determines the texture and weight of the paper to be used. Paint easily covers smooth paper while heavily textured paper leaves small flecks of white.
Rowney (1) and Grumbacher produce soft pastels in an

extremely wide range of colours, defined on a numerical scale from 0 (light) to 8 (dark).
A light, medium and dark graduation of each colour will probably be enough for pastel drawing. Pastel pencils (2) are easy to blend, are non-toxic and do not fade. Oil pastels (3) can be mixed directly on the paper while wax pastels (4) have the added advantage of being usable on any surface; they are non-toxic and water- and light-resistant. Caran d'Ache (5) crayons range from medium to hard and Neocolor II (6) is softer. Conté crayons (7) are similar to natural chalks and are available in a limited range of colours.

Top left *Woman Seated by a Dressing-table*. This drawing on cartridge paper illustrates the strong line and fine graduations of tone which can be achieved with black chalk. White chalk is used to create highlights and to show the fall of light.

Above left *Sleeping Mother and Child*. This sketch shows the subtle effects which can be achieved with pen and ink on Schoellershammer paper. A heavily loaded pen has been used to obtain the scratchy, straight lines to build up the

mother's head, and less heavily loaded to draw the rounded contours of the baby.
Above *Seated Nude*. The expressive quality of charcoal is shown on a slightly grainy cartridge paper where the mottled surface of the paper

shows through the light application of the medium to create a textured background.

been used but today willow twigs are converted into charcoal in special ovens.

The advantage of charcoal as a drawing material is that it is soft, gives a sympathetic but positive line, and can be corrected easily if necessary. To exploit charcoal to the full, it should be used on a toned, slightly granular paper. This means that the black areas of tone will be broken up by the untouched cavities in the paper where the charcoal cannot reach; this gives a sparkle and spontaneity to the drawing.

As charcoal can only be used in a negative sense, to show where light is not falling, it is often very effective to use white chalk for highlights or to indicate where light is falling. On toned paper, this combination works particularly well. Charcoal is at its best when the subject calls for a forceful approach – broad and confident bands of tone with relatively little detail.

Chalk

Conté chalks are similar in effect to charcoal but they are much harder and therefore can be used for finer lines and greater detail. These little sticks are available in both black and white, and also come in the traditional terracotta red and dark brown. More recently, Conté have introduced a range of coloured chalks which include strong primaries and soft pastels.

Like charcoal, these chalks show to their best when used on tinted paper with a fairly rough texture. The mood of the subject can be emphasized as much by the choice of paper colour as by the drawing materials. Leonardo used red chalk, made from iron oxide, usually drawing onto a warm buff-coloured paper. Later, from the mid-sixteenth century onwards, the combination of black, white and red chalk was favoured by many artists. Notable exponents of this syle of drawing include Rubens and the Italian, Tiepolo (1696-1770).

Pastel

A softer and more luminous effect is given by the use of pastels, which were much beloved for their opalescent quality by the Impressionists. Pastels are composed of finely ground pigment, held together in sticks with gum. They are powdery and difficult to control, but can be used to produce drawings of great subtlety.

Like charcoal and chalk, pastels rub off rather easily and need to be fixed to the paper if the effect is to have any permanence. This is achieved by spraying the finished drawing with some sort of binding agent such as glue or resin. In the past, a variety of fixatives were used including beer, skimmed milk, egg white and gum arabic. Today, synthetic resin is widely employed and is applied either with

a spray-applicator or an aerosol can, which is more expensive but easier to use. Another way of fixing dry pigment is to impregnate it with a binding agent. Charcoal or pastels can be soaked in a drying oil immediately before they are used. The drawing should be completed before the oil has had time to dry.

Crayon

Wax crayons are an example of the way that dry pigment can be held together so that it does not smudge. Generally speaking, though, the quality of wax crayons is unsubtle and they are not particularly popular as a drawing material. They can, however, produce interesting effects when used as a mask before making a drawing in pen and wash. Because wax is water-resistant, lines drawn onto the paper will repel any water-based ink or paint which is subsequently laid over the top. This can produce exciting, though unpredictable effects.

Silverpoint

A drawing technique popular with artists of the Middle Ages and the Renaissance, though little used nowadays, is silverpoint. The drawing surface, most often paper or vellum, is given a coating of opaque white, and a sharp metal point, usually made of silver, is then used to scrape through this prepared surface. The metal point, which can also be made of gold, copper or lead, is secured in a wooden holder or leather casing in much the same way that modern graphite pencils are held in a wooden sleeve. The line produced by this method is very fine, which makes it most suitable for delicate and elaborately detailed drawings, such as portraits. Because it is such an exacting medium with little room for correction, the draughtsman must make confident, disciplined strokes to achieve the best results.

Pencil

The use of graphite as a drawing medium was developed in sixteenth-century England; later, wooden sleeves, similar to those used in silverpoint, were added. The modern graphite pencil is manufactured in a range from very hard to very soft. The harder pencils (H to 6H) are more suitable for architects and technical draughtsmen as they can be sharpened to a fine and durable point. The HB pencil is midway between the hard and soft and is good for everyday use. Most artists, however, prefer to draw with the range of softer pencils (B to 6B) which allows a greater intensity of effect to be achieved. Carbon pencils are a mixture of clay and carbon and can be used to produce a savage black line.

Working in pencil allows for an infinite

Above left *Two Nudes*. This charcoal sketch illustrates how the medium can be used to give an impression almost like ink on very smooth paper.
Far left *Study for Pink Nude* (1935), Henri Matisse. This charcoal sketch demonstrates Matisse's marvellous sense of rhythmic line and form. Rubbed tone emphasizes the rounded forms while highlights are created by erasing certain areas.
Left *Seated Boy with Straw Hat*, Georges Seurat. The founder of neo-Impressionism, Seurat developed the Pointillist technique, used here to great effect. In this monumentally conceived drawing, strong, static luminosity is conveyed through large areas of tone. Using chalk on rough paper, Seurat has achieved a granular appearance similar to the surface in his paintings.
Above *My Father, Richard Bellamy* (1982), John Bellamy. This charcoal portrait shows how much can be conveyed with a few economical lines and squiggles. The features are dominated by the piercing glance from eyes which are the only heavily worked area of the picture.

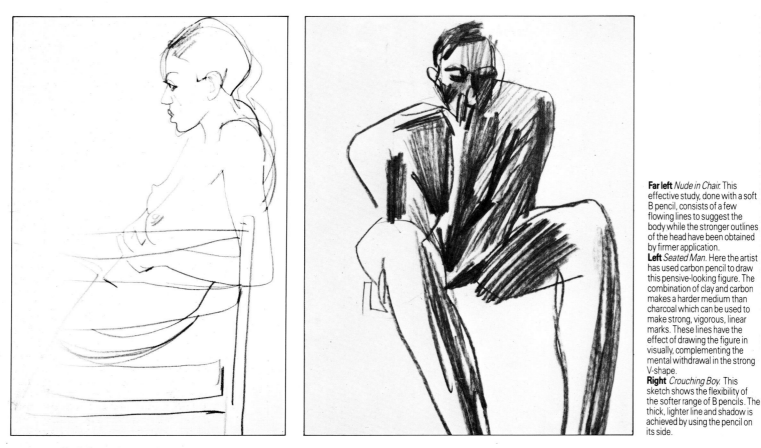

Far left *Nude in Chair.* This effective study, done with a soft B pencil, consists of a few flowing lines to suggest the body while the stronger outlines of the head have been obtained by firmer application.

Left *Seated Man.* Here the artist has used carbon pencil to draw this pensive-looking figure. The combination of clay and carbon makes a harder medium than charcoal which can be used to make strong, vigorous, linear marks. These lines have the effect of drawing the figure in visually, complementing the mental withdrawal in the strong V-shape.

Right *Crouching Boy.* This sketch shows the flexibility of the softer range of B pencils. The thick, lighter line and shadow is achieved by using the pencil on its side.

amount of elaboration and corrections are easy to make. Although pencil smudges less than chalk, pastel or charcoal, it is still a good idea to spray all drawings with fixative.

There are many brands of coloured pencils which are available in a variety of qualities and every conceivable colour. Some are also water-soluble and a wash effect can be produced by going over the drawing with a wet brush. These pencils are a relatively new development, and, although interesting results can be accomplished, the possibilities have not yet been fully explored.

Ink

A drawing medium which can produce a mark of authority, but also allows for a fine degree of subtlety, is ink. This was popular with many artists, including Rubens and Michelangelo and, in the hands of a penman such as Rembrandt, proved itself to be a technique of extreme versatility. The best ink has always been made in China, although, strangely, it became known in the the West as Indian ink, acquiring this misleading name because it was the East India Company which first introduced Chinese ink to Europe. The main ingredient of Indian ink is carbon, which is made by burning various resinous woods, such as pine. The soot is

then collected on the underside of metal or stone slabs and combined with glue or resin. In the East, ink is moulded into cakes or sticks which are rubbed against abrasive stones before use and mixed with water. In the West, Indian ink is usually sold already mixed into a liquid.

True sepia comes from the ink sacs of the octopus. It gives a fairly permanent colour, ranging from nearly black in its undiluted state to a pale yellowish brown with the addition of water. Bistre is a cheaper substitute for sepia and is made from charred wood. It is less satisfactory, however, as the colour is less intense and less permanent. Another alternative to real sepia is oak-gall ink which has been in use since the eleventh century. Concentrated water which has been used to boil oak-galls renders a brown fluid which is very similar in effect to sepia. Unfortunately, its rather acid content tends to burn paper and it bleaches rapidly if it is exposed to direct light.

Apart from these traditional inks it is possible to purchase a good range of coloured inks, which are available in a transparent or opaque form. Although the transparency of ink is one of its more attractive qualities, it is sometimes useful to have opaque ink for use on dark paper. With

opaque ink, white or light colours can also be used to draw in details over the top of darker areas of a drawing. In the past artists have often introduced small amounts of coloured pigment to modify black ink slightly. Both vermilion and terre verte were commonly used in this way, the former to produce ink of a warmer, the latter, ink of a cooler character.

The main tools used for the application of ink are the pen and the brush. The pen has been in use since early Egyptian times, or longer. Ink pens can be made easily and cheaply, which accounts for their widespread popularity. In its simplest form, a stick with a slightly sharpened end can be dipped in ink, or any other coloured liquid, and used to make a mark, but in order to control this mark properly it is better to make a slightly more sophisticated version. Reed or bamboo are often used to make ink pens because their hollow centres allow for a reservoir of ink to be retained. The ends are usually tapered either to a point or a blunt chisel-like shape. If the ends are also split then the artist can vary the width of the stroke by exerting a greater or a lesser pressure on the pen.

A favourite choice for drawing in ink has always been the quill pen. Any kind of feather can be used, but the best are the long wing feathers of swans or geese. These are

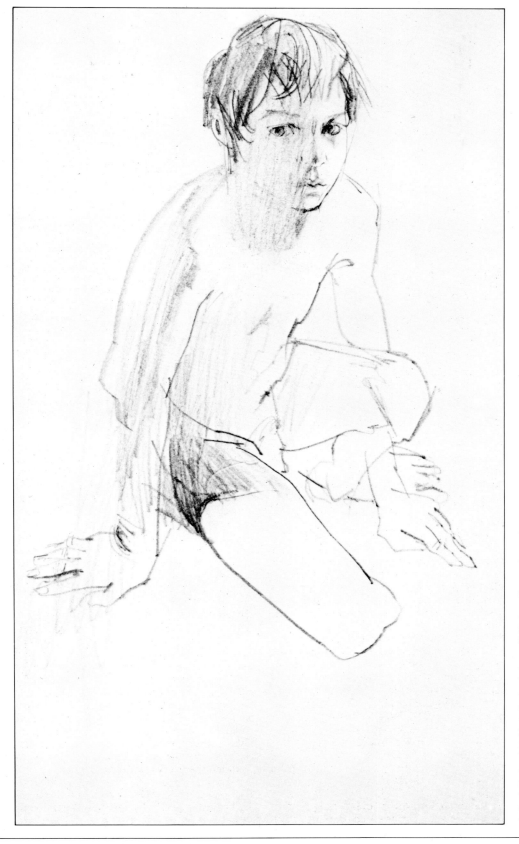

sharpened and shaped in the same way as reed or bamboo pens and are springy and pleasant to use. The drawback with quill pens and others of this type is that they wear out quickly so the quality of line can alter a great deal during the course of the drawing. This can be turned to good effect: many of Rembrandt's pen and ink drawings, acknowledged as being among the best of their kind, show evidence of his having used an increasingly worn nib, but with such empathy that the finished result is considerably enhanced.

More durable, if slightly less sympathetic, are nibs made from different types of metal which fit into a shaft or holder. The best and most expensive metal nibs are made of gold, but silver, steel and chromium are all common and perfectly satisfactory. However, a metal-nibbed pen imposes a greater uniformity of drawing technique and many artists prefer the freshness and vitality of the reed or quill.

With such a variety of different drawing pens available it is best to experiment with as many as possible. A pen with a pointed or rounded end will give a line which varies only slightly in breadth but is excellent for free, expressive drawing. A sharper edge and greater variation in breadth of stroke can be achieved with a chisel-ended nib, the type designed for calligraphy, particularly italic writing. If the italic pen is held consistently at an angle of 45° then the line will alternately narrow and thicken as it describes a curve.

Possibly the most difficult tool for the draughtsman to use, but certainly one which has enormous versatility, is the brush. To use it properly demands forethought and sureness of touch, but the flexibility of this implement allows for great variety and beauty in the drawn line.

Originally brushes were probably no more than a twig or reed which had been hammered until the end was splayed out. Although drawings of some immediacy can be produced, this type of brush is clumsy and awkward to handle. Today, brushes are generally made of synthetic fibres or some sort of animal hair gathered then bound to a metal or wooden shaft. The hairs are so arranged that the brush is either round and tapers to a point, or is flat in section and has a chisel-shaped end. The natural ends of the animal hair should be left intact, as this not only improves the shape of the brush but also facilitates the flow of ink or paint. The hair most commonly used in the manufacture of brushes is hog's hair, which is stiff and coarse, cow's or badger's hair, which is slightly less stiff, and a variety of softer hairs, more usually either squirrel or sable. The most expensive of all of these is sable, but it is well worth the extra cost as it is springy and

resilient. With proper care, sable brushes should have a reasonably long life. Sable brushes should never be left standing in water; they should be washed in clean water and pulled back into shape.

In China and Japan, where the brush has always been a greatly favoured implement, both for drawing and for writing, it is manufactured with meticulous care. The centre of the brush is made up of a cone of stiffer hairs around which are assembled layers of longer and softer hair. This system of assembly allows a reservoir of ink to be held between the nucleus of stiff hair and the more pliable outer layers. The root of an Oriental brush is the thickest part and even a very large one will taper to a fine point. A skilled practitioner can produce drawings of extreme subtlety and sensitivity with this sort of brush, but it requires an entirely different technique, with the brush held vertically.

The effects which can be achieved with an ink-loaded brush are numerous. Broad washes of dilute ink can be contrasted with fine but strong lines of more concentrated colour. Crosshatching, stippling, splattering and the sharp, freely drawn line can all be used. The drawing can be given a softly graded tonality or high contrast. Francisco Goya was fond of making direct brush drawings which have a very atmospheric quality. He sometimes introduced a colour, such as red, in order to give a heightened effect. Certain European artists, such as Nicolas Poussin (1593/4-1665) and Claude (1600-82), used ready mixed washes which gave three or four different grades of tone. This gave their drawings a distinctive quality because of the ordered tonality. William Turner (1775-1851), who was a great admirer and imitator of Claude, nevertheless did not adopt this system of using a predetermined tonal scale. His drawings, which are in many respects similar to those of Claude, remain individual because of their more specific tonal effects.

Alternative Media

The drawing implements and media described here are those which have been in most common usage throughout the ages and have retained their popularity up to the modern day. This should not deter the artist from experimenting and inventing different methods of drawing. Rags dipped in ink can be used to dab or smear expressive marks on paper. Fingers, hands, leaves, flowers and pieces of string can all be used to transfer colour with excitingly unpredictable results. Smudges and blots used judiciously can give a drawing an air of immediacy; even accidental marks can be incorporated.

Certain types of pen not normally associated with fine art can nevertheless be employed in an interesting and creative way. A drawing in ballpoint pen can be rendered

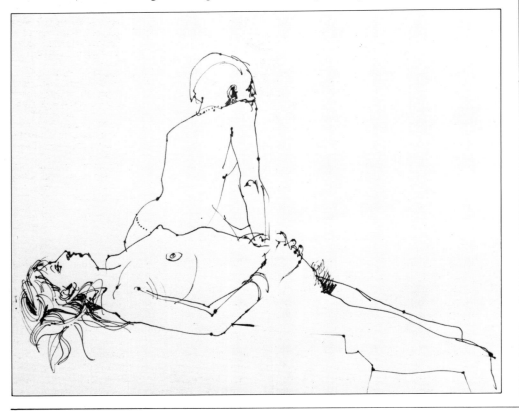

quite atmospheric by flooding it with oil or turpentine. Coloured felt-tip pens are worth investigating; some of the newer brands come in colours which can be blended.

A sharp point or stylus can be used to scratch through a layer of opaque ink or paint, allowing the paper to sparkle through; in fact, a product called "Scraperboard", specially prepared to give precisely this effect, is commercially available. It has a black surface which can be drawn into with a

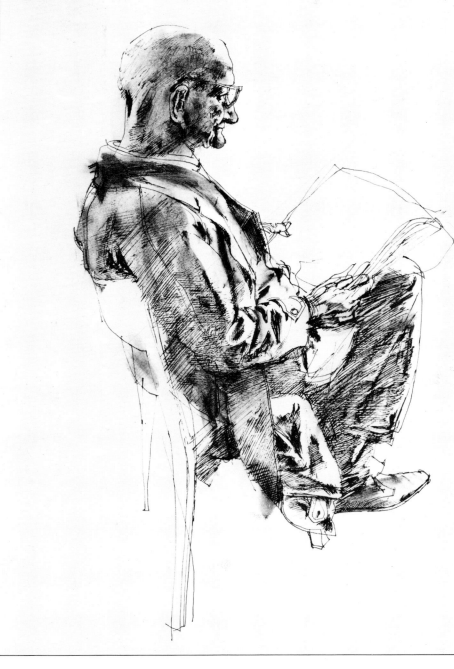

Far left *Two Women, Nude.* Pen and ink have been used since about the twelfth century, although not generally by European artists until the Renaissance, when the reed pen was introduced. There is little or no margin for error when using the pen. Spatial relationships between subjects have therefore to be worked out as well as the placing of the composition on the paper. This sketch shows the care with which each mark has to be made and the way in which tone and texture can be implied with the medium.

Centre *The Illness of Reason,* Francisco Goya y Lucientes. Goya's early works are full of Rococo decorative charm but by the 1790s, after a severe illness which left him deaf, his style changed and he became more interested in strange genre themes and imaginative scenes with overtones of terror and menace. These fantasies were exemplified in the series of etchings called *Los Caprichos* (Caprices) done in *c.*1793-8, savagely satirical attacks on social customs and on Church abuses. Although this illustration is an etching, Goya has used the etching needle as a pen, making scratchy uncomfortable marks to suit his uncomfortable subject. The strong contrast between light and dark evoke the macabre nature of the subject.

Left *Old Man Reading.* This careful study has in fact been drawn with an ordinary cartridge pen, with its easy flowing ink a perfect medium for scribbling and hatching. Before the ink dries, it is possible to spread the tone and soften its effect with fingers or a damp brush. Smudges can also add greatly to the pen's descriptive capacities. This characterful drawing shows the expressive qualities of the medium, the lively play of light on the forms emphasizing the intense concentration on the sitter's face.

sharp implement to allow the white under-layer to show through.

Techniques

Art schools have traditionally adhered strictly to an academic approach for teaching figure drawing. Until quite recent times, students had to spend a considerable period making studies of antique plaster casts. Only after they were thought to have reached the necessary level of competence in this discipline were they allowed to draw from a live model. Although this may seem to be quaint and old-fashioned, there are certain points in favour of this approach. Plaster casts are naturally easier to draw because they do not move around. They are also more likely to represent the "ideal" human figure than a real live model; beginning with a standard notion of proportion can help the artist to appreciate individual differences later. Modern art schools no longer put their students through this type of apprenticeship but there is nothing to stop anyone from adopting the same tactics as Auguste Renoir, who believed that his figure drawing was inadequate and inaccurate and drew literally hundreds of studies from plaster casts in order to improve. Whether this discipline is employed or not, much useful information can be gained by examining the way the great masters of the past have drawn the figure.

Selecting your viewpoint
Before choosing a viewpoint, it is important to take time to study the exact position you wish to draw, the pose and its surroundings. This can be done by moving gradually around the model, which will show the different angles and play of light on the form. The body's main volumes are basically composed of cylinders, each having a central axis and linking up with the spine, as the superimposed lines over these photographs show. When starting a drawing, a useful method is to work out the volumes in terms of cylindrical shapes.

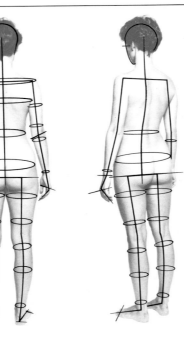

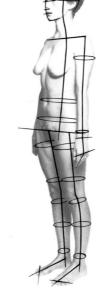
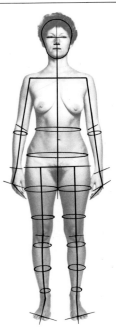

Limb movements
These poses show the arm's relation to the rest of the body and the effect of its movements on the contiguous muscles. By raising one arm, the whole of that side of the body is slightly raised; with both arms raised, the area above the waist is lifted and the muscles tightened. With the legs apart and arms down, the whole body has a more relaxed and heavier appearance, and the shoulders and chest muscles sag.

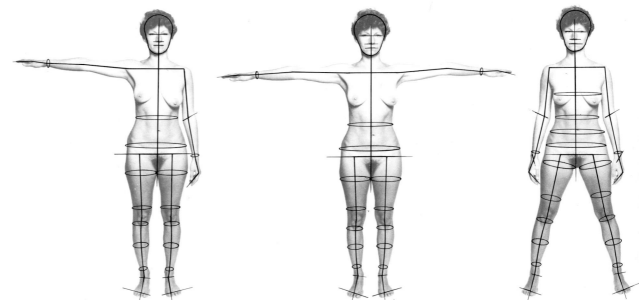

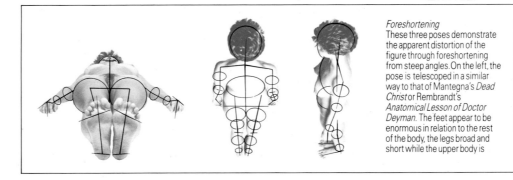

Foreshortening
These three poses demonstrate the apparent distortion of the figure through foreshortening from steep angles. On the left, the pose is telescoped in a similar way to that of Mantegna's *Dead Christ* or Rembrandt's *Anatomical Lesson of Doctor Deyman*. The feet appear to be enormous in relation to the rest of the body, the legs broad and short while the upper body is hardly visible. Viewed from above, the head and shoulders of the central pose dwarf the figure's lower half which diminishes into a V-shape. Artists should learn to measure by eye or by holding a pencil at arm's length, drawing entirely what they observe in front of them rather than relying on any foreknowledge.

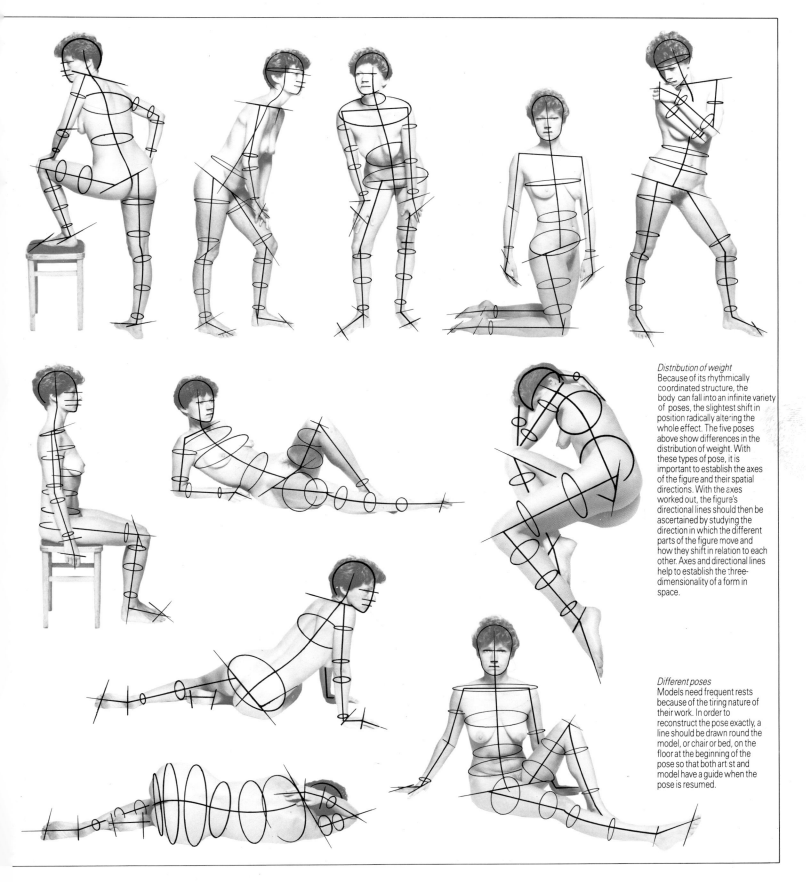

Distribution of weight
Because of its rhythmically coordinated structure, the body can fall into an infinite variety of poses, the slightest shift in position radically altering the whole effect. The five poses above show differences in the distribution of weight. With these types of pose, it is important to establish the axes of the figure and their spatial directions. With the axes worked out, the figure's directional lines should then be ascertained by studying the direction in which the different parts of the figure move and how they shift in relation to each other. Axes and directional lines help to establish the three-dimensionality of a form in space.

Different poses
Models need frequent rests because of the tiring nature of their work. In order to reconstruct the pose exactly, a line should be drawn round the model, or chair or bed, on the floor at the beginning of the pose so that both artist and model have a guide when the pose is resumed.

Methods of drawing differ from one artist to another and it would be ridiculous to suggest that there was a right or a wrong way. Even so, there are certain guidelines which can be useful to follow, especially for a straightforward study of the figure. The best advice of all is just to practise. Drawing has to do with training the eye as much as with a facility with pen or pencil; the actual technical skills, although important, are secondary to quality of vision. For this reason, the best way of starting a figure drawing, or any other sort of documentary drawing for that matter, is to spend some time analyzing the various shapes and relationships. Before starting to draw, the overall proportions of the figure should be considered and the correct format of paper selected. The height of the posed figure should be compared with the breadth by holding a pencil at arm's length and using the thumb as a sliding measure. It is often surprising to find that the width of the pose is greater than the height, in which case it is best to use the paper in a landscape (horizontal) format. By again holding up a pencil, or any other straight edge, in a vertical position, the central axis of the pose can be

Above *Plants and Two Nudes.* This atmospheric drawing in charcoal and 8B pencil has been done on cartridge paper. The strong charcoal verticals and diagonals create the spatial dimensions in which the figures are placed while the figures are outlined in pencil, with a good deal of finger work to create the hazy shadows, and the highlights rubbed in with a putty rubber.

determined. Judging the distribution of forms about this axis plays an important part in the dynamics of the drawing.

After checking the overall proportions and choosing the size and shape of the paper, the artist must decide how much space will be occupied by the drawn figure. The mood of the finished work will be influenced by how large the figure is in relation to its surroundings. Even if there is no indication of background at all, the position of the figure on the paper is important. Quite apart from making sure, before starting work, that the whole figure is going to fit, it is also important to avoid creating an uncomfortable feeling by siting the figure too close to the top or bottom. Some people like to make a series of little crosses or dots on their paper to mark points of reference before they actually begin to draw. The top of the head, the feet, shoulders, knees and elbows can be plotted out in relation to one another and

Below *Portrait of a Man.* This somewhat sculptural drawing, executed in carbon pencil, shows the planes and curves of the torso and head, and how the forms are built up through the contrast of the strong black hatching with the lighter diagonal lines.

Drawing from photographs
The artist has used a photograph of a model for this charcoal with Conté crayon study drawn on good quality cartridge paper. A comparison of the two demonstrates his use of artistic licence: the casual appearance of the photographed model has been transformed into an impression of a figure moving out of darkness into light, with the accent on the verticals. The charcoal edge is used with a full arm movement for the main contour lines of the figure and tone of the shadows. The charcoal is used as tone to pick out the details such as the hand emerging from the shadow of the thigh, and lines such as the floor. Smudging has been done with the fingers and the lights cleaned up with a rubber.

the corners in order to translate it back into living, moving flesh.

Sensitive handling of line can fill a drawing with energy and vitality. As discussed earlier, an important role of the line is to imply shape or mass, but sometimes the line must also indicate a meeting between two solid forms. This poses a very interesting problem. It is easy to see that certain drawing media have characteristics which make them more suitable to use for describing particular effects. But if a soft yielding form, such as the human body, is in contact with something hard and unyielding, such as stone, the line which separates them will have to imply the characteristics of both. In such a case the line must indicate the displacement of one form by another more dominant one, marking the point of contact and conflict.

A line need not always represent the "edge" of a shape. A drawing is usually made up of a mixture both of outlines and interior lines. Many of the interior lines discernible on a drawing of the nude show the interlocked and underlying structure of the body; here a knowledge of anatomy can be very useful. Emphasizing these lines of structure establishes the nude as a three-dimensional form in space. This feeling of solidity can be enhanced further if the artist imagines that lines are drawn around the body of the posed model. (A particularly cooperative model may allow real lines to be traced around his or her body, but this is not really necessary.) Two imaginary lines drawn one above and one below the waist would mark out a cross-section rather like a chunk out of the middle of a tree trunk. By putting a line around the model's middle the artist is obliged to consider and analyze this shape and to find a way of showing this. It is important to learn to use the line in an exploratory fashion and to feel a way around the form.

A drawing which sets out to express movement of the body needs to be treated in an entirely different way. Careful analysis and preliminary measurement depends upon the figure remaining still; even a slight alteration of pose sets up a whole new series of relationships. A drawing about movement cannot be as detailed as one from a posed, static figure, because there is only enough time to put down a minimum of information. However, a few rapid pencil lines are often enough to capture the spirit of a movement. Many artists find that the best way of recording the figure in motion is to make large numbers of quick drawings, spending no longer than a couple of minutes on each. By their very nature, these fleeting glimpses are more likely to convey the impression of movement than more considered and finished work.

marked lightly on the paper.

This system of marking out points of reference can be taken much further. All the features of the figure can be translated into a series of interrelated marks on the paper, providing a good method of crosschecking. A dot on the paper which indicates the position that will be taken by the tip of the nose is related to a dot which marks the point of the chin and another which marks the ear lobe. This triangle can be related to the position of the other, larger, triangle which is made up from the point of the knee, the ankle and the iliac crest. An elaborate network of tiny marks can be built up in this way, which can eventually be joined, after the fashion of children's dot-to-dot drawing games, to produce the image of the posed figure.

It must be remembered that the patterns built up from these measurements and comparisons are flat. They must be so because they are recorded on a surface which is two-dimensional, but what they represent are three-dimensional relationships occurring in reality. If these triangles were constructed as a piece of sculpture, their planes would all be facing in different directions; the artist has to be aware not just of how one area of the drawing relates to another but of a myriad of plane shapes which also have interrelationships within the space they occupy. This analytical approach has much in common with the ideas of the Cubists. Paul Cézanne believed that "one should try to see in nature the cylinder, the sphere, the cone, all put into perspective". In making a mental image of the figure as a construction built from familiar volumetric shapes, the artist is simplifying it into a series of forms easier to understand. If there are any flaws in the way that this basic construction hangs together then they can be readily seen and corrected. Having built up the framework it is easy to fill in the gaps and round off

RECLINING NUDE
pastel and charcoal on paper 32 × 20 inches (81 × 50 cm)

1

Working within a set period of time, an artist will always find certain areas of a drawing or painting taking precedence over others. In this pastel drawing, the head and face provided a focal point, and this resulted in a portrait study being made at the expense of detail over the rest of the body. The study evolved by constantly relating all the points of the drawing with the head. By placing the figure in a diagonal position, the composition is given more interest.

Even when there is unlimited time, a certain amount of selection is inevitable and indeed preferable when confronted with the complexity of reality. Here, the model is reclining on a number of cushions each of which is delicately patterned, and behind the figure is a table heaped with plants. Natural light coming from behind the figure provides a further complexity which was overcome by simplifying some areas and strengthening others. The greens reflected on the skin from the plants were given a new source: a simple, blocked-in background. The result shows how different the personal view of a drawing can look when compared with the relatively indiscriminate view through the camera lens.

The reclining figure has always been a popular subject: the pose can suggest a sense of calmness and relaxation, or invite a frank observation or admiration of the naked body. The artist must pay careful attention to the way the body changes in a horizontal position – the rib-cage may be more prominent, the flesh may slacken and the angle of the head can take on a particular importance. Of especial interest is the way in which the body is supported. A bed or divan presents a fairly uniform surface, but cushions give a more undulating support, echoing the curves of the figure itself (1).

2

3

The initial stage is a charcoal drawing. The artist begins by sketching the head in a relatively detailed fashion and then gradually works across the paper, delineating the rest of the figure. The figure is placed diagonally on the page, at a slightly different angle to the actual pose (2). The pose of the model changes slightly as she relaxes, the angle of her right arm becoming less acute and her hand moving further down the cushions. The artist takes account of this change and redraws the arm in the new position. Alterations of this nature need not be eradicated: the original lines are faint enough to be incorporated (3). The monochrome drawing is not yet complete, and the artist adopts a tonal approach to the work and covers most of the paper with charcoal. This creates shaded areas and areas of highlight (4).

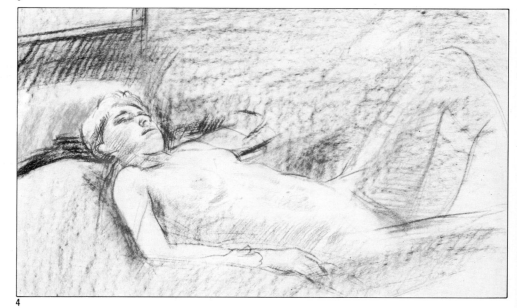

4

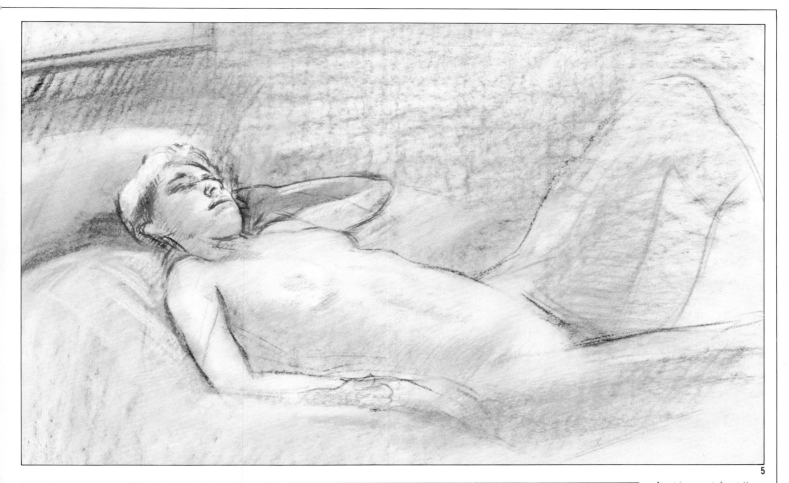

5

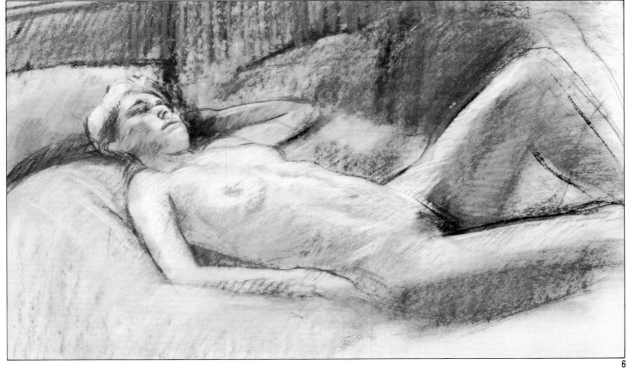

A certain amount of pastel has already been added to the basic charcoal drawing. More pastel is now incorporated, the artist restricting his choice to subdued hues in order to concentrate on the tonal qualities. At the same time as the tonal structure is being carefully built up, the detail is beginning to emerge, the figure being strengthened with firmer charcoal lines (5). In another change of pose, the position of the left leg alters: the model moves her left foot down slightly. This change is correspondingly made in the drawing and the pose is now the same as that which will appear in the finished drawing. The artist does not need to alter his work as the model moves, but small changes of this kind keep the drawing alive and, in this example, better express ease and relaxation. The drawing is now well established; further alterations would be difficult to make. The lighter areas of the figure are modelled and the artist sprays the picture with a commercial fixative. in effect creating a grey underpainting to which more vivid pastel colours can be added (6).

6

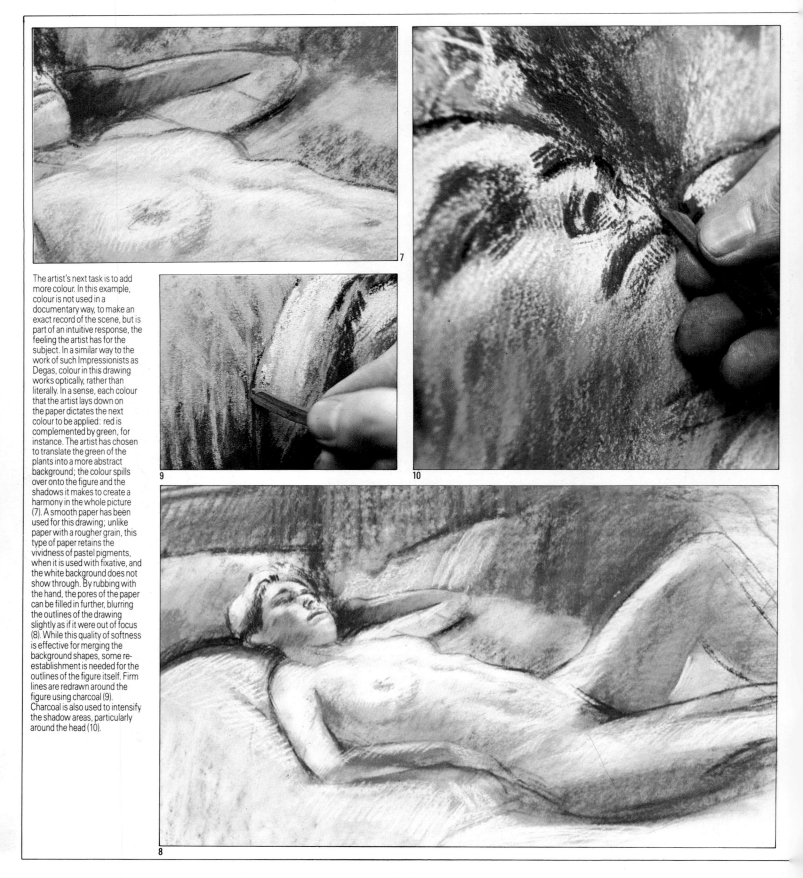

7

The artist's next task is to add more colour. In this example, colour is not used in a documentary way, to make an exact record of the scene, but is part of an intuitive response, the feeling the artist has for the subject. In a similar way to the work of such Impressionists as Degas, colour in this drawing works optically, rather than literally. In a sense, each colour that the artist lays down on the paper dictates the next colour to be applied: red is complemented by green, for instance. The artist has chosen to translate the green of the plants into a more abstract background; the colour spills over onto the figure and the shadows it makes to create a harmony in the whole picture (7). A smooth paper has been used for this drawing; unlike paper with a rougher grain, this type of paper retains the vividness of pastel pigments, when it is used with fixative, and the white background does not show through. By rubbing with the hand, the pores of the paper can be filled in further, blurring the outlines of the drawing slightly as if it were out of focus (8). While this quality of softness is effective for merging the background shapes, some re-establishment is needed for the outlines of the figure itself. Firm lines are redrawn around the figure using charcoal (9). Charcoal is also used to intensify the shadow areas, particularly around the head (10).

9

10

8

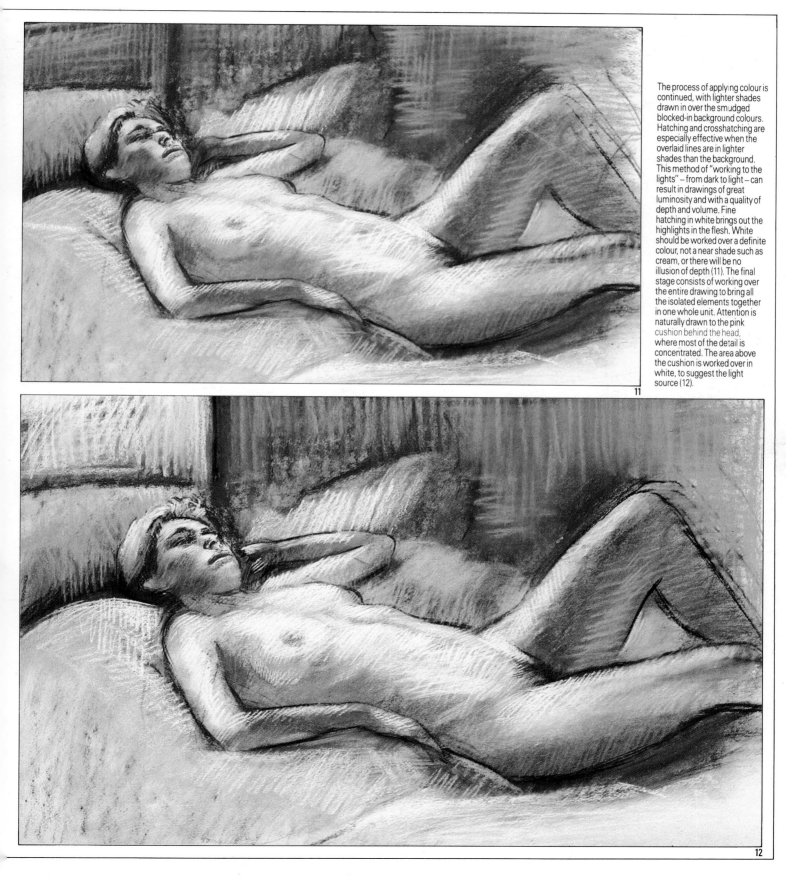

The process of applying colour is continued, with lighter shades drawn in over the smudged blocked-in background colours. Hatching and crosshatching are especially effective when the overlaid lines are in lighter shades than the background. This method of "working to the lights" – from dark to light – can result in drawings of great luminosity and with a quality of depth and volume. Fine hatching in white brings out the highlights in the flesh. White should be worked over a definite colour, not a near shade such as cream, or there will be no illusion of depth (11). The final stage consists of working over the entire drawing to bring all the isolated elements together in one whole unit. Attention is naturally drawn to the pink cushion behind the head, where most of the detail is concentrated. The area above the cushion is worked over in white, to suggest the light source (12).

SEATED MALE FIGURE
pen and ink wash on paper 20 × 15 inches (51 × 38 cm)

A monochrome wash together with line drawing is used in a lively and spirited way in this picture. Attempting to describe both colour and tone with such a wash can be difficult because the two concepts sometimes become confused. In this case, the colour of the skin in a badly lit interior presents a problem for the artist, the skin tones being difficult to distinguish from shadows. However, with a single light source, the resulting scene is challenging.

The artist chooses to use the washes to represent the dark sides of solids. The principles of interpreting solids are used, with dark sides dark on paper, lights left white and the edges between lights and darks merging softly. Allowance is made for residual light, which is the light striking surfaces behind the form and reflecting back. This results in thin, soft edges along the darks. In energetic and successful drawing, such refinements are important.

The model is seated on the arm of the sofa, comfortable and relaxed with the weight of his body taken on his left arm and his right arm crossing to the left knee.

The artist sits in front and just to one side of the model, so that the composition forms a strong diagonal, shaped by the side of the torso and the left calf. This is perfectly intersected by the symmetrical zigzag of the left elbow and right knee. Light coming through the window creates highlights on the top edges and the far side of the figure (1).

1

The first stage of the drawing process is achieved, working on a heavy, smooth Hot Pressed paper in pencil. The shape of the head is drawn and redrawn to establish its position in relation to the angles of the shoulders and arms. The initial stage inevitably involves some searching and experimenting before pleasing angles and proportions are established (2). With a fine reed pen and Indian ink, the outlines of the form are carefully delineated (3).
Single drawn lines provide a solid impression of the figure, and the drawing fills the paper. The lines are bold and energetic, showing a sound knowledge of the anatomy of the figure and the directions of tension. The shapes of muscles and bones are implied in the curves and corners and a three-dimensional effect is achieved in the fore-shortening which is particularly evident in the left thigh and right arm. The hands and feet are described in general outline, details such as fingers and toes being avoided at this stage (4).

2

4

3

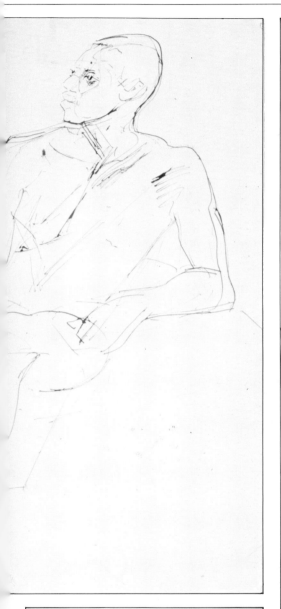

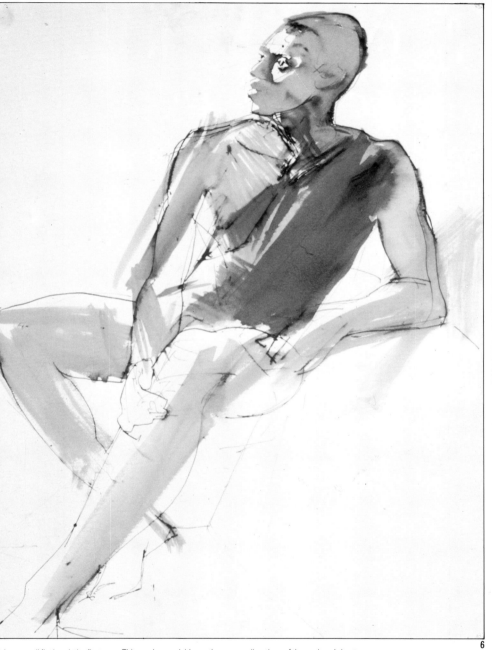

6

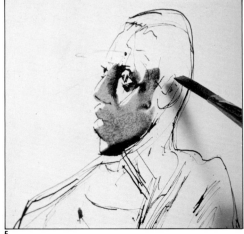

5

Using a small flat brush the first wash is laid over the face, carefully describing the shadowed parts and avoiding thin areas left white to bring out the volumes of the lips, chin and nose, and the circle of the eye-socket. It is possible to take out the intensity of a wash using a sponge to soak up excess ink. The artist leaves thin, dark areas under the brow, down the side of the nose and under the ear to describe shadow and form; the rest of the face is painted in a flat tone to give an impression of the colour of the skin (5).

Thin washes are laid over the whole figure to bring out the form almost in an abstract way. The shadowed parts of the body are filled in straight, flat stripes; the upper left arm, being in shadow, is completely blocked in. At the same time, the artist changes his position, moving further round to the front of the model. As a result, the position of the right arm is moved out from the body, the elbow creating more of an angle. The neck and collarbone are carefully detailed at this stage, with brushed ink describing the

directions of the neck and chest muscles, and also describing the flesh wrinkling over the abdomen (6).

The artist's new position is further to the front of the model (7). The detail (8) shows the artist using a sponge to make wide, flat stripes in the thick ink wash to describe shadows on the figure and the sofa. The ink is well diluted but, despite this, the outline drawing beneath, which has previously soaked into the paper and dried, does not run.

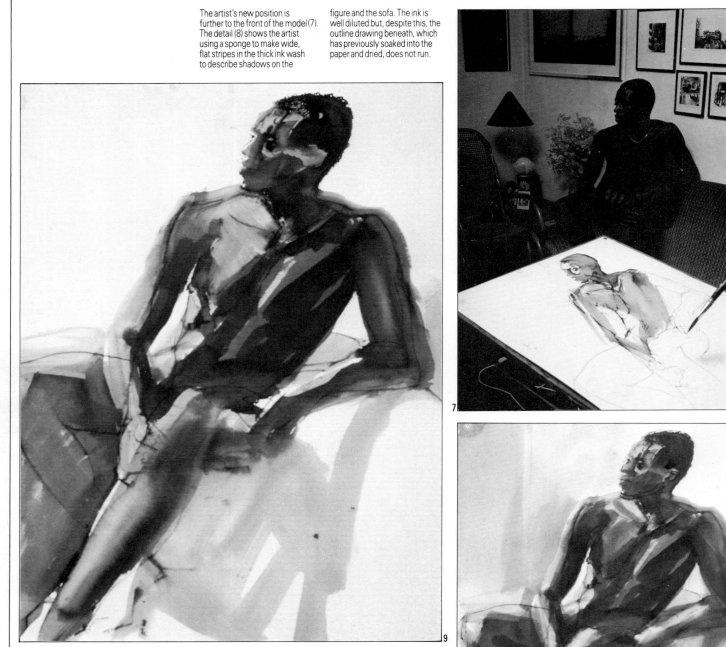

Working on shadows and highlights, the artist continues blocking in areas of darker ink, sometimes on wet patches of paper deliberately to cause the outlines to blur, then allows the washes to dry. The hair is carefully worked to look curly against the white background (9). Lights are emphasized by adding strong black areas of shadow in juxtaposition, down the front of the left shin, for example. The blurred outlines are firmed, details such as the ear added and the background filled in with thin washes (10).

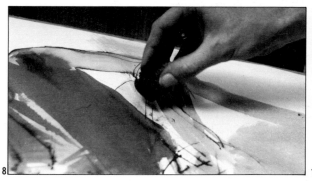

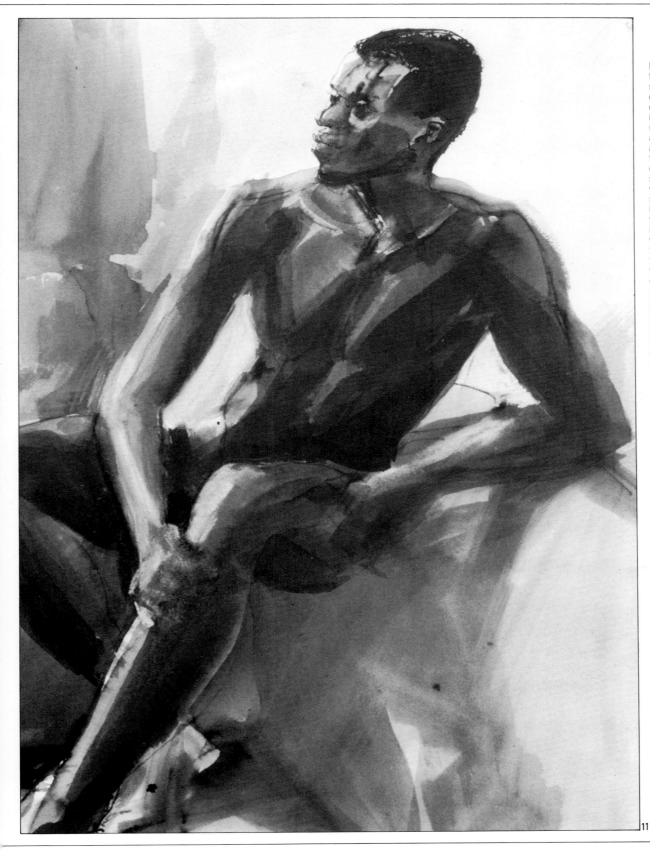

Making such a detailed and well-formed picture in ink washes is a slow-moving process, because of the need to wait for the ink to dry at various stages. The final image displays a depth and roundness which can only be achieved by the careful working and over-laying of washes. The figure is drawn and almost completely filled with various shades of grey and some black, which indicate the model's dark skin. The form of the figure is indicated by the intricate and varied shadows; the highlights, in thin tones which allow the white of the paper to show through, add interest and vitality to the picture. The technique works well, describing the directions and shapes of muscles, and directions of tension within the figure in the built-up tones, which seem to have been nonchalently laid and match the mood of the subject, but which describe the figure accurately and with great energy (11).

11

GIRL IN WAISTCOAT
monoprint and pastel on paper 25½ × 20 inches (65 × 51 cm)

Printmaking usually involves making an edition of near-identical images from one plate or block. The exception is the monoprint, which is a print in that the picture is made on another surface and transferred to the support, but it is a once-only image. It involves removing ink from an inked plate by drawing with a stick, a pen or a brush, and placing the paper to take the image over the top.

Monoprints are sometimes used as a basis over which elaborations of colour or incised drawing can be added. Edgar Degas reinforced some of his with pastel drawing. Monoprinting is often considered the most immediate means of drawing, enabling the artist to work with the kind of freedom normally associated with oil paint, and the flexibility of the technique allows considerable alteration to be made while drawing is in progress. It is particularly suited to representing strong tonal contrasts.

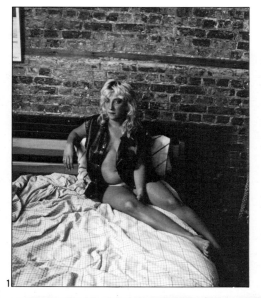

The model is seated at the end of a bed, with her legs stretched out to one side of her, down the side of the bed. It is a relaxed and casual pose, although the face is angled at the viewer who is asked to meet her level gaze. The lines of the pose are straightforward and uncomplicated; there are no overwhelming problems of foreshortening or complex anatomical demands. The model is well-built and fleshy; the curves of her stomach and thighs provide interesting volumes for the artist. The light is coming into the room from the model's righthand side, and highlights are clearly visible on her right hand, her stomach, right shin and over the thighs and the right side of her face. The leather waistcoat also reflects streaks of light. The artist deliberately chooses an article which enables him to exploit the medium (1).

Linseed oil is added to some black lithographic ink to thin the ink and make it less sticky. Only a small amount of ink is required and it is mixed with the oil until the substance is creamy. The artist applies the ink to a sheet of formica using a roller. Sometimes glass or copper or zinc plates are used. The method works as long as the surface is smooth and completely non-absorbent (2). The drawing process begins. A broad brush and a rag are used to remove ink from areas of the formica. A rag can be used to remove solid areas of ink, which will indicate whole areas of light. Starting with the head, the artist works over the whole area, indicating the basic position of the figure (3). A variety of brushes are employed, for marks of different sizes and shapes; these will give the impression of different textures. If a mistake is made, it is possible to replace the ink and start again. Otherwise, ink can be removed in an area, then some can be brushed back to create marks within the highlight (4).

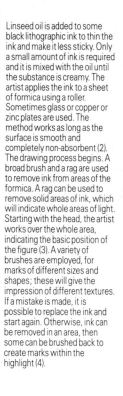

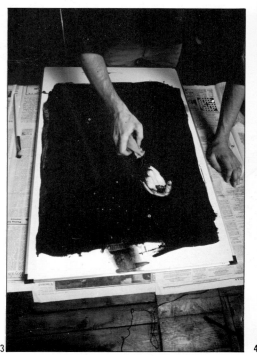

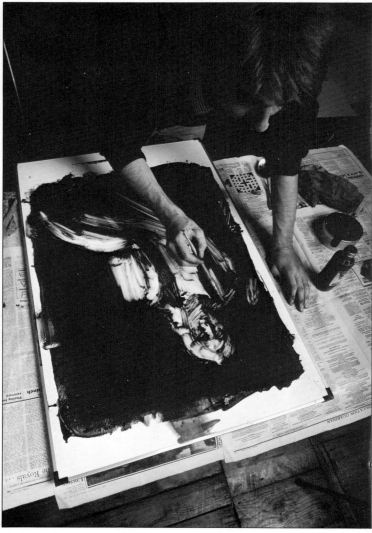

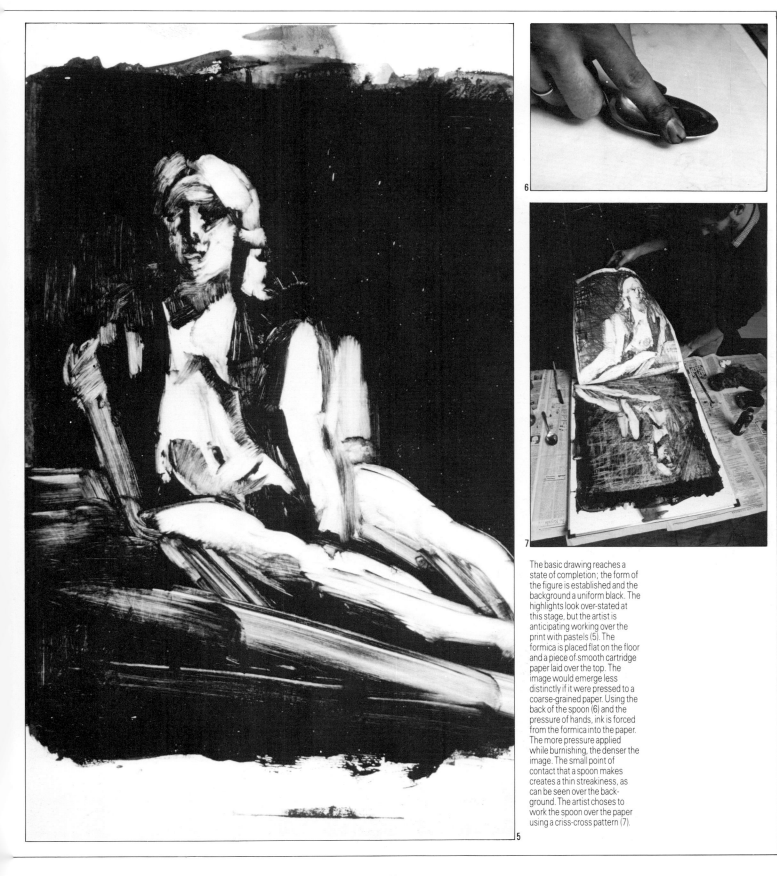

The basic drawing reaches a state of completion; the form of the figure is established and the background a uniform black. The highlights look over-stated at this stage, but the artist is anticipating working over the print with pastels (5). The formica is placed flat on the floor and a piece of smooth cartridge paper laid over the top. The image would emerge less distinctly if it were pressed to a coarse-grained paper. Using the back of the spoon (6) and the pressure of hands, ink is forced from the formica into the paper. The more pressure applied while burnishing, the denser the image. The small point of contact that a spoon makes creates a thin streakiness, as can be seen over the back-ground. The artist choses to work the spoon over the paper using a criss-cross pattern (7).

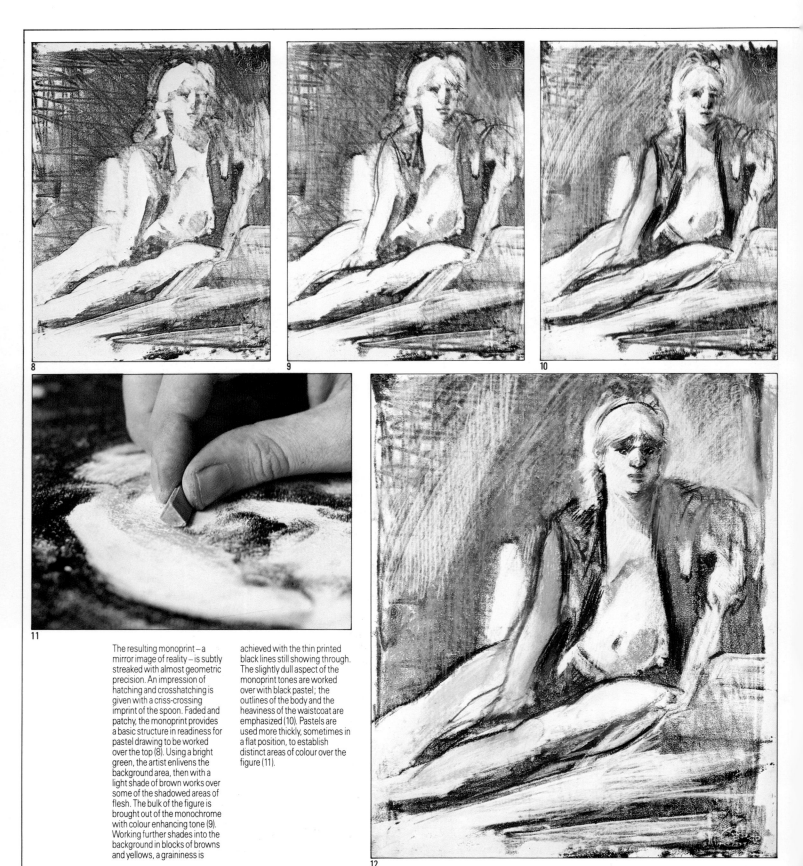

8

9

10

11

12

The resulting monoprint – a mirror image of reality – is subtly streaked with almost geometric precision. An impression of hatching and crosshatching is given with a criss-crossing imprint of the spoon. Faded and patchy, the monoprint provides a basic structure in readiness for pastel drawing to be worked over the top (8). Using a bright green, the artist enlivens the background area, then with a light shade of brown works over some of the shadowed areas of flesh. The bulk of the figure is brought out of the monochrome with colour enhancing tone (9). Working further shades into the background in blocks of browns and yellows, a graininess is achieved with the thin printed black lines still showing through. The slightly dull aspect of the monoprint tones are worked over with black pastel; the outlines of the body and the heaviness of the waistcoat are emphasized (10). Pastels are used more thickly, sometimes in a flat position, to establish distinct areas of colour over the figure (11).

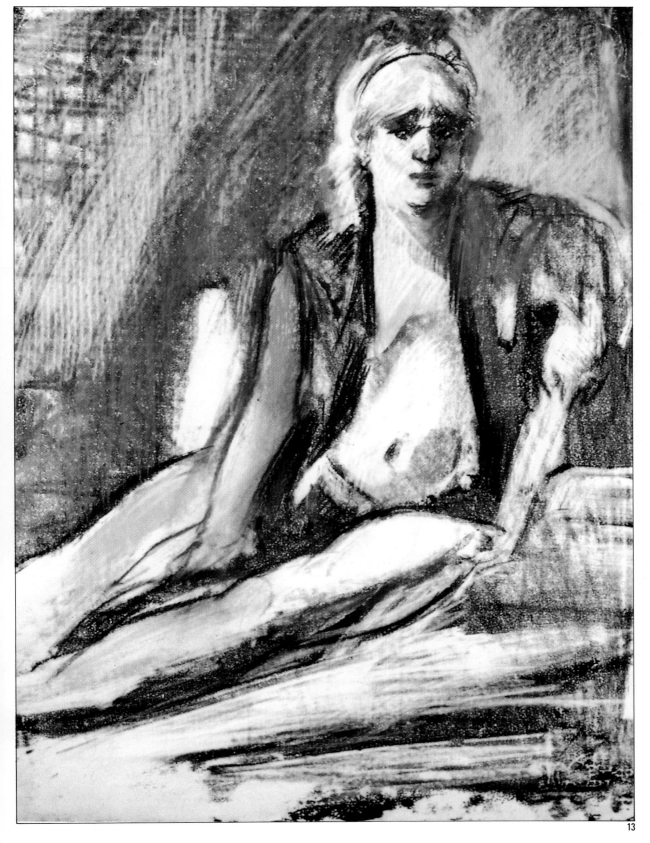

A strong rust-red pastel is used to block in areas of shadow and add some richer flesh tones. The white of the unprinted paper still shows through, but the effect is more solid than the graininess of the background. Detail is added to the face, and white highlights bring out the volume against the darks (12). The artist decides in this final stage to change the model's pose slightly. This last-minute decision illustrates the way pastel can be used as an opaque medium. To give some balance to the pose, and break the strong, curving diagonal of the body, the elbow is moved out using highlights to cover the shape beneath. The right hand and fingers are detailed over the strong lines of the model's left thigh, white and cream pastel covering the black, reds and browns underneath. Although pastel is generally considered to be a transparent, luminous medium, it also has a covering potential, which is fully exploited here (13).

13

RECLINING MALE FIGURE

charcoal on paper 20 × 37½ inches (51 × 95 cm)

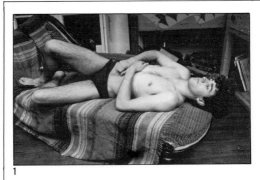

1

For any artist familiar with the use of a pencil, the prospect of drawing with charcoal can be slightly daunting. Even the softest pencil allows for precision and control and enables the artist to follow sinuous contours with a certain amount of ease. Charcoal is more abrasive and dramatic and should be used with less concern for sharp definition. Available either in pencil form or in the traditional sticks of varying thicknesses, it can be applied in broad areas, smudged to achieve blurred effects, and fixed at intervals to maintain its richness.

For this drawing a grey-green paper was chosen, which provided a mid-tone ground. Papers in dark colours and mid-tones, which can be bought or otherwise made by laying a watercolour wash and allowing it to dry before beginning work, are sometimes chosen so that the artist can "work to the lights". A feeling of volume is often more apparent if white chalk is added for the highlights after the drawing has been established in charcoal.

Occasionally the size of the paper proves inadequate as the drawing progresses. In this case the drawing was extended by adding an extra piece of paper to the lefthand side of the drawing to accommodate the legs.

Although a reclining pose is often suggestive of ease and relaxation, this need not always be the case. Here, the slightly uncomfortable position of the male figure exhibits a certain tension, the clasped right hand and angled shoulders implying a latent energy in the form. Attention is directed to the sharp angles and strong shadows, an interest which demands a forceful and immediate treatment. Charcoal is the chosen medium for this drawing, being more direct and less hesitant than pencil. The artist intends to make the figure occupy most of the paper area and has discounted the surrounding area. Only a slight reference is made to context, enough to establish the position of the figure in space, but not detract from it (1).

Using a linear approach, the artist begins the drawing by concentrating on the head and upper torso, roughly sketching in the main outlines and contours lightly, to allow for redefinition (2). Moving across the paper, more detail is added to the face and hair. The artist uses a putty rubber to erase some of the initial lines; the position of the left arm is redrawn and a greater emphasis is placed on the sharp angle it makes. Some shading is added, but the main concern at this stage is to establish the crucial angles of the head, shoulders and arms (3). Light hatching on the shoulders, neck and torso begin to suggest volume; heavier lines behind the figure fill in the shadow areas (4). A slight movement of the model's head calls for small adjustments to be made to the

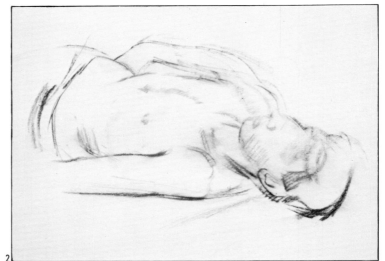

2

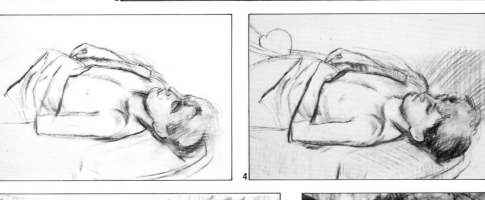

3 4

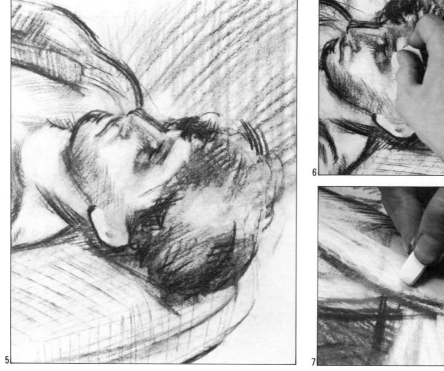

5 6

7

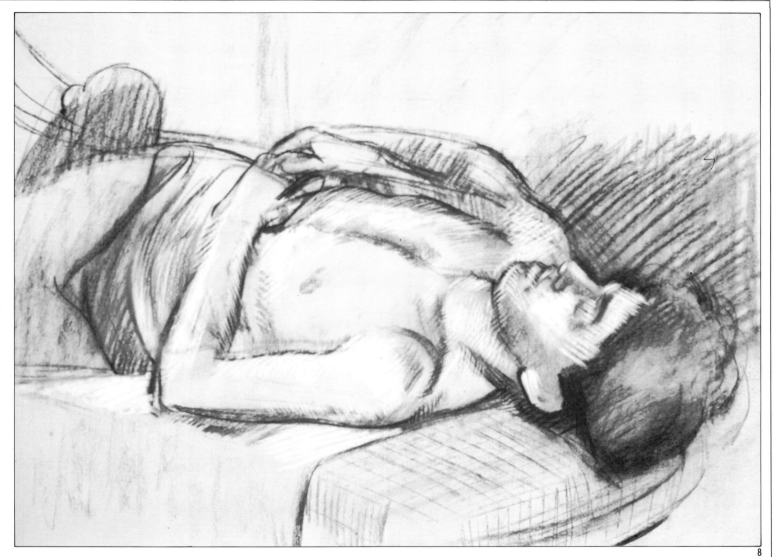

8

drawing. The artist again uses a putty rubber to make these alterations, restating the hair (5). Putty rubbers are more suitable for erasing charcoal lines than hard erasers. They are soft and can be moulded to a point to take out small details or make highlights, or they can lighten an area by a tone without smearing (6). The drawing has been executed on handmade paper with a slight grain, suitable for charcoal. It is grey-green in colour, establishing a mid-tone ground. Highlights are added with white chalk to reinforce the sense of volume in the figure. Adding highlights to a toned ground, rather than using a stark white paper, is the traditional method of working (7). Although the addition of high-lighting in white chalk has virtually completed the drawing, the artist is dissatisfied with the result (8). As happens quite

frequently, especially when making preparatory studies for further work in another medium, the paper's format and the composition look wrong. The artist decides to add more paper to the lefthand side of this drawing to accommodate a representation of the legs of the figure. Once this has been accomplished and the extended drawing is completed, the benefits become obvious. The shaded area of the legs balance the detail and definition of the head and make sense of the pose. Such alterations are part of a process of investigation and discovery (9).

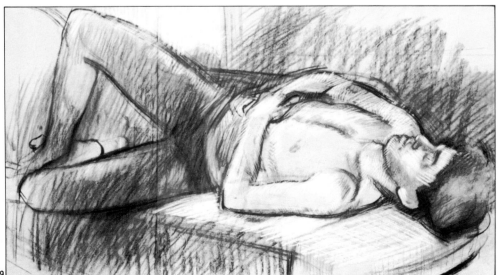

9

PAINTING THE FIGURE

Painting, like drawing, is the enclosing of a view of three-dimensional reality in two dimensions. The difference between the two techniques is that drawing is concerned with the use of line to convey the solidity of form, whereas painting is generally more concerned with the use of tone and colour to convey not only form but the qualities of light. Finished paintings are also more likely to give a complete picture, whether realistic or symbolic, because the whole surface is usually covered.

Colour and Pigment

An understanding of colour and the effects of colour in different combinations is important before an artist can hope to paint in the way he or she intends. Often this understanding is gained through experience in using pigments, but it is worth becoming familiar with basic colour theory. Colour can vary in three ways: there can be differences of tone, which is the lightness or darkness of a colour; there can be differences in hue, which is the quality that distinguishes red from blue or green, for example; and there can be differences in intensity of colour, which is the purity or saturation value of the hue. All these can be used with different effects in painting.

The three primary colours, red, blue and yellow, are the only colours that cannot be produced by blending and which, in various combinations, mix to form all the others. The complementary colour of each primary is the secondary colour made by mixing the other two primaries. So, green, which is made from a mixture of blue and yellow, is the complementary of red; purple is the complementary of yellow; orange is the complementary of blue. Tertiary colours are those

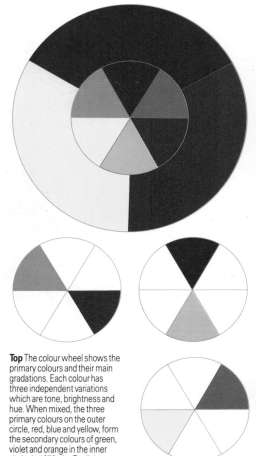

Top The colour wheel shows the primary colours and their main gradations. Each colour has three independent variations which are tone, brightness and hue. When mixed, the three primary colours on the outer circle, red, blue and yellow, form the secondary colours of green, violet and orange in the inner circle. In 1672, the English scientist, Sir Isaac Newton (1642-1727) discovered that a beam of white light could be split by a triangular prism into its component chromatic rays; he named the seven divisions of colour – red, orange, yellow, green, blue, indigo and violet.
Above Complementary colours are those from opposite sides of the colour wheel, and they have no primary colours in common.

Pigment sources
Artists' pigments were made from natural or readily accessible substances until the early nineteenth century when the rapidly developing chemical and dyeing industries led to a burst of brilliant new colours. Charcoal (1) yielded black, earth (2) produced various browns and chalk (3) white. Cinnabar (4), realgar (5), malachite (6), orpiment (9), azurite (11), naturally-occurring minerals ground into powder by the Bronze Age Egyptians, produced vermilion, orange, green, yellow and blue. The Romans developed Tyrian purple from whelks (7) and the blue-green colour known as verdigris from corroded copper (8). From lapis lazuli (10) came ultramarine, one of the popular colours in the Middle Ages.

Left Primary colours are so called as they cannot be made by mixing; however, all other colours can be produced by mixing them, either physically or optically. To experiment with the range of hues between the colours is a useful exercise.
Above Secondary colours, orange, purple and green, produce greys when they are mixed together. By combining secondaries or complementaries a wide range of broken colours can be made; these tend to be closest to the colours of nature.
Above right This range of neutral greys gives an idea of how many hues are easily obtained.

which are arrived at by mixing a primary colour with one of its own secondaries. Blue mixed with green gives turquoise, for example. A colour wheel is simple to make and quickly gives information about complementaries, when required.

The Impressionist painters were particularly interested in the effects of light and colour and were fascinated to find that the shadow of any given colour produced its own complementary. They banished black from their palettes and concentrated on painting in a way which gave the impression of real light, hence their name. More recent artists have experimented with the optical effects of juxtaposing colours which clash or argue with one another, as happens, for instance, with certain reds and greens. Medieval artists often used colour symbolically. For instance, blue and gold were considered to be the colours of eternity. Colour is usually used subjectively, and many artists are recognizable for the use of particular colour ranges in their paintings.

The paints used by artists to convey colour have two main ingredients: finely ground pigment and some form of binding medium. The chosen medium dictates the painting technique to be used in applying the colour to the surface. There is a very wide range of pigments available today; most of the paints and coloured pencils or pastels in current use are made from pigments which have only been discovered within the last 200 years. This fact has been of considerable assistance when verifying the dates of paintings and drawings.

In the past, the range of pigments has been very limited. The roughly prepared earth pigments of cave paintings, for example, which were probably bound with some sort of animal glue, afforded the early artist a palette consisting of only browns and ochres. To this was added a black made from carbonized organic matter. Because of the conditions under which these paintings were executed, it is unlikely that any attempts were made to expand this colour range.

By the time of the Egyptian civilization, there were several more pigments available to decorate the walls of the tombs. Their paintings include a delicate yellow which was often used as a background colour; this is probably the colour we know as Naples yellow, made from lead antimonate. Terre

verte, which literally means "green earth", and malachite, which is a natural, basic copper carbonate, provided them with a choice of greens. Their brown pigments included raw and burnt umber (iron hydroxide and manganese oxide) and cappagh and Verona brown which are natural earth colours. Like the cave painters, the Egyptians used carbonized organic matter for black.

The range of pigments in use in the Middle Ages had extended to include burnt sienna, which is calcined iron and manganese oxide. Around A.D.1400, flake white, or white lead, came into use and despite its disadvantages has been an important component in the artist's palette ever since. Besides being poisonous, this basic lead carbonate tends to darken when exposed to hydrogen sulphide. Many poisonous colours or fugitive colours used in earlier times, including verdigris, orpiment, realgar, massicot yellows, minium and several red lakes, have now become obsolete and have been replaced by more reliable, modern pigments.

It is always worth ascertaining the qualities of each pigment before starting to paint; even now, relatively few pigments are fully permanent and safe to mix with all the others. A pigment's mixing capabilities, its transparency or brilliancy, its consistency when mixed and its drying time are all discovered by experience; whether it is "permanent" or "fugitive" and, if applicable, "toxic" is marked on the label by the maker. The latter description need not deter the artist; it is no more than a warning.

About 60 different pigments are readily available; a decision to limit the palette is important as a choice of too many colours can be confusing and will not lead to a full understanding of the potentialities of each pigment. An exception to this would be if an artist wishes to emphasize brilliance of colour above everything else, because colours made by mixing are slightly denser. A simple palette of warm and cool permanent colours might consist of: flake or titanium white (not needed for watercolour), lemon yellow, yellow ochre, light red, Indian red, raw umber, terre verte, viridian and cobalt blue. Cadmium yellow could be used if a stronger yellow is required; cadmium red, vermilion or alizarin crimson if a brighter red is required. Raw and burnt sienna, French ultramarine and Hooker's green are also useful. These additions are all reasonably permanent if protected from a strong light. Instead of using black, which tends to make colours dull, it is usually better to mix dark colours using, for example, a blue with burnt sienna or raw umber; this principle inspires the artist to discover the true nature of shadows. Endless colour variations are

possible with just a small selection of pigments, which, in any case, will demand extensive experimentation before the required colour is achieved whenever desired, and before the properties of each pigment are understood.

Pigments themselves were traditionally ground by the artist, which was a time-consuming and arduous occupation. Part of an artist's training in previous centuries involved learning how to prepare his own paints and materials; in the Renaissance workshops this job was given to the young apprentices. The more finely the pigment is ground, the better the finished product. The main reason for the disparity in price today between paints described as being for artists and those for students is that the former are more finely ground. Pigments which have not been properly ground produce paints which are patchy in colour, particularly apparent in thin washes. Another reason for paints being expensive is costly raw materials; pure ultramarine, for example, is made from ground lapis lazuli.

Media and Techniques

In the past, the varied methods of using the pigments and the different techniques of

application have been influenced by the binding medium or vehicle with which they have been mixed. Egyptian and Assyrian painters mixed dry pigments with glue or gum to make paints which they used for decorating both the insides and outsides of their buildings. In the Orient, water-soluble gum or eggwhite was used for painting miniatures, and size, which is a thin liquid glue, for paintings on either paper or silk.

During the first few centuries A.D. the Egyptians, Greeks and Romans made use of beeswax as a medium for encaustic painting. This technique of painting involves fixing the colours by heat, and the results are particularly durable. Great practical problems occurred in its application, however, because the paint only remained fluid enough to work for a short time, even when the palette was kept over a fire and the paint applied with warmed instruments. The technique did not lend itself readily to much elaboration or refinement. Surviving examples of the use of this technique in Egypt, mainly portraits in tombs, have a rough finish showing traces of the instruments used to apply the paint. Some of the wall paintings found in Pompeii and Herculaneum are also thought to be examples of the encaustic method although their surfaces are smooth.

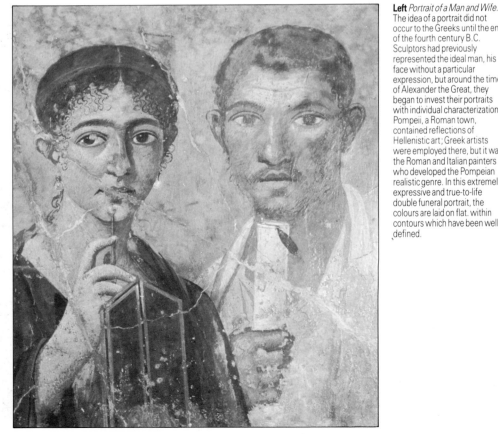

Left *Portrait of a Man and Wife.* The idea of a portrait did not occur to the Greeks until the end of the fourth century B.C. Sculptors had previously represented the ideal man, his face without a particular expression, but around the time of Alexander the Great, they began to invest their portraits with individual characterization. Pompeii, a Roman town, contained reflections of Hellenistic art; Greek artists were employed there, but it was the Roman and Italian painters who developed the Pompeian realistic genre. In this extremely expressive and true-to-life double funeral portrait, the colours are laid on flat, within contours which have been well defined.

Palettes
Influenced by Velasquez' solid tonal paintings and Courbet's Realism, the art of Whistler (1834-1903) was delicate and low-toned. He spent much time mixing colours in advance in order to paint quickly. For portraits, he advised students to have oval palettes with white at the top in the centre and to the left yellow ochre, raw sienna, raw umber, cobalt and mineral blue; to the right, vermilion, Venetian red, Indian red and black. Flesh tones were placed at the top near the centre with a black strip curving downwards to create shadows. Colour was spread between lights and darks so that tonal changes could be made and a tonal picture built up; preparation for the background was made on the left. A modern palette might include white, lemon yellow, yellow ochre, light red or Indian red, terre verte, cobalt blue, raw umber, and crimson. Rembrandt's rectangular palette of warm, strong colours consisted of white, black, burnt sienna, ochre, Vandyke brown, vermilion or medium red, Chinese yellow, cobalt blue, ultramarine and medium green.

Fresco

Fresco was the first important and popular technique used in applying paint to a background. Both Vitruvius and Pliny (*c.* A.D.23-79) make reference to it in their writings but it was not until the thirteenth century that it came to be widely used across Europe. It is the only method of painting which can truly be termed "watercolour" as it is the only one to use just water as the vehicle for the pigment. It is, however, called "fresco" painting because it involved the application of pigment to fresh plaster. As the plaster dried, the colour was bonded into it and became a part of the wall, instead of lying separately on the surface. This made it a particularly durable method.

Because the paint had to be applied while the plaster was still wet, the design of the intended painting had to be planned in sections, each one representing a day's work, and carefully drawn out on paper beforehand. At the beginning of each day, exactly the right area of wall was covered in fresh plaster. Giorgio Vasari, the sixteenth-century artist, architect and biographer, gave fresco his highest accolade, describing it in *Lives of the Most Excellent Painters, Sculptors and Architects* (first published in 1550) as being "the most masterly and beautiful" of methods. He explained how the technique was employed:

"It is worked on the plaster while it is fresh and must not be left until the day's portion is finished. The reason is that if there is any delay in painting, the plaster forms a certain

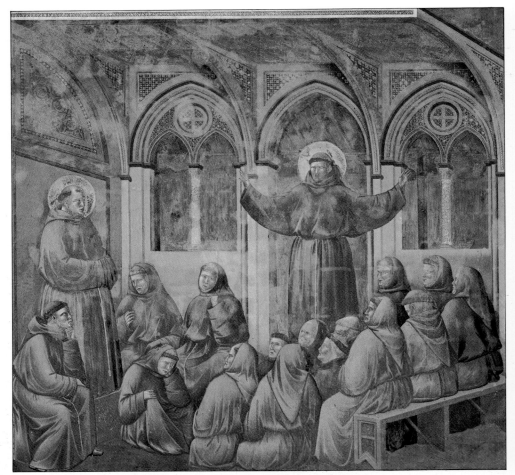

Above *St Francis Preaching* (1297-*c.*1305), Giotto. Giotto's ability to represent the human figure and emotions and to recreate the visible world on the two-dimensional plane is well demonstrated in this fresco scene.
Left *The Annunciation*, Fra Angelico (*c.*1387-*c.*1455). This fresco, with its perfect sense of colour and composition, shows Angelico's interest in perspective to create a harmonious setting for his figures.
Right *Virgin Annunciate* (1527-8), Jacopo Pontormo (1494-1557). Pontormo's works are often exaggerated in form and emotional content. Here he combines high tonality and shot colours to create the Virgin's graceful figure.
Far right *The Delphic Sybil* (detail), Michelangelo Buonarotti. Michelangelo worked on the Sistine ceiling between 1508 and 1512. The Sybil's head and eyes turn away from the movement of her arms, her strong body and face derived from classical sculpture.

slight crust whether from heat or cold or currents of air or frost, whereby the whole work is stained and grows mouldy. To prevent this, the wall that is to be painted must be kept continually moist, and the colours employed thereon must all be of earths and not metallic and the white of calcined travertine. There is needed also a hand that is dextrous, resolute and rapid, but most of all a sound and perfect judgement; because while the wall is wet the colours show up in one fashion and afterwards when dry they are no longer the same. Therefore in these works done in fresco it is necessary that the judgement of the painter should play a more important part than his drawing and that he should have for his guide the very greatest experience, it being supremely difficult to bring fresco work to perfection."

The colours used for fresco work were almost entirely earth colours, most vegetable and metallic pigments being chemically unsuitable. The "white of calcined travertine" to which Vasari refers, had to be used because the more usual lead white, "biacca", was incompatible. Travertine was a building material widely employed by the Romans, a notable example of its use being the Colosseum. By burning travertine, a white lime appears from which the fresco white "bianco Sangiovanni" was manufactured. As the surface of the painted plaster dried, a chemical reaction caused a crystalline skin of carbonate of lime to form on the surface. This not only protects fresco paintings from damp and other atmospheric conditions but also lends them a metallic lustre which is part of their unique appeal.

The limitations of this technique are paradoxically also the reasons for high standards being achieved in its use. The practitioners of fresco painting were obliged to give careful consideration to the planning of the composition, which gave an overall unity of style to each. Also, working against the clock, the frescoer was required to paint deftly and with a sureness of touch. There was no time for corrections, and although details could be added after the work was dry ("fresco-secco") this was not advocated by purists. Additions were sometimes made in tempera paint but this tended to darken quickly and spoil the fresco. Vasari pointed out that it was necessary to "... work boldly in fresco and not retouch it in the dry because, besides being a very poor thing in itself, it renders the life of the picture short".

The most common method of transferring the design to the plaster on the wall involved preparing a full-sized cartoon on paper, then pricking tiny holes along the drawn lines on the cartoon. The paper was then held against the surface to be painted, and a muslin bag containing powdered charcoal was dabbed onto the cartoon so that the design showed up on the plaster as a series of black dots.

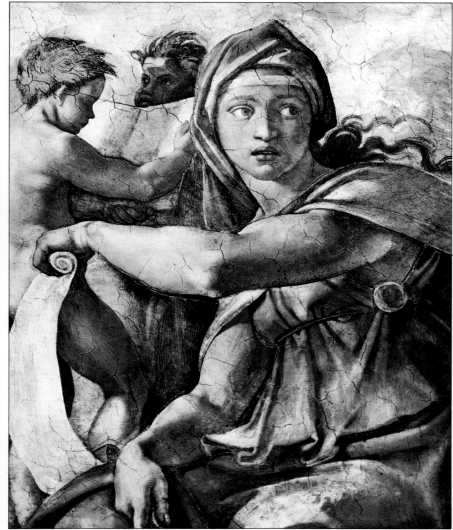

Right *The Boxers*. This modern painting shows the effectiveness of large blocks of tempera colour combined with acrylic.
Below Looking from left to right, different consistencies can be seen. A directly applied and unworked pure egg tempera is similar to thickly laid water-colour. Painted in a similar way, an egg yolk, stand oil emulsion and damar varnish resemble a mixture of pure tempera and oil paint, resulting in very dense colour. A whole egg mixed with damar varnish and oil of cloves emulsion produces a flat, dense colour.
Bottom These illustrations show various egg-oil emulsion mixtures which produce a glossier finish than pure tempera. Looking from left to right the mixtures are: one level teaspoon of linseed oil with one egg yolk; one egg yolk, one level teaspoon of blended stand oil and damar varnish; the yolk and white of an egg blended with a teaspoon of linseed oil added drop by drop, and four drops of white vinegar, all strained; 20 drops of oil of cloves added to one egg and a quarter of the egg's volume of damar varnish.

Tempera

Painting in the tempera medium has a longer history than fresco painting. The word "tempera" comes from the Latin verb "temperare" which means "to divide or proportion duly; to qualify by mixing; to regulate; to discipline". The literal translation seems appropriate; the mixture of pigment and medium is difficult, needing precision, and the method of applying tempera paint to a ground is itself a discipline. The method has been widely used both in the Orient and in Europe from the earliest times and was extremely popular through the Middle Ages to the fifteenth century, when it was superseded by oil painting. Occasional revivals of interest in this technique have kept it alive until the present day, although it is no longer widely popular.

The normal ground for tempera painting was a wooden panel which was occasionally covered with canvas. The choice of wood varied according to availability. In Italy, poplar was most commonly used, as recommended by the Italian artist and writer Cennini (born *c*.1370); in central Europe the choice was pine, while in Flanders and northern Europe it was oak. Other woods, including larch, maple, box, lime, fir and willow were also used. The wood had to be well seasoned, planed and, if necessary, jointed. The practice of covering panels with canvas or linen was to prevent joints opening later and spoiling the picture. Next, several layers of gesso ground, the main ingredients of which were size and some form of whitening agent, usually plaster of Paris, were laid over the panel. The gesso was sanded down after it had dried to provide an even, smooth surface on which to work. Sometimes the gesso ground was toned by a coat of resin or size with an added colouring agent, although it was more usual to retain the white surface which reflected light back through the translucent paint, adding brilliance and depth to the colour.

A number of different media are favoured by different people as the best vehicle for the

Left *Family and Rainstorm,* David Alexander Colville (b.1920). This painting, on a board support and almost photographic in its treatment of the subject, demonstrates the versatility of tempera, one of the earliest types of paint media. The cool colours, grey, yellow and brown, have a smooth, opaque quality which help to create the sense of stillness and the monumentality of the figures.

pigment in tempera painting. Vasari was firmly of the opinion that the yolk of an egg excelled all others. The following is his description of the way in which the Old Masters prepared tempera paint:

"They whisked up an egg and shredded it into a tender branch of a fig tree, in order that the milk of this with the egg should make the tempera of the colours, which after being mixed with this medium were ready for use. They chose for these panels mineral colours of which some are made by the chemists and some found in the mines. And for this kind of work all pigments are good, except the white used for work on walls made with lime, for that is too strong. In this manner their works and their pictures are executed, and this they call colouring in tempera. But the blues are mixed with parchment size, because the yellow of the egg would turn them green, whereas size does not affect them, nor does gum."

Tempera paint has a number of advantages over fresco painting and many of the great exponents of the latter worked their smaller pieces in tempera. With its brilliant white gesso ground the paint has a greater luminosity than it was possible to achieve in fresco work, and also a slightly greater depth

of tone. Because the paint could be laid in thicker layers, the light areas could be built up more strongly. It was also the practice of artists to create softer transitions of tone by "scumbling". This is the laying of semi-transparent light paint over darker areas, sometimes in an irregular way, to modify the paint beneath by creating areas of broken colour. Being a flexible medium, artists were able to include areas of fine elaboration in tempera paintings.

Medieval artists were beginning to establish a method for painting the human figure. Areas which were to be flesh were given an underpainting, usually of terre verte. This subdued green complemented the pinkish colour of the flesh and was allowed to shine through in areas of shadow to provide the half-tones. The green underpainting was sometimes heightened by the addition of white and occasionally greater depth was added by shading areas in transparent brown. All this preparatory work was important in helping to give tonal depth to the finished painting and was, interestingly, closer to the ideas of the Impressionists than to the practice of adding black to arrive at darker tones, which was more normal at the time.

After the underpainting, the artist mixed enough of each of the colours he intended to use, to avoid running out before completing a painting. As with fresco, tempera changes as it dries and the colours lighten by several shades. The experienced tempera painter would make allowances for this but it was always difficult to match a new batch of colour with any that had already dried. The preparatory mixing partly accounts for the continuity of hue which is noticeable with this method of painting. Three main colours were mixed in order to paint the flesh. The artist began by laying in the main areas with a mid-tone, then worked over the top with the darker then the lighter tones. Later, a semi-transparent mixture of black and yellow ochre called "verdaccio" provided the deepest shadows.

When painting the clothed figure, the system was almost the same as for flesh. The colours for the underpainting were designed to complement whatever colours were chosen to go over the top; red, for example, took a greenish-grey underpaint, and blue usually took a white-grey or occasionally a green. The top colour was similarly painted in stages: the mid-tone first, then the darker and then the lighter areas.

Oil

The invention of oil painting is attributed, by Vasari, to Jan van Eyck who was working at the beginning of the fifteenth century. Although oil had been used as a vehicle for pigments by earlier artists, van Eyck was certainly the first artist to develop a recognizable technique of working with pigment suspended in oil. He was the first to exploit the way in which colours could be blended softly to achieve a more natural effect than was possible with tempera. He probably ground his pigments in some sort of refined oil, possibly linseed or walnut oil, which, according to Vasari, is less inclined to darken with age. Because oil paint alone would, it is believed, take about 400 years to dry, it was necessary to add an agent to accelerate this process. Van Eyck probably used turpentine which would have thinned the paint as well as helping it to dry.

The support which is most commonly associated with oil painting is canvas although artists continued to use wooden panels as well. These had originally been used because of their rigidity which was an important consideration when working with a medium such as tempera. With its greater flexibility, oil paint could be applied to a less rigid support without the danger of its cracking. There are obvious advantages in using canvas. It is light, which makes it easier to transport than wood and also allows for larger paintings than had previously been practical. Canvas can be rolled when not in use which makes it economical of space, and it is also more economical to buy than large panels of wood.

The traditional method of preparing a canvas, and one which is popularly used today, is to stretch the canvas over a wooden frame and secure it with tacks. Wooden frames consist of "stretchers" which can be made at home but are also available at art suppliers. The stretchers are jointed at the corners in such a way that the tension of the canvas can be adjusted at a later stage by hammering in wooden pegs. Raw linen is the best material to use and it is easier to stretch if it is slightly dampened first. Once stretched, the surface of the canvas can be prepared for the oil paint. Some of the earlier users of oil paint continued to lay a ground of gesso, but this was not found to be entirely suitable as canvas tends to contract and expand with changing atmospheric conditions, which caused the rigid gesso to crack and flake off. Also, finished canvases were often rolled up for transportation, and a flexible grounding was obviously necessary. The usual method employed by artists today is to give the canvas several coats of size, the purpose of which is to fill the pores of the canvas and make it non-absorbent. There are various

Above *Gabrielle d'Estrées and her Sister*, School of Fontainebleau. This double portrait in oils of the mistress of François I and her sister exemplifies the sensual and decorative style of painting which flourished in France between 1528 and 1558. The rich, glossy qualities of the medium complement the etiolated elegance of the subject.

Right Canvases are usually made from linen, cotton, a linen cotton mixture, and hessian. Unbleached calico is a cheap cotton weave (1). A good cotton canvas is almost as good as linen provided that it has previously been primed (2). Hessian is coarse and needs a good deal of priming (3) while linen (4 and 5) is the best and most expensive type of canvas coming in several weaves, the best of which are closely woven with the threads knot-free. Linen primed with acrylic, is multi-purpose (6).

1 2 3
4 5 6

Right Canvas is the most common support for oil paintings, and is extremely receptive to the paint when fixed to a stretcher. Wood for stretchers comes in many lengths, and pieces can be fitted together to make rectangles of all sizes.

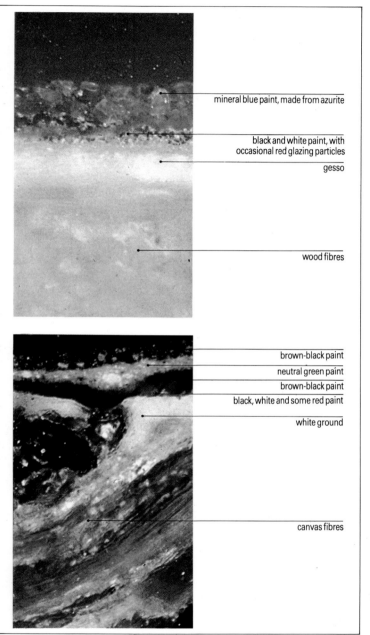

mineral blue paint, made from azurite

black and white paint, with occasional red glazing particles

gesso

wood fibres

brown-black paint
neutral green paint
brown-black paint
black, white and some red paint

white ground

canvas fibres

Left This cross-section of an early Flemish painting has been magnified 200 times. Wood was used as a support for easel paintings by the Egyptians, and again in medieval and early Renaissance art. This cross-section shows the gesso ground, made from plaster mixed with size, and layers of paint.
Below left This cross-section of an early painting by Titian has been magnified 100 times. It was one of the first paintings to be done on canvas. The white ground has penetrated the canvas fibres and the neutral green underpaint, terre verte, applied as a ground for f esh painting, is revealed.
Below *Portrait of a Woman with Gloves and Crossed Hands,* Frans Hals. Chiefly known as a portraitist, Hals was an extremely original artist with a unique directness of approach. Influenced by the Caravaggisti, he used *chiaroscuro* for dramatic effects in rendering instantaneous impressions. Bold brushstrokes and impasto build up textures, particularly evident in the hands.

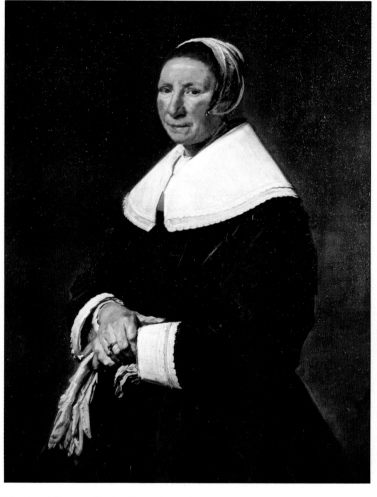

kinds of size available; rabbit-skin preparations are generally considered to be the best.

The next stage involves covering the surface of the canvas with a "primer" which is prepared from a number of ingredients. Vasari gives a recipe which consists of "a paste made of flour and walnut oil with two or three measures of white lead put into it". The following recipes for grounds are only guidelines and should not be considered as the only possible ones to use; grounds are very much a matter of individual preference.

A simple but efficient oil ground consists of six parts turpentine, one part linseed oil and some flake white. This should be applied to a dry surface which has already received two coats of size, applied when hot. The ground should be brushed on, and left to dry for 24 hours, and then a second coat applied and left for about a month before using. An emulsion ground might be mixed with one part whiting, one part glue size, one part zinc oxide and half part linseed oil. A simple gesso ground, for use on wood or hardboard, might consist of one part whiting and one part size. The dry whiting should be sieved into some of the heated glue size until a smooth paste is achieved. The rest of the hot size should then be mixed in to give the gesso mixture the consistency of cream.

The addition of white clay gives greater body to the ground, while an acrylic medium, a synthetic resin, could be included for its elastic properties. It is a good idea to include an anti-fungus and anti-bacterial agent, which is often added into proprietary brands of glue size as a matter of course.

Several layers of primer should be laid. For the final coat, some artists prefer to add some colouring pigment, thus giving themselves a tinted ground on which to work. Some, preferring to give the surface of the canvas

"teeth", dab the heel of the hand against the wet primer. Applying the primer with a foam sponge roller gives a similar effect.

Many of the pigments used today are recent innovations. Artists from previous centuries had very few colours to choose from, but even so they often deliberately worked from a palette with further restrictions self-imposed. Now, with a large range of pigments available, it is more important than before to choose a palette of only a few colours, as this is more likely to result in a unity and harmony being achieved in a painting than when a confusing jumble of pigments are at hand. Also, it means that the artist becomes increasingly familiar with the few chosen colours, and can exploit them to the full.

Because the pigment is suspended in oil, which turns into a solid, transparent substance when dry, a number of glazes need to be laid, one over the other, to achieve the required shades and tones. The layers together combine to give depth to the colours, while they retain a brilliance in the transparency. These qualities are enhanced by the use of underpainting. Light reflects back through thin layers of paint from a white or pale underpainting, so giving work an extra luminosity.

The major advantage of oil paint is that it remains workable over a long time, allowing colours to be blended, modified or changed as the work progresses. The oil itself retards the drying time of the paint, while the addition of turpentine or varnish accelerates it. Each subsequent glaze should contain more oil than the previous layer; the last layers need to be well oiled, so that progressive workings retain their elasticity. This means that artists, working from dark to light, can blend highlights carefully and with

as much detail as is required into the hard, dry underlayers without fear of the paints muddying.

The special qualities of oil paint are particularly evident in pictures of the human figure, when they can be exploited to make flesh appear almost translucent, and can be used to express the different textures of cloth very realistically. The medium is also suited to the rendering of mood and emotion, because the paint itself can be varied in texture. The painter can mix it thick or thin, dry or wet, and can either apply it smoothly

so that there is no surface texture and no evidence of manipulation, or roughly, with brushstrokes a definite, stylistic feature. Scumbling, and the techniques of working wet paint into dry, and dry paint into wet are examples of further ways of achieving textured effects and tonal depth. This versatility allows artists to work fluently and expressively within the restrictions of the media, adding their own enthusiasm to the mood of a painting. The variety of techniques can be used in many ways to create vivid representations of nature.

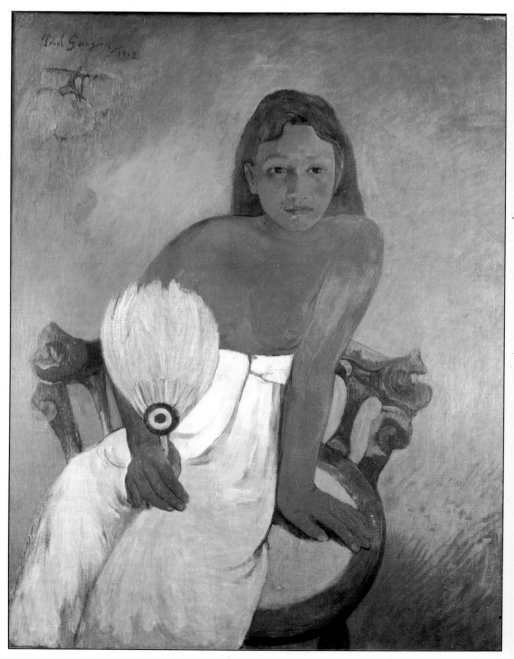

Right *Girl Holding a Fan* (1903), Paul Gauguin. One of the first to find inspiration in the arts of primitive civilizations, he rejected the representational function of colour, using it in flat, contrasting areas which strengthened its emotional and decorative effect. He went "native", painting his finest pictures in Tahiti, fascinated by native sculpture and ritual. His forms became more simplified and his colours richer, in tune with his tropical surroundings. In this oil painting, the strangely represented right arm can be seen as an example of the primitive influence. Using almost flat areas of rich colour within strong outlines to form rhythmic patterns, he creates a strong visual image redolent of the nostalgic nineteenth-century idea of the Noble Savage.

GIRL IN CHAIR
acrylic and gouache on paper 21 × 14 inches (53 × 36 cm)

Glazing is a method of painting in which thin layers of paint suspended in the sort of medium which allows colours beneath to shine through, are laid one over another. The system of underpainting a monochrome structure and glazing colour over the top is part of a long painting tradition. In the past, the common medium for the underpainting was tempera and gouache was used for the glazings. Modern artists have adapted the tradition to accommodate recent developments in materials; acrylics are often used today for the underpainting and gouache

mixed with casein for the glazes. If the underlayer of paint is white, and the glazes semi-transparent, a luminosity and vibrancy is achieved in the harnessing of the priming colour; dark or mid-toned underlayers enhance a feeling of depth in the shadows.

The structure of the figure in this painting, which was emphasized by bright, afternoon sunlight, was delineated in firm monochrome strokes. Darks were toned and lights painted in white to give a strong impression of the form of the figure before the gouache was added.

The model is posed beside a window with bright sunlight slanting into the room, creating strong patterns of light and shade over the body (1). The artist chooses to ignore the stark contrasts of tone, concentrating instead on the general effects of light. It is interesting to compare the positions of the shadows in this photograph and in the final picture; in the latter a shadow is delineated over the right thigh in a different position. The picture takes some time to complete, and the artist is always aware of movement, accommodating his painting to it, rather than forcing a rigidity.

.1

2

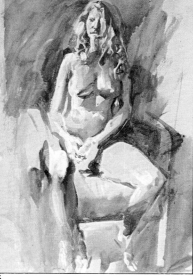

3

Almost like a sculptor coaxing form from a piece of stone, the artist brings the form of the figure out from the paper by careful modelling. The figure emerges in the building up of a series of monochrome washes in umber on biscuit-coloured David Cox watercolour paper. The method is suited to representing subjects or scenes under direct light where volume is emphasized by extremes of light and dark (2 and 3). In the detail, highlights are added in blue and white to give a strong overall structure to the underpainting (4). The background is also laid and blurred streaks of white worked over the model's right shin in preparation for the dark shadows which are to be painted against the bright highlights of that area of the painting (5).

4

5

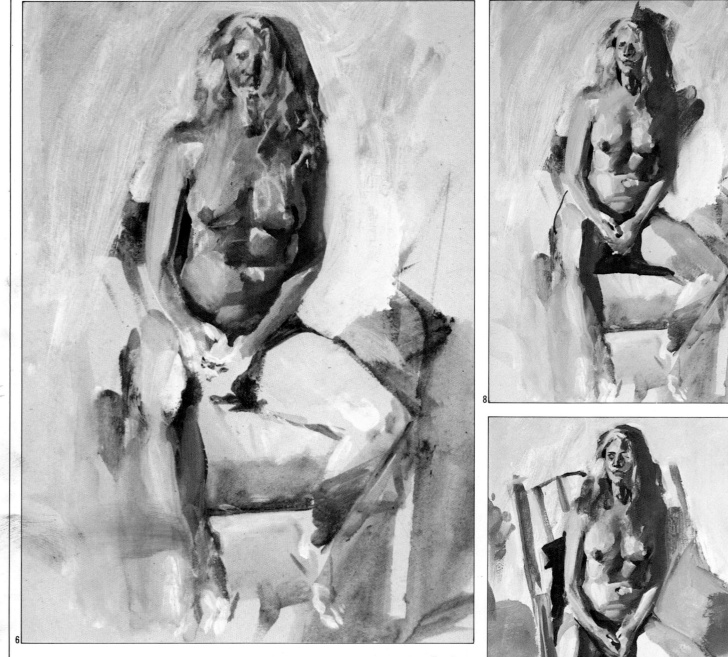

Colour is worked over the monochrome structure. Yellows and red-browns are painted over the torso, face and hair, their intensity and tone matching the tones of the underpainting (6). The stomach and breasts are carefully filled with a variety of hues, with a resulting precision of shape and form despite the obvious nature of the brushstrokes (7). Thin and dark, warm patches of brown are laid to delineate the shadows of the thighs, then a series of dark streaks of brown, blue and green are laid to cover the shadowed area of the model's hair and left shoulder (8). The glinting yellow and light brown of the hair beneath is allowed to show in a frame around the face, the rest of the hair looking almost black; this gives a subtle impression of the slanting sunlight. Details of the hands, shins and feet, and the features of the face, are added. With the chair and background also filled, using fingers to smudge the colours, the picture gains overall shape (9).

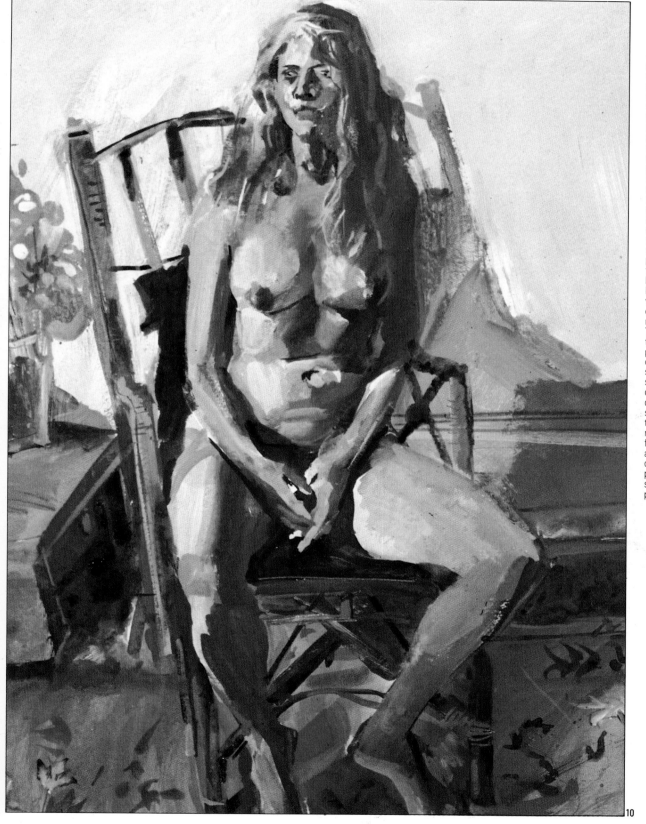

Some lights are added; some show through from the underpainting. Over the stomach, breasts, face and hair, extra highlights are painted where sunlight glints over the flesh; the rounded volumes of the figure, however, are mostly achieved in the actual process of underpainting and glazing. The casein medium with gouache allows for a great spontaneity because it is quick-drying and it covers well at the same time. Oil requires waiting because each glaze takes time to dry. It is an exciting technique, creating an opportunity to use a traditional method with a quick-thinking, modern approach. The covering power is visible in this painting in the way the dark, monochrome background becomes a cool, light blue, and also in the way yellow is painted over the very dark brown hair, and over the mauve of the carpet.

The artist changes the shape of the chair to suit the shape of the paper and of the figure. Instead of a rounded back he paints a square, barred back to give strength to the surface pattern of the painting, creating a diverse interest in the slightly slanting angle and its shadow on the wall behind. A sense of the room's space is implied by a line for the junction of wall and floor and the placing of the vase of dried leaves. The carpet pattern provides a delicate yet lively side-interest to the finished painting (10).

10

WOMAN IN A GARDEN

mixed media on paper 21 × 14 inches (53 × 36 cm)

Mixing media is an interesting way of making pictures. Artists have always experimented with combinations of techniques to create a range of effects. Pastels worked into mono-prints, and ink and pencil added to watercolours are just two examples. Oil paint, rubbed onto a support with a rag soaked in turpentine, will form a solid colour base capable of endless enrichment with pastels, inks or coloured pencils. Paper, millboard or stout, sealed cardboard are suitable supports for this kind of work.

The composition of this picture, painted in watercolour and gouache with pencil, ink and pastel elaboration, required thought because of the richness of the available subject matter. Planes were set in relation to the ground level and the table, and the figure was placed in the middle distance behind a large bush which was an atmospheric part of the garden and a contrasting foreground form. The various textures within the picture were of prime concern while working. The mixed media brings out a lively sense of the variety of shape, pattern and colour in the garden scene, a variety it would be difficult to suggest in a single medium.

1

5

This relaxed, informal view of a woman sitting in a garden poses interesting problems of scale, texture and content. There is a danger, with such busy subjects, that the artist's eye may be overwhelmed and the result be unsatisfactory through attempting to achieve too much. To represent this scene, the artist has to act as a visual editor, selecting areas of prime concern from the mass of detail available. Although the figure is undeniably the main interest in the painting, it is not given a correspondingly prominent position, but assumes its importance through its location. Setting the figure in the middle distance, behind a large, flourishing bush, has the effect of leading the eye back to this point, rather as if the observer is walking down a garden path. The understated, reserved placing of the figure creates a sense of discovery (1).

2

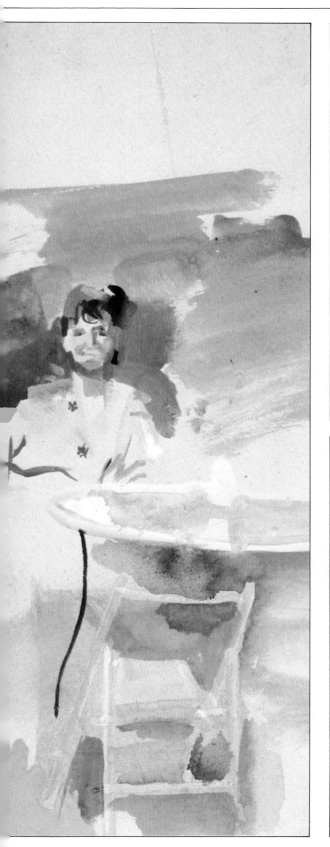

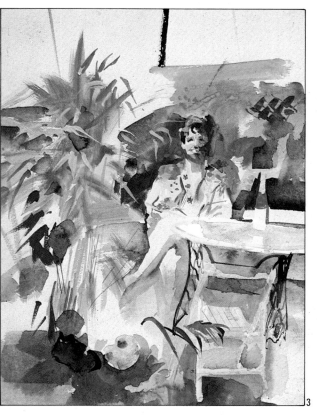

3

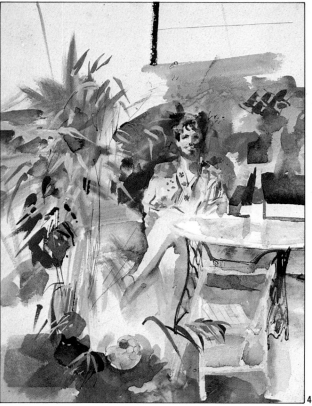

4

The initial preparations include stretching the paper, ready for painting in watercolour. A sheet of rough watercolour paper is soaked in water and taped right side up to a board, with gum strip. The two long sides of the paper are taped down first, then the two short sides. Using a large brush charged with pure watercolour, the foliage, table, chair and figure are quickly blocked in.

This initial blocking in of the main forms is loose and suggestive, to allow room for subsequent alteration, while at the same time establishing the main relationships. The chair has shrunk in proportion to its actual size and a soccer ball has been added in the foreground. The ball establishes a ground level in the forefront of the picture and serves to carry the eye back to the figure's face, echoing the shape of the head (2). The watercolour painting is gradually built up, using a variety of shades of green to organize the variety of tones present in the foliage. More detail is added to the figure and a strong vertical established for the wire fence in the background (3). At this stage, the artist introduces a new medium – pen and ink – to add a further dimension to the work. The thin, spidery marks of the pen sharpen up the details and express the spindly stems and pointed leaves of the large foreground plant (4). Taking care to allow the painting to dry before applying the ink, the artist makes quick, light strokes with a dip pen over the painted areas and into the blank spaces (5).

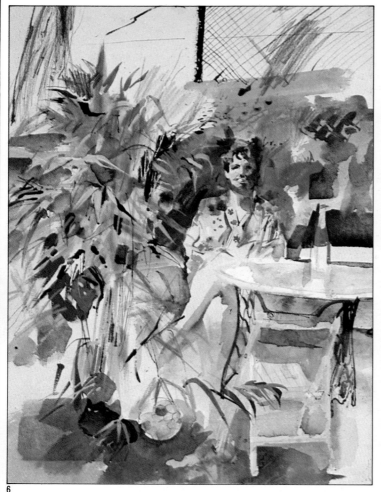

6

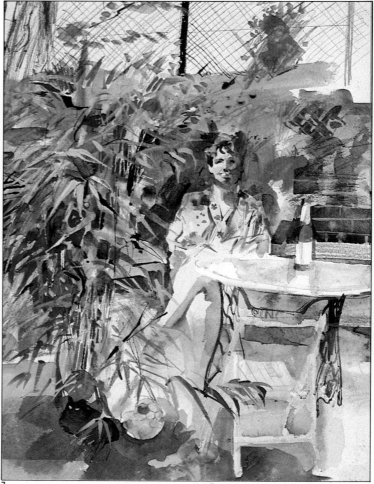

7

Further experiment is made with other materials and techniques. Pencil, coloured pencil and water-soluble pencil are used to treat some of the background areas of the picture including the fine grid of the wire fence. The tree trunk is drawn boldly with coloured pencil. Blots of ink give a depth to the foliage (6). Water-soluble coloured pencils are a relatively new medium; combining the fine line possible with pencil with the translucency of water-colour, when water is applied to the drawing. They have many interesting possibilities for the artist. When dampened, the line produced by such a pencil floods the surrounding area with colour, but remains visible under the wash (7). White is added to the pure watercolour, making a gouache. This serves to build up the solid areas of colour and introduces new tones in the foliage (8).

8

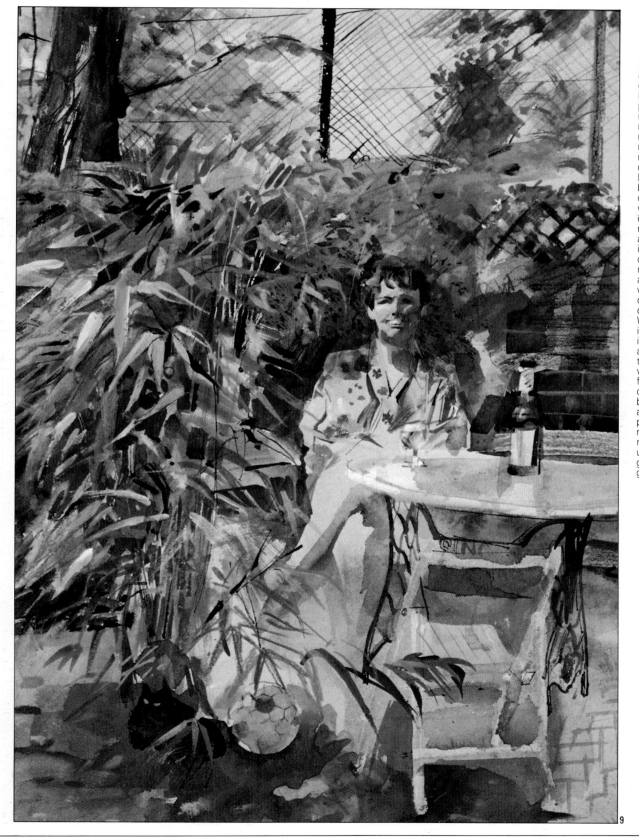

Mixing media is particularly appropriate when there are different textures and different levels of interest to consider in a picture. Simply combining media for the sake of it, or with no thought how the different materials will work together, will not guarantee a sensible result; materials must be chosen with definite effects in mind. Experiment is the best way of becoming aware of the potential of mixed media. In the finished work, the overall impression is one of liveliness, light and movement: this has not been achieved, however, by indiscriminate or haphazard use of media. An element of restraint and a constant awareness of how each addition will combine with the whole are crucial aspects of attempting complex, detailed subjects. Watercolour, gouache, pen and ink, pencil, coloured pencil and, in the final stages, oil pastel are all used here; each has its part to play in the rendering of the various textures, tones and forms. Small busy areas are contrasted with large relatively blank spaces; touches of light and colour create a vivid surface pattern which suggests movement and vitality. A wide range of colours have been used, including a wide variety of greens, to give depth to the garden landscape (9).

9

Watercolour

Watercolour painting, a method which has been particularly associated with British artists, is a more recent technique than oil painting, and has been popular since the eighteenth century. It is a difficult technique to master, because the paint is transparent and purists do not use white pigment to produce the lighter tones. Watercolour technique involves the artist working from the lightest through to the darkest tones by laying a series of coloured washes. Paintings are usually executed on white paper, the colour of the paper itself showing through to provide the light tones. If pure white areas are required, then the paper is left completely uncovered by paint. The pigments, which must be finely ground, are mixed with a water-soluble gum, gum arabic being the most usual. A small amount of added glycerine helps the paint to retain its solubility, even after it has dried.

The best watercolour paper is handmade and has a rough texture which causes tiny points of untouched white paper to sparkle through the washes, giving greater luminosity to the result. It is advisable to stretch watercolour paper before use, to prevent it from buckling and wrinkling as the water soaks in.

Gouache

If white body colour is added to the pigment the technique is known as "gouache". The paint used for gouache is not transparent and it is possible to use lighter paint across areas of darker tone. This allows for greater elaboration when painting. It is a less exacting medium than watercolour, but the result is less luminous. An artist wishing to produce spontaneous paintings of figures can choose either of these media, but as watercolour demands a speed of working and its luminous effect implies the changing qualities of light, it seems particularly well suited to capturing the moving figure.

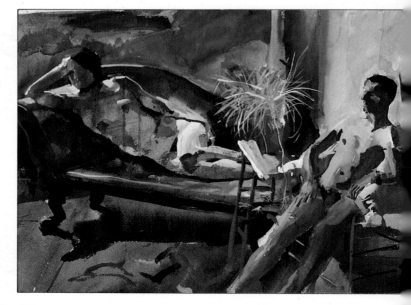

Left Watercolours can be bought in three forms, the most popular being semi-liquid paint in tubes. Semi-moist pans and dry cakes are also available, as are bottles of liquid watercolour with applicators.

Above The range of watercolour papers is almost inexhaustible. Here are just a few: Green's de Wint Rugged (1), Crispbrook handmade (2), Kent (3), Arches M38AM (4), Arches M131AM (5), Rice M11401 (6), Schoellershammer T (7), Schoellershammer (8), Montgolfier (9 and 10), Canson (11), Fabriano (12), Canson Mi Teites (13), and Ingres (14 and 15).

Right *Seated Male by Female on a Couch, both Nude.* In this painting, watercolour has been used and white body added to render the paint opaque. The artist has created strong, shifting light effects in his broad handling of the medium.

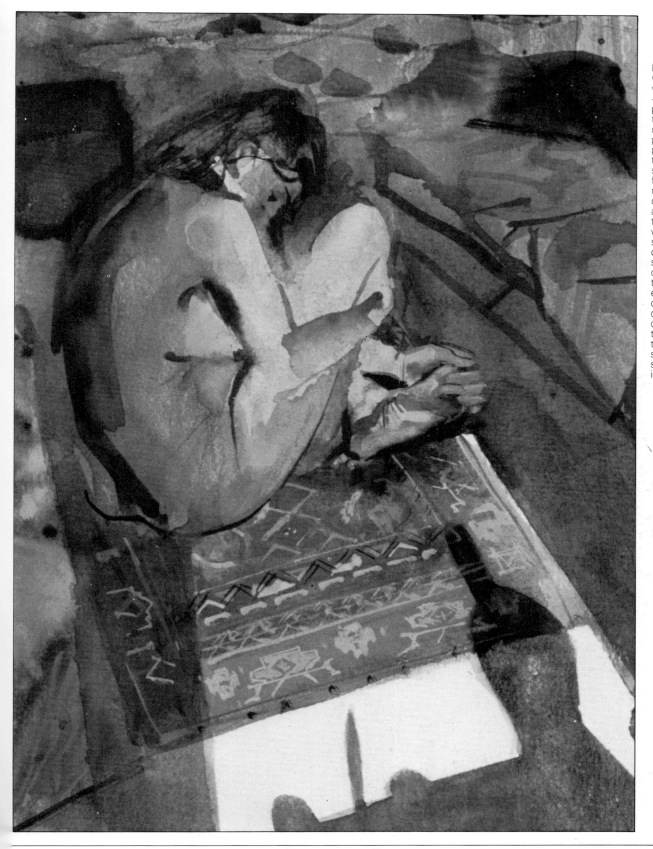

Left *Nude on Oriental Rug*. A true watercolour makes no use of white pigment – or body colour – but relies on the white of the paper for the lightest areas in the painting. Such a technique is difficult to master, but it can be particularly effective. This painting includes some small touches of body colour in the shadow to the left of the rug and for the restated pattern on the rug itself, but its special quality derives from the large unpainted area in the foreground and the translucency of the washes which depict the figure. The shaft of light from the window creates a border pattern of shadows and slants across the carpet to just touch the side of the huddled figure. The effectiveness of this composition is not only that the diagonal shape of the light area directs the eye to the figure, but that it also draws attention to the woman's vulnerability. A series of warm grey washes suggests the intimacy of the interior.

Acrylics

Recently, the advances in technology have led to the development of a wide range of artificial pigments. Acrylic paints, which are bound in a synthetic resin, are a regular medium with many artists today. They have the advantage of being water-soluble while they are wet but are quick-drying and extremely durable. They are not to be confused with oil paints, however, and cannot be used to achieve such subtle effects, mostly because they are more opaque and do not allow the artist to build up tone and colour in the same way

Brushes and Palette Knives

For all the methods of painting described in this chapter, the most common instrument of application is the brush. Generally the stiffer bristle brushes are used for oil and acrylic painting. A long handle allows the artist to use the brush as an extension of the arm in large, sweeping strokes. For more detailed work and for watercolour, soft sable brushes are a usual choice, but the size, shape and texture of a brush is always a matter of

Artist's box
This Winsor and Newton box contains acrylic paints. A plastic emulsion, soluble in water, acrylic allows for thin washes, although not as thin as water-colour, as well as thick impasto. Its particular advantages are that it dries very quickly and is permanent.

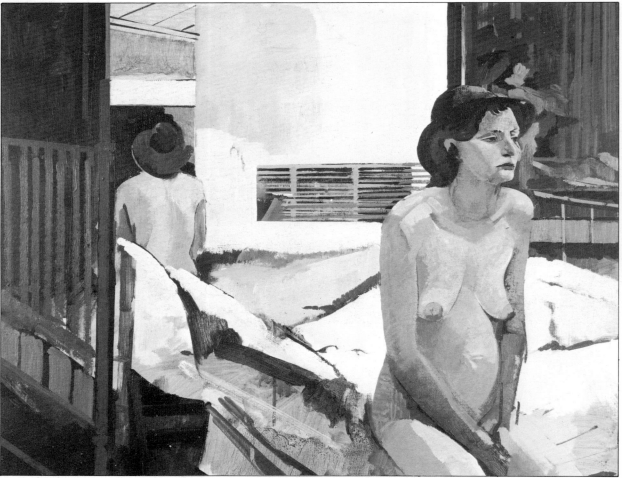

Left *Girl Sitting on a Bed*. This painting demonstrates the strong colours of acrylic and its covering power. The model is seated on a bed, her back reflected in the mirror. This device is used to extend the picture space and to lighten the background tones. The main colour areas are first blocked in with opaque paint, and subsequent layers built up without the colours coming through. The figure is built up in

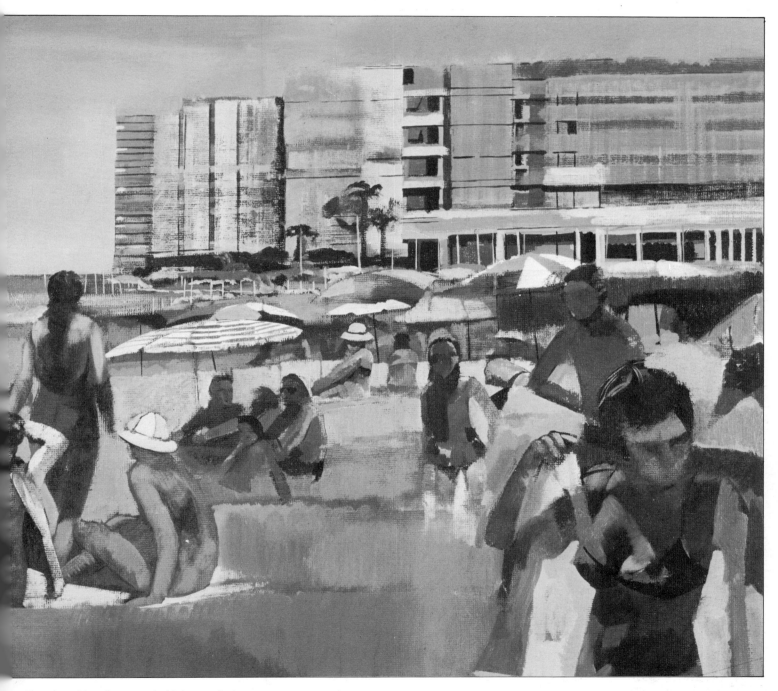

thin washes and the outlines strengthened with black paint. Lights and darks are contrasted by showing the play of light on the forms.
Above *Beach Scene*. This hot scene illustrates the strong contrasts obtainable from acrylic paints. Constructed from a series of photographs taken from different angles, it demonstrates the "correctability" of the medium: the transparent yellow jacket in

the right foreground is a late addition as are the buildings in the background, brought in to close off the picture space and to direct the spectator's eye to the figures. The sense of hazy heat is captured in the shimmery effect of the buildings and blurred outlines of the figures.

individual preference. There is no right or wrong tool for any particular painting technique. Many artists keep a selection of brushes; this would probably include round and flat brushes of varying sizes with handles of different lengths, some made of hog-hair, others of squirrel or sable.

The brush is not the only tool to be used in applying paint; palette knives are also used. Two notable exponents of this technique are Courbet and Vlaminck who painted some of

their pictures entirely with this tool. Palette knives are designed for two distinct purposes: for mixing the paint and for scraping the palette clean. The former are designed in different shapes, usually either spatula- or trowel-shaped. They can be useful in conjunction with a brush for laying in the larger areas of paint. The textural effect given by a palette knife is very different from that of brushstrokes, and it is often considered to be particularly suitable for impasto work.

Sketchbook Preparation

Before embarking on a painting, it is worth being acquainted with some of the basic problems and possibilities inherent in the situation and the composition. By working on a small scale with an implement which lends itself to rapid notation it is possible to discuss the best way to approach the subject, working on angles, lines, tones and even colours until the essence of the desired effect is realized. Sketching works almost like a dialogue; suggestions arise, are discussed and then either discarded or accepted.

Some artists work better by "hitting" the support with fervour and directness, allowing the image to emerge spontaneously from a struggle carried out without any preparation. For many, however, the advantages of sketching outweigh the benefits of a spontaneous method of painting. Certain types of work seem to demand a careful and considered approach, and the resulting sense of calm that can be brought into a picture is often important. As a compromise, and to ensure a continuing liveliness while painting, many artists use visual notes only as a general aid, and do not allow themselves to be bound by the lines and spaces, rhythms and intervals of the sketches. The elaborating, changing process continues: angles and stresses may be changed and extraneous elements brought in to increase the atmosphere or add strength.

Above right and right These two sketches offer the viewer intimate glimpses of a girl completely relaxed in her bath. A sense of movement and indulgence is achieved in their combination; separately they may be taken as useful preparatory studies, helping the artist to build up a store of visual information. The back view was established in a very short time, with verticals, including the hose and the girl's spine, creating a symmetry only upset by the glass balanced on a corner. Because the artist is looking down on the girl, a cramped sense of space is implied.
Establishing the idea of a side view, the girl is again sketched briefly but with a little more care. Background details and a mirror reflection are included. The artist still stands above, so that the angles of the side of the bath are sharp, and the body foreshortened.

Left *Girl in a Bath*. The position finally chosen by the artist for the painting is much lower and closer, so that the figure fills more of the paper and the viewer is on a level with the subject. The resulting picture is intimate and tantalizing, its blatancy tempered by the feelings of well-being and enjoyment. The composition is nicely balanced with strong diagonals taking the viewer's eye back to the girl's head, and offset by the doubled vertical of the left thigh and right shin in the foreground. Although roughly drawn and painted, the shapes of the head and legs are accurate and well rounded. The varied textures of water, enamel and skin are strongly contrasted in close-up.

Fixed Lighting

Light is normally used in painting as an aid to the expression of form and colour. The transience of natural light is used to express reality, to enhance feelings of movement and liveliness in pictures and to create the impression of three-dimensional form. Always changing, presenting different aspects of objects and altering local colour, light is used to present an endless variety of moods.

To consider light as a constant, however, presents an entirely different world. When directly lit by a single, fixed source, the figure takes on a monumental, almost abstract quality, decorated with a surface pattern, which reveals form incidentally. To avoid abstracting the forms completely, figures need to be made to look realistic in other ways. In these pictures, the artist displays his comprehensive knowledge of anatomy and a proficient understanding of movement and foreshortening. In outlines, filled in with areas of flat, unbroken colour in the two paintings, the artist describes movement and mood, despite each picture being dominated by the stripes of bright light striking the bodies through blinds. The results bring to mind the brilliance of a southern sun and create a strong sense of interior space.

Below Compiling a sketchbook of drawings in preparation for painting a series of figures in sunlight streaming through a window with blinds, the artist includes views of models from all angles. The form of the figure is more detailed in pencil than in the paintings because the artist is experimenting with the stripes. In the process of working out how the slanting lines fall across the the body, it is essential to discover the precise forms and curves, so that the stripes can follow round them.
Bottom The back is not traditionally popular in figure painting because it is generally considered uninteresting. Sometimes, however, if some added interest is created by, for example, the head turning over the shoulder, then a back view can be intriguing. Character might be expressed by hair and a profile, by the set of the ear and the angle of the neck. Despite the fact that no facial expression is visible in this sketch, mood is implied in the positions of the limbs. The arms are apart, the head is slumped and the legs create an angle of 90°, indicating the model's casual air.

Left *Standing Girl in Sunlight*. The form of this figure is filled in almost uniform, flat colour, to give an abstract impression of a girl. However, because of the powerfully representative positions of her legs, the position of her hands folded in front of her and the wistful expression on her face, a great deal of feeling is evoked. The strong sunlight over the left arm and the torso gives the painting strength and vitality, and, crossing the picture at a slanting angle, creates a tension, being in conflict with the vertical position, self-protective pose and personality of the subject.

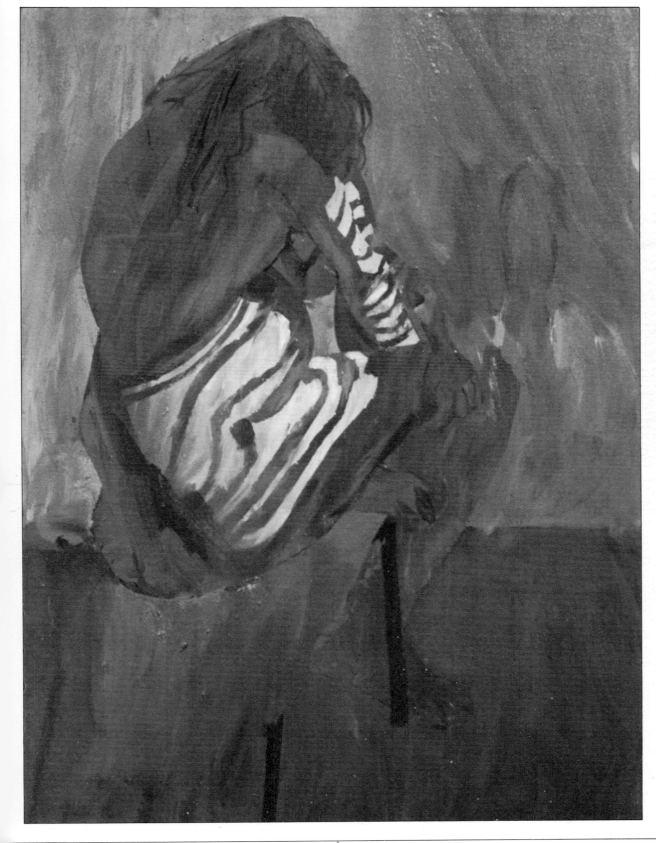

Left *Seated Girl in Interior.*The sketches helped to decide the artist on the view to take, and he used the composition of one of them to work the final painting. Composing a back view requires care because a simple, straight back set in the middle of the paper or canvas tends to be divisive, cutting the whole into three parts. The spaces between the edge of the support and the edge of the figure, and between the other edge of the figure and its own side of the picture, should vary. The composition of this painting may initially look one-sided. However, a balance is achieved by the generalized semi-circular curve of the figure being almost centrally intersected by the diagonal of the slanting sunlight. Being strongly represented, the diagonal is enough to offset the figure being so solidly set to the left.

The girl's form is created in persuasive outline, which describes the muscles and bones of the back. Shadows and highlights are hardly used. The human eye is incapable of discerning details under bright light and in gloom at the same time; the artist reflects this in his work. Because the light is so strong, the interior is gloomy and cool by contrast.

GLOSSARY

Abstract art A form of art in which the subject matter is approached in a deliberately unnaturalistic way in the expression of space, colour or form. Abstract art is usually associated with art of the twentieth century. The Russian painter Kandinsky (1910-13) is widely credited with having painted the first abstract works.

Acrylic A painting medium in which pigments are bound in a synthetic resin, such as acrylic emulsion. The main advantages of acrylic paints are that they have a fast drying time, may be diluted with water and they are permanent and durable. The British artist David Hockney (b. 1937) is one of the main exponents of acrylics today.

Binder A liquid such as linseed oil which when mixed with pigments holds or "binds" them together to form what is commonly called paint. The binder, or medium, determines the type of paint. Oil painting, for example, is so-called because oil is the medium used to bind the pigments together.

Blocking-in A term given to an underpainting technique in which the initial forms of a composition are sketched in and roughly described by the artist.

Body colour Also known as poster paint or gouache, any watercolour paint to which white has been added so that it is opaque rather than transparent.

Broken colour This description is given to paint which is applied in a pure state to the support instead of mixing it on the palette or the surface of the composition. Broken colours are usually thick and they can be used on top of one another in a dragging motion so that previous layers of colour show through. The use of broken colour was an important feature of Pointillism.

Camera obscura A darkened box or tent which was widely used by artists in the seventeenth and eighteenth centuries. With the aid of the lenses and mirror in the box, an artist could trace out a projected image of an object onto a painting surface.

Chiaroscuro This Italian term is literally translated "light-dark". Today it is used to refer to skilful rendering of light and shadows within a painting which has often been executed in oils. The Dutch painter Rembrandt (1606-69) is one of the artists most associated with the use of *chiaroscuro*.

Chronophotography A photographic technique invented by Etienne Marey (1830-1904) in which many images were captured on just one plate. By this process artists could study, second-by-second, the precise action in movements made by animals, birds and people.

Complementary colour Each of the three primary colours has a complementary colour which is made by mixing the other two primaries. For instance, the complementary colour of red is green, a combination of yellow and blue. The complementary lies exactly opposite a colour on the colour circle.

Crosshatching A technique by which depth and form can be built up using a series of lines or strokes which criss-cross each other. Although crosshatching can be used in painting, it is more commonly a drawing technique.

Cubism An abstract art movement which was originated by Picasso (1881-1973) and Braque (1882-1963) in Paris in about 1907. Reacting against earlier naturalistic traditions, Cubists often showed many different views of an object in the same work and frequently depicted forms as geometric planes.

Dipper A small container with an open top for holding oil or turpentine. The most useful type of dipper can be clipped onto the side of a palette.

Emulsion A mixture in which minute particles of one substance are suspended in a liquid. An emulsion ground consists of white pigment suspended in size and oil, for example, and egg tempera is also an emulsion made from egg suspended in oil.

Encaustic An ancient painting technique in which pigments were mixed with molten wax or occasionally resin and then applied to a surface, such as a wall, while still heated. The wax gives colours used in this way a glossy shine when dry.

Expressionism A twentieth-century movement whose artists deliberately abandoned the naturalistic style of painting favoured by the Impressionists and instead used exaggerated line and colour to give emotional force to their work.Van Gogh (1853-90) is thought to be one of the great forerunners of the movement.

Fauvism An art movement of the early twentieth century so-called because its exponents were nicknamed Les Fauves (the wild beasts) after their work had been exhibited in Paris in 1905. This was a reaction against the way the painters used wild distortions of colour in their work. Matisse (1869-1954) was the main exponent of Fauvism.

Fixative A thin varnish sprayed onto pastels, chalks or charcoal to hold them on the support after a work has been completed. It also prevents the image from becoming smudged or blurred.

Foreshortening A way of showing an object in perspective. For example, an outstretched arm is said to be foreshortened if the viewer can see little more than the hand.

Fresco A method of wall-painting, begun in Italy in the thirteenth century and perfected in the sixteenth, in which pigments mixed with water are applied to a ground of wet plaster. True fresco which is worked in this way is extremely permanent whereas pigments applied to dry plaster tend to fade.

Fugitive colour The name given to any colour which is impermanent. This means that it has a tendency to change colour or fade with time due to exposure to light and the elements.

Genre painting A type of art in which scenes from everyday life are depicted. The Dutch artist Vermeer (1632-75) is a well-known genre painter.

Gesso A white, plaster-based ground sometimes used to prime hard supports like wood for oil or tempera painting. It was commonly used before canvas became popular as a support in the fifteenth century.

Glaze A thin transparent layer of paint which can be applied over opaque colour to enrich or modify it.

Gouache Opaque watercolour paint which has a much faster drying time than oils. The pigments in gouache are bound together with gum.

Ground The painted surface on which a picture is made. The ground prevents the paint from being absorbed into the support. Usually grounds are white, but they may be tinted and their absorbency and texture can also be varied.

Gum arabic Derived from the acacia plant, a binding agent which is used in watercolours, gouache and pastels.

Highlights The areas in a composition where the light is most intense.

Hatching A method of building up tone and density in a composition by placing fine parallel lines over and next to one another.

Impasto The term given to paint when it is applied very thickly. Paint in which brushstrokes are clearly visible or which has lumps in it can be described as heavily impasted.

Impressionist A member of the loose association of painters who formed a group in 1874 for the purpose of exhibiting work outside the academic Salon school in Paris. One of the aims of the Impressionists was to capture the fleeting effects of natural light. For this reason they frequently painted outdoors using broken colours. They painted shadows of objects in complementary colours.

Local colour The inherent colour of an object when it is seen without the interference of other colours, light or atmospheric conditions. For example, the local colour of grass is green although, when it is seen from a distance, it often appears pale blue.

Linseed oil An oil which comes from the flax plant. Linseed oil is frequently used as a painting medium and in tempera emulsions. Although it has a fast drying time and gives a smooth effect, it tends to yellow with age.

Medium Specifically, the liquid used to bind pigments together to make paint. Oil for instance is the medium used in oil paint. The term media is also generally used in a wider sense. Pastel, watercolour, pencil and pen-and-ink can all be described as media.

Modelling In painting and drawing, this means the way in which artists build up the representation of three-dimensional forms on a flat surface to give the impression of solidity.

Orientalism The study of the art, language and culture of the peoples of the Orient.

Overpainting One or more layers of paint which are applied over paint already on the support.

Palette The surface on which artists mix their paints. Palettes can be made from almost any substance including paper, metal and plastic. Palette can also refer to the range of colours an artist uses.

Permanence When applied to paints this refers to their ability to retain their colour without fading in normal atmospheric conditions.

Picture plane The region of the painting lying directly behind the frame which separates the viewer's world from that of the picture.

Pigment The raw materials which create a colour which can be used for painting when mixed with a liquid. Pigments can be either organic (earth colours) or inorganic (chemicals and minerals). Sometimes the word is used to describe colour or paint.

Pointillism A painting technique developed by Seurat (1859-91) in which colours are placed beside each other on the picture surface so that they mix in the viewer's eye when seen from a distance. This was thought to give a more intense colour than if the colours had been mixed on a palette.

Post-Impressionism A movement which developed as a reaction against Impressionism and neo-Impressionism. It was a purely artistic movement which stressed the importance of the subject in a painting.

Pre-Raphaelite Brotherhood A group of English artists living in the nineteenth century who tried to revive the ideals of Italian art painted in the fourteenth and fifteenth centuries. Rossetti (1828-82) is one of the better known members.

Primary colour Red, yellow and blue are the three primary colours from which in theory all the other colours can be made.

Priming The first coat on which all paint layers are subsequently applied. The surface on which priming is put is usually already prepared with size. After the support has been primed the ground can be added.

Realism A nineteenth-century artistic and literary movement which took happenings in everyday life as subjects. Courbet (1819-77) is considered the first major Realist.

Retarder Any ingredient which is added to paint in order to reduce its drying time.

Scumbling A painting technique in which dry, fairly thick paint is applied in a loose, direct manner. Areas of broken colour with previous layers showing through are often created by this technique.

Secondary colour A colour made from two of the primaries such as orange which is made from red and yellow.

Size A thin glue, frequently made from powdered pigment and rabbit skins. It is applied to a support to prevent subsequent paint layers from corroding the surface.

Stippling A painting technique in which a loaded paintbrush is dabbed over the surface to create a dotted effect.

Support The material on which a drawing or painting is executed. The commonest types of support are canvas, board, paper and wood. Frequently the name is used synonymously with "surface".

Surrealism A twentieth-century movement whose artists deliberately banished preconceived ideas from their minds and allowed their subsconscious thoughts a free rein. The paintings this movement produced tend to have a dream-like quality and are often pure fantasy.

Symbolism A movement founded in the late nineteenth century by a loose association of artists. Their work was both decorative and mystical and often in unnatural, bright colours.

Tempera A type of binder which is added to powdered pigment. More often, however, the word refers to egg tempera painting which was popular until the late fifteenth century. Tempera dries fast which makes it difficult to work with.

Tertiary colour A colour made when a primary colour is mixed with one of its secondaries.

Vanishing point The imaginary point in a view at which receding parallel lines appear to converge.

Wash A very dilute, transparent colour which is applied loosely to a surface. Washes are usually executed in a water-based paint such as watercolour.

Watercolour A pigment that is bound with a water-soluble medium.

INDEX

M

N

O

P

CONTRIBUTORY ARTISTS

Roger Coleman	132 (t)
Anthea Cullen	56, 57 (tl)
John Devane	60-63, 94-5, 120-123, 124-125, 112-115, 146(b), 146-7
Rob Evans	38-39
Aldous Everleigh	90-91, 104, 110, 116-119
Philip Morsberger	77 (t)
Stan Smith	32 (l), 34 (t), 36 (b), 37 (tr), 40, 57 (b), 58-9, 74-5, 76, 76-7, 77 (b), 78-9, 92-3,101, 102 (t), 104, 105, 106, 107, 110 (r), 111, 137-139, 140-143, 144 (b), 145, 148,149, 150, 151.

ACKNOWLEDGEMENTS

The illustrations on these pages were reproduced by courtesy of the following:

6 Christies, London; 6-7 Jeu de Paume, Paris (Scala); 7(l) Museum of Modern Art, Venice (The Bridgeman Art Library); 7(r) National Gallery of Scotland, Edinburgh (The Bridgeman Art Library); 8-9 The Metropolitan Museum of Art, New York, Rogers Fund 1919 (Eric Pollitzer); 9 The Tate Gallery, London; 10 Palatina Gallery, Florence (Scala); 10-11, 11 Prado, Madrid; 12(t) Delphi Museum (Scala); 12(b) (Fotomas Index); 12-13 (Ronald Sheridan Photo Library); 14(l) National Museum, Naples (Scala); 14(r) National Gallery of Art, Washington, Mellon Collection; 15 Accademia, Venice (Scala); 16, 16-17 (Ronald Sheridan's Photo Library); 17 Uffizi, Florence (Scala); 18(t) S. Maria Novella, Florence (Scala); 18(b) Uffizi, Florence (Scala); 18-19 Borghese Gallery, Rome (Scala); 20(l) reproduced by gracious permission of Her Majesty the Queen; 20-21 National Gallery, London; 21 Rijksmuseum, Amsterdam (The Bridgeman Art Library); 22(b) Louvre, Paris (Scala); 22(t) Uffizi, Florence (The Bridgeman Art Library); 22-23 Louvre, Paris (Scala); 24 Jeu de Paume, Paris (Josse); 24-25 National Gallery of Art, Washington; 26(t) Louvre, Paris (Scala); 26 (bl) Féderation Mutualiste Parisienne, Paris (Giraudon); 26(br) Kunstsammlung Nordrhein-Westfalen, Düsseldorf; 27 Oesterreichisches Museum, Vienna (The Bridgeman Art Library); 28 Ann Ronan Picture Library; 28-29 British Museum; 31 Mauritshuis, The Hague; 32(r) Quarto Publishing; 33 Uffizi, Florence (The Bridgeman Art Library); 35 Quarto Publishing; 36(tl) Albertina, Vienna; 36(tr) Dubant Collection; 37(tl) (Fotomas Index); 37(b) Uffizi, Florence (Scala); 38 Ashmolean Museum, Oxford; 39 Quarto Publishing; 41, 42 (Fotomas Index); 43 Quarto Publishing; 44 reproduced by gracious permission of Her Majesty the Queen; 45(l) Royal Library, Turin; 45(r) Quarto Publishing; 46 Kunstmuseum, Basel (Hans Hinz); 46-47 Gemäldegalerie, Staatliche Museen Preussischer Kulturbesitz, West Berlin; 48 Uffizi, Florence (Scala); 48-9 Frans Halsmuseum, Haarlem (Tom Haartsen); 50(t) The Tate Gallery, London, V. Sivitar Smith; 50(b) Prado, Madrid; 51 Louvre, Paris; 52 (Fotomas Index); 52-3 Lugano, Thyssen Collection (Scala); 53 Musée Toulouse Lautrec (Scala); 54(t) Christie's, London (The Bridgeman Art Library); 54(b) The Tate Gallery, London; 54-55 The Hermitage, Leningrad (The Bridgeman Art Library); 55(t) Lugano, Thyssen Collection (Scala); 55(b) Birmingham Museums and Art Gallery; 64-65 Uffizi, Florence (Scala); 65 by gracious permission of Her Majesty the Queen; 66-67 Louvre, Paris; 67 Uffizi, Florence (The Bridgeman Art Library); 68 Albertina, Vienna; 69 (Fotomas Index); 70(t) The Tate Gallery, London; 70(b) The Hermitage, Leningrad (The Bridgeman Art Library); 70-71 The Tate Gallery, London; 71 Philadelphia Museum of Art (The Bridgeman Art Library); 72 The Tate Gallery, London; 72-73 The Victoria and Albert Museum, London; 80 Musée Départemental des Vosges, Epinal (The Bridgeman Art Library); 81 Louvre, Paris (Scala); 82 Surrey, Andrews Reddwill Collection (Scala); 82(b) (Fotomas Index); 83 The Tate Gallery, London; 84(t) from The Rape of the Lock, 1896, Mansell Collection; 84(b) Féderation Mutualiste Parisienne, Paris (Giraudon); 84-85 National Gallery, London; 86(t) The Tate Gallery, London (artist's copyright); 86(b) Home House Society Trustees, Courtauld Institute Galleries, London (Courtauld Collection); 87, 88 The Tate Gallery, London; 88-89 Sir Roland Penrose Collection (The Bridgeman Art Library); 89 Lugano, Thyssen Collection (Scala); 96 (Ronald Sheridan's Photo Library); 98 (Fotomas Index); 98-99 National Gallery of Art, Washington, Rosenwald Collection; 100(b) Quarto Publishing; 102(b) Baltimore Museum of Art, Cone Collection; 103(t) John Bellamy; 103(b) Yale University Art Gallery; 106-107 Prado, Madrid (Scala); 126, 127 QED Publishing; 128 (Ronald Sheridan's Photo Library); 130(t) (Scala); 130(b) San Marco Museum, Florence (Scala); 131(l) Chiesa S. Felicita, Florence (Scala); 131(r) Sistine Chapel, Vatican (Hans Hinz); 132(c), 132 (b) QED Publishing; 133 National Gallery of Canada, Ottowa; 134(t) Louvre, Paris; 134(c) QED Publishing; 134(b) Louvre, Paris (Scala); 135(l) QED Publishing; 135(r) Louvre, Paris (Scala); 136 (The Bridgeman Art Library); 144(t) Quarto Publishing.

Key: (t)top, (b)bottom, (l)left, (r)right, (c)centre.

LIBRARY